THE ART OF THE
Renaissance

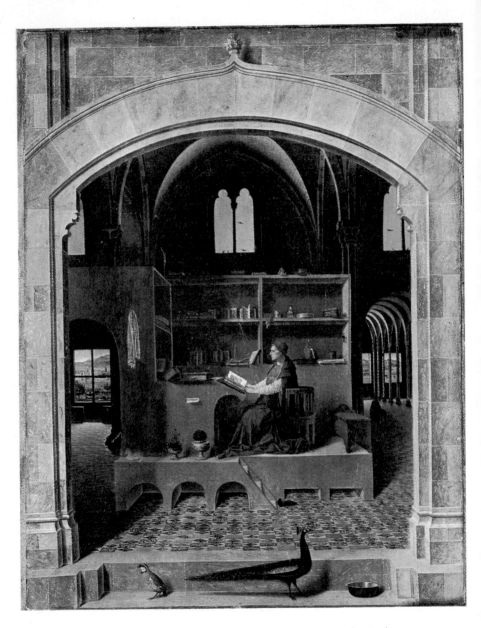

Frontispiece ANTONELLO DA MESSINA *St Jerome in his Study*

THE ART OF THE
RENAISSANCE

Peter and Linda Murray

with 251 illustrations, 51 in colour

THAMES AND HUDSON

© P. and L. Murray 1963

Reprinted 1978

Printed in Great Britain by Jarrold & Sons Ltd, Norwich

Contents

The Publishers wish to thank all those Museums, Galleries and private
collectors who have been kind enough to allow works in their possession
to be reproduced in this book. They are also grateful to The Viking Press
Inc. for permission to quote from *The Portable Renaissance Reader*, edited by
Ross and McLaughlin, New York, 1958, on pages 8–9 and 12–15. The
passages from Alberti's *On Painting* appearing on page 116 are from the
translation of John R. Spencer, Routledge and Kegan Paul Ltd., London,
1956, and the quotation on page 15 is from W. K. Ferguson, *The Renais-
sance*, Henry Holt and Co. Inc., New York, 1940.

Renaissance is a word which is very generally understood, but which few people would care to define very closely. This book is almost entirely about the Early Renaissance, about the formation of that style in the arts which, culminating in Leonardo da Vinci, Michelangelo, and Raphael, is still generally used as a touchstone of aesthetic quality. The period is usually reckoned to begin in Italy earlier than elsewhere, in the fifteenth century or at some point in the fourteenth century, perhaps as early as Giotto (died 1337), and to end in the sixteenth century, at any time after the death of Raphael (1520) and before that of Tintoretto (1594). The word itself means 'rebirth', and there can be no doubt that the Italians of the fifteenth and sixteenth centuries regarded their own times as immensely superior to all the ages since the fall of the Roman Empire (that is, about a thousand years earlier), and in this opinion posterity has largely concurred. The idea of the rebirth of letters and of the arts after a sleep of a thousand years is an Italian one, as quotation can easily establish. Marsilio Ficino, writing to Paul of Middelburg in 1492, says: 'This century, like a golden age, has restored to light the liberal arts, which were almost extinct: grammar, poetry, rhetoric, painting, sculpture, architecture, music, the ancient singing of songs to the Orphic lyre, and all this in Florence. Achieving what had been honoured among the ancients, but almost forgotten since, the age has joined wisdom with eloquence, and prudence with the military art, and this most strikingly in Federigo, Duke of Urbino, as if proclaimed in the presence of Pallas herself. . . . In you also, my dear Paul, this century appears to have perfected astronomy, and in Florence it has recalled the Platonic teaching from darkness into light. . . .' Half a century earlier, the same ideas were expressed by

Lorenzo Valla in proclaiming the perfections of the Latin language: 'the glory of Latinity was allowed to decay in rust and mould. And many, indeed, and varied are the opinions of wise men on how this happened. I neither accept nor reject any of these, daring only to declare soberly that those arts which are most closely related to the liberal arts, the arts of painting, sculpture, modelling, and architecture, had degenerated for so long and so greatly and had almost died with letters themselves, and that in this age they have been aroused and come to life again, so greatly increased is the number of good artists and men of letters who now flourish. . . .' Thus, the Renaissance was thought of both as a revival of good Latin literature and of the figurative arts. One reason for the apparently overwhelming importance which the men of the age attached to good Latinity was, of course, the fact that it was the common tongue of all educated men—a tiny proportion of the population in any country; another, less obvious, reason was the fact that the new European states were coming into existence; some, like France and England, with centralized monarchies, and others, like most of the Italian states, independent merchant communities. These states needed a professional administrative class, well grounded in Roman Law, which was still a living thing. They were inevitably exponents of the new, lay, learning, which, like the professional studies of the clergy, was based on Latin.

Giorgio Vasari, the painter, wrote the first important book on art history in 1550 (it was so successful that it was reprinted, with many additions, in 1568), and he shared this view of the revival of the arts as a rebirth of antiquity after the long sleep of the Middle Ages. In the Preface to his *Lives of the Painters, Sculptors, and Architects* we find such statements as: 'But in order that it may be understood more clearly what I call "old" and what "ancient", the "ancient" were the works made before Constantine in Corinth, in Athens, in Rome, and in other very famous cities until the time of Nero, the Vespasians, Trajan, Hadrian and Antonius; whereas those others are called "old" that were executed from St Sylvester's day up to that time by a certain remnant of Greeks, who knew rather how to dye than how to paint. . . . For having seen in what way art, from a small beginning, climbed to the greatest height, and how from a state so noble

she fell into utter ruin, and that, in consequence, the nature of this art is similar to that of the others, which, like human bodies, have their birth, their growth, their growing old and their death; they will now be able to recognize more easily the progress of her second birth and of that very perfection whereto she has risen again in our times. . . .'

This self-confident view met with approval in the nineteenth century, and in 1855 we find, for the first time, the word 'Renaissance' used—by the French historian Michelet—as an adjective to describe a whole period of history and not confined to the rebirth of Latin letters or a classically inspired style in the arts. Very soon—in 1860 to be precise—it came to have some of that over-life-size glamour which still lingers; when all Italians were conscious exponents of *virtù*, all statesmen Machiavellian, and all Popes either monsters like Alexander VI or splendidly enlightened patrons like Julius II and Leo X. The choice between these latter was not infrequently connected with the political and religious sympathies of the individual historian. Incomparably the greatest monument of this approach to history is Jacob Burckhardt's *Civilization of the Renaissance in Italy*, first published in 1860 and still an influential book. It was followed, and reinforced for English readers, by John Addington Symonds's *Renaissance in Italy*. Both these books present a rather romantic account of the period, in which the exuberance of the Italian temperament is occasionally taken at its face value, with results that might have surprised the principals. Symonds was by temperament and upbringing almost entirely antipathetic to everything valuable in Italian civilization, and he wrote from a position which almost automatically disqualified him from a true understanding of the Renaissance—yet his very weaknesses enabled him to write a biography of Michelangelo with sympathy and insight into at least some aspects of that strange genius.

Burckhardt's pupil and successor, Heinrich Wölfflin, was in some ways more successful. His *Classic Art*, first published in 1899, deals with the art of the Italian Renaissance from an almost exclusively formal point of view, and its analyses of the works of art themselves have hardly been surpassed: on the other hand, Wölfflin did not really attempt to explain the art of the period in terms of anything

9

but aesthetic impulses, and it is short-sighted to imagine that the sublime pathos of Michelangelo's late *Pietàs* or the fervour of Donatello's *Magdalen* (*plate 2*) were inspired solely by a Will-to-Form. This avoidance of the fundamental inspiration of Renaissance art is on a par with the current improper usage of the word Humanism: the fact is that Italian art of the fifteenth and sixteenth centuries, even when treating a 'classical' subject, is entirely Christian in its roots and in its meaning. Even Botticelli's *The Allegory of Spring* (*plate 1*) has been shown to have a Christian interpretation, esoteric and elaborated though it may be; and there can be no doubt that Masaccio and Donatello, Piero della Francesca and Bellini, were overtly or implicitly Christian, just as much as Fra Angelico or Michelangelo. A century ago it was imagined, because Botticelli painted the *Birth of Venus* (*plate 190*), because Alberti in his *De re aedificatoria* refers to 'temples' and 'the gods', or because Humanist poets wrote about Mars and Venus or treated astrology seriously, that all these sensible and educated men were neo-pagans, anxious only to promote irreligion and to follow (somewhat tardily) in the footsteps of Julian the Apostate. This fallacy has been encouraged by the modern misuse of the word Humanism to mean 'non-Divine', a sort of substitute religion in which Man is not only the measure of all things but also his own end: thus the modern atheist seeks to supply himself with a spurious ancestry in Pico della Mirandola or Marsilio Ficino.

In fact, Humanism in the Renaissance was *humanitas*, a word adapted by Leonardo Bruni from Cicero and Aulus Gellius to mean those studies which are 'humane'—worthy of the dignity of man. (The word Humanity still survives in the Scottish universities with the meaning of Latin and Greek literature.) They were, of course, distinct from theological studies, but distinction need not imply opposition, and it is essential to realize that the new secular learning was parallel to the older clerical studies rather than opposed to them. Secular learning of some kinds—law, or medicine—was not new; what was novel was the study of language, literature, and philosophy in a new context. This is one explanation for the hero-worshipping attitude to antiquity and especially to the great masters of Latinity —the Humanists were amateurs in theology or medicine, but avid professionals in grammar, rhetoric, poetry, history, and the study of

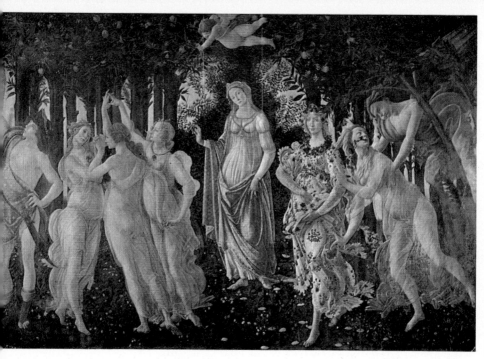

1 BOTTICELLI *Primavera, The Allegory of Spring*

Latin (and some Greek) authors: they invented textual criticism and philology in their concern to re-create antique wisdom and elegant prose. They naturally quoted extensively from classical writers, but they did not distinguish sharply between pagan and Christian classics (except to prefer Cicero's Latin to St Jerome's). A recent historian of Humanism, P. O. Kristeller, in *Renaissance Thought: The Classic, Scholastic, and Humanistic Strains,* has described it thus: 'We can understand what it meant for a Renaissance humanist with religious convictions to attack scholastic theology and to advocate a return to the Biblical and patristic sources of Christianity. It meant that these sources, which after all were themselves the product of antiquity, were considered as the Christian classics which shared the prestige and authority of classical antiquity and to which the same methods of historical and philological scholarship could be applied.' This is equally true of Renaissance artists. Donatello is perhaps the best example, but most of the leading figures of the fifteenth century

used Early Christian and Late Roman art as a source-book, often preferring the dramatic and expressive qualities of Early Christian art to the smoother, more flowing forms of the Augustan period.

Vitruvius was a text book for architects, but the text—known at least from the second decade of the fifteenth century—was so obscure that little attention was paid to it, and, in actual fact, architecture was surprisingly free from the precise imitation of extant remains all through the fifteenth century: the real cult of Antiquity as something to be imitated very closely hardly dates from before the early sixteenth century.

Poggio Bracciolini, who is supposed to have rediscovered a manuscript of Vitruvius in the Swiss monastery of St Gall, wrote a noble lament on the Ruins of Rome and the Mutability of Fortune, which perfectly expresses the nostalgia for the Roman past and the longing of the best minds of the fifteenth century for that Romantic conception of the Golden Age which they hoped to recapture and to bring to a rebirth on Italian soil. In 1430, before any serious attempt had been made by anyone but Brunelleschi, Donatello, and Michelozzo in Florence to re-create the actual architectural forms of the Romans, Poggio wrote: 'Not long ago . . . Antonio Lusco and I . . . used to contemplate the desert places of the city with wonder in our hearts as we reflected on the former greatness of the broken buildings and the vast ruins of the ancient city, and again on the truly prodigious and astounding fall of its great empire and the deplorable inconstancy of fortune. Here, after he had looked about for some time, sighing and as if struck dumb, Antonio declared, "Oh, Poggio, how remote are these ruins from the Capitol that our Virgil celebrated: 'Golden now, once bristling with thorn bushes.' How justly one can transpose this verse and say: 'Golden once, now rough with thorns and overgrown with briars.' But truly I cannot compare the tremendous ruin of Rome to that of any other city; this one disaster so exceeds the calamities of all other cities. . . .

'"Surely this city is to be mourned over which once produced so many illustrious men and emperors, so many leaders in war, which was the nurse of so many excellent rulers, the parent of so many and such great virtues, the mother of so many good arts, the city from

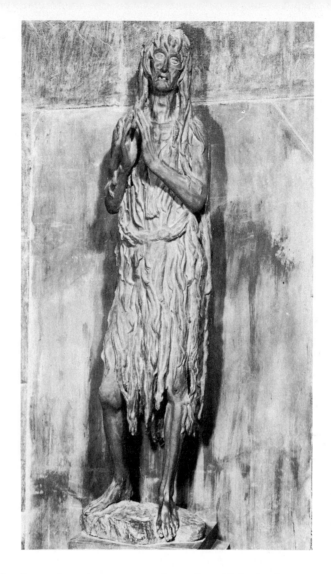

2 DONATELLO
Magdalen

which flowed military discipline, purity of morals and life, the decrees
of the law, the models of all the virtues, and the knowledge of right
living. She who was once mistress of the world is now, by the in-
justice of fortune, which overturns all things, not only despoiled of
her empire and her majesty, but delivered over to the basest servitude,
misshapen and degraded, her ruins alone showing forth her former
dignity and greatness. . . .

13

'"Yet truly these buildings of the city, both public and private, which it seemed would vie with immortality itself, now in part destroyed entirely, in part broken and overturned—these buildings were believed to lie beyond the reach of fortune. . . ."

'Then I answered, "You may well wonder, Antonio. . . . For of all the public and private buildings of this once free city, only some few broken remnants are seen. There survive on the Capitoline the double tier of arcades set into a new building, now a receptacle of the public salt . . . that Q. Lutatius, Q. F., and Q. Catulus, the consuls, had charge of making the substructure and the *Tabularium*; this is an edifice to be revered for its very antiquity. . . .

'"This will perhaps seem trivial, but it moves me greatly, that to these monuments I may add . . . only these five marble statues, four in the Baths of Constantine, two standing beside horses—the work of Phidias and Praxiteles—two reclining, and the fifth in the forum of Mars. . . . And there is only one gilded bronze equestrian statue, which was presented to the Lateran basilica by Septimius Severus. . . .

'"This Capitoline hill, once the head and centre of the Roman Empire and the citadel of the whole world, before which every king and prince trembled, the hill ascended in triumph by so many emperors and once adorned with the gifts and spoils of so many and such great peoples, the cynosure of all the world, now lies so desolated and ruined, and so changed from its earlier condition, that vines have replaced the benches of the senators, and the Capitol has become a receptacle of dung and filth. . . ."'

The shadow of Rome thus lay always over the Italy of the Humanists, and any contribution to the restoration of arts and letters was sufficient to ensure immortality for a writer, an artist, or a patron. Thus, some thirty years after Poggio's threnody, Platina, the historian of the Popes, records that Nicholas V, who had himself been a professional Humanist, 'began the great vault for the apse of St Peter's, popularly called a tribune, by which the church itself is made more splendid and capable of holding more people. He restored the Milvian bridge and erected a princely palace to house the baths of Viterbo. And it was by his decree that almost all the streets of Rome were cleared and paved.' Platina records that 'On his sepulchre this epitaph is fittingly inscribed: Here lie the bones of

the fifth Pope Nicholas, who restored the golden age to you, O Rome. . . .'

Aristocratic societies tend to look back to the achievements of their ancestors, but the Italians of the Renaissance looked much further back into history, to find their spiritual ancestors in ancient Rome. This was because they knew they were attempting something no feudal society could understand, let alone emulate. Modern society—in its managerial, capitalist, and political aspects at any rate—was born in Italy in the Late Middle Ages. The Great Schism of the fourteenth century and the exile of the Papacy in Avignon meant that the one great central (but not hereditary) power was removed from the Italian scene, and the oligarchical societies of Florence and Venice were able to establish themselves as the leading powers of Italy: the ascendancy of Venice was maritime, that of Florence financial. The skill of the Florentines in banking operations and in large-scale enterprises involving international commerce, mostly in the wool trade, meant everyday dealings with England and Burgundy, which in turn meant a very high average of education and culture among the Florentine ruling classes. These classes eventually became the patrons and supporters of the new Humanist art, and, in due time, formed the public which bought the books made available by printing; they were able to exploit their own abilities far more freely than the feudal aristocracy, confined as they were to the Church or to a relatively brutish military career. 'The Medici family produced numbers of cultured bankers and wool-merchants, a politician with a taste for Platonic philosophy, a poet prince, two popes and a condottiere.'

The numerous Italian schools of painting arose from the different factors in each town—Venice, for example, with its Eastern interests, would naturally be more Byzantine in outlook than Florence. Florence, virtually dominated by the Medici family for sixty years from 1434, lies at the heart of the Renaissance, partly because of her economic power and stability. As soon as the Medici fell, in 1494, the leadership of Italy began to pass to Rome, now once more the centre of a rejuvenated and strong Papacy. The reign of Julius II (1503–13) was one of the great moments of humanity. This was soon to vanish. The new national states, France and England at their head,

were rapidly rising to power, and in 1494 the French learned how easy it was to invade Italy and to subjugate the small individual states: the Italians learned the lesson of unity too late, and, after the appalling Sack of Rome in 1527, France and Spain fought for domination in the distracted peninsula. Not until the late nineteenth century did the Italians again enjoy the liberty to decide their own fate, even though they continued to be the cultural leaders of the world throughout the sixteenth century, and in the seventeenth century the vast spiritual forces of the Counter-Reformation were directed from Rome.

The history of Burgundy in the fifteenth century is almost exactly the opposite. The small Duchy, sandwiched between France and the Empire, was dependent for its livelihood on the ports of Bruges and, later, Antwerp, and on the wool trade with England and Italy. In order to maintain their independence the Dukes of Burgundy, from John the Fearless, murdered by the French in 1419, to Charles the Bold, killed in battle by the Swiss in 1477, made the most of their feudal and aristocratic pretensions, always hoping that Burgundy would truly become the Middle Kingdom that it set out to be. The political use of feudal pomp can be seen in the Order of the Golden Fleece, founded in 1429, which was rigidly aristocratic and exclusive, second only to the Garter. More sensibly, the Dukes maintained an uneasy series of alliances, mainly with the English, whose wool they needed, against the French, whose depredations they feared. The marriage of Duke Charles the Bold to Margaret of York in 1468 was part of this policy, all of which collapsed when Charles was killed at Nancy by the Swiss allies of Loüis XI of France. Eventually Burgundy passed to the Empire and, when Spain and the Empire were united by Charles V, Burgundy was one of the reasons for the Franco-Spanish struggle fought out in Italy in the sixteenth century.

It is by no means unusual for a new style in the arts to exist alongside an older one which it subsequently replaces; the history of the early struggles of Impressionism affords a striking instance of how new ideas, after meeting with the strongest opposition, can so impose themselves that within a half-century or so they become the accepted academic style and in turn are replaced by a fresh vision. What is peculiarly interesting about the history of the arts in Florence in the first quarter of the fifteenth century is that not one but two new styles were seeking to assert themselves in the face of traditional forms. A century earlier, Giotto had imposed a new and more human vision on the arts of Western Europe; representations of scenes from the Bible, or the Lives of the Saints, depend upon the dramatic gestures and facial expressions of the actors, and the human figures who carry the action and make it vividly comprehensible do so through the immediacy of their naturalism. Giotto made tremendous advances in the technique of representing the human body in a more realistic way than any practised since classical antiquity; he took much of his inspiration from sculpture, and in his truth to nature he had been preceded by Nicola and Giovanni Pisano, whose sculpture was itself inspired by antique art.

From the beginning of the fourteenth century the representational arts in Italy were linked, on the one hand with the heritage of Roman art, particularly sculpture, and on the other hand with the dramatic possibilities inherent in Christian subject-matter. The Black Death of 1348 cut short the movement initiated by Giotto, and it was not until the early fifteenth century that his ideas were taken up once more. Late fourteenth-century art tended to be reactionary in the extreme, partly as a result of the Black Death itself, and partly, possibly, because no major artist seems to have survived it. At the very end of the century the cloud lifted somewhat, and a new note

of joy in living and in the vanities of this world made its appearance at the Court of Burgundy, centred on Dijon. From the standpoint of style this art made few innovations, but it marks a new approach to the world, gayer, more sophisticated, deliberately elegant and even precious, and it very rapidly became fashionable, spreading quickly into France and Italy.

Of this so-called International Gothic style, characteristic examples are to be seen in two works made for the Court of Burgundy. The first of these is an altarpiece which is probably the sole survivor of a series of works commissioned from Melchior Broederlam in the early 1390s for the Charterhouse at Champmol, near Dijon, a ducal foundation destined to receive the tombs of the family and therefore an object of splendid munificence. Broederlam's work consists of a pair of oddly shaped painted wings enclosing a carved wooden altar-piece; the inside of each wing contains a pair of scenes—on the left the Annunciation and the Visitation, on the right the Presentation and the Flight into Egypt (*plate 3*). Delicate, fragile almost, in clear, bright colours, they have the sensitiveness of a newly awakened feeling for natural detail, for the play of light on rocks and flowers, for the picturesqueness of flights of birds and spiky little castles crowning jagged pinnacles, for the patterns of tiled pavings within the tiny buildings in which the Virgin sits to receive her angelic visitor, or in which the Infant Christ is presented to Simeon. Not much is known about Broederlam. He came from Ypres, and is mentioned several times in the accounts of Duke Philip the Bold of Burgundy as his painter from 1385 onwards, as employed on all manner of jobs from decorating rooms in the castle at Hesdin to designing tiled floors and painting altarpieces. Nothing is known of his training, and little else of his life except for his patronage, that he was in Paris in 1390/95, and that he died about 1409 or later. But the resemblance between his surviving work and the products of the Giottesques and of Sienese painters such as Simone Martini and the Lorenzetti brothers cannot be dismissed merely as one of those instances of what appear to be coincidences in the arts, but which are in fact the results of the pervasive influence of a widespread trend in thought and culture. In this case it indicates rather the spread of ideas from Italy to Avignon, which, as the seat of the Papacy for over seventy years, was a centre

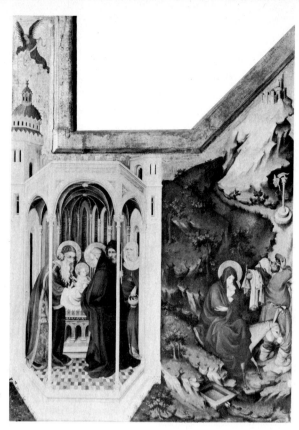

3 MELCHIOR
BROEDERLAM
*Presentation and
Flight into Egypt,
detail from the
Dijon Altarpiece*

for the dissemination of Italian ideas, and hence the permeation of
the Gothic North with influence from Italy, a permeation which
eventually bore its fullest fruit in the conjunction of North and South
in International Gothic.

The domed building next to the little room in which the Virgin
Annunciate sits, the recession of one room space behind another, the
delicate tracery, the thin colonnettes, the central space in which the
Presentation takes place, and even the *coulisse* system of the landscape,
where the sense of recession is achieved by winding the pathway
between the rocky masses in a series of diagonals, all suggest that at
some point in his career Broederlam had been in contact with Italian
forms. He had transmuted them into something more Northern by
including picturesque details taken from the Apocryphal Gospels—
that favourite compendium of amusing stories and fantastic additions

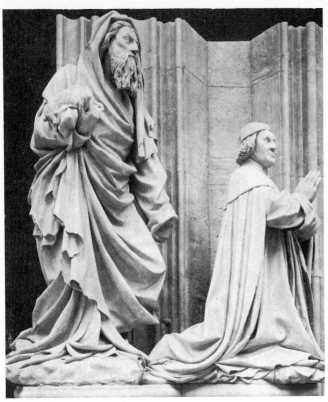
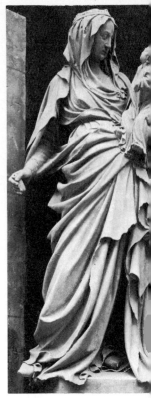

4 CLAUS SLUTER *Duke Philip of Burgundy and his Patron Saint* 5 CLAUS SLUTER *The Virgin*

to the strict Gospel narrative, which, while they enliven a picture with charming details, also weaken its impact by substituting decorative incidents for the simple dogmatic themes of the New Testament.

Among the assessors who valued the Broederlam wings was the sculptor Claus Sluter. For the same Charterhouse at Champmol he made its main portico sculpture representing Duke Philip (*plate 4*) and his Duchess presented by their patron saints to the Virgin (*plate 5*) standing on the *trumeau* between the double doors of the entrance. Lifelike, realistic, vivid in their portraiture, enveloped in the bulky folds of flowing garments, the four figures of the ducal donors and their patron saints flank the doors, filling the splays. On the *trumeau* the Virgin gazes at the Child, her heavy robe swirling about her in deep rhythmic folds, and her whole body turned to develop the fullest frontality of pose, while her outspread arm and the movement

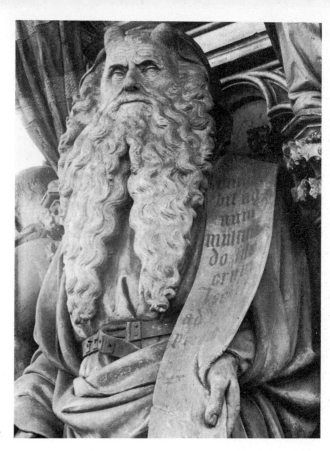

6 CLAUS SLUTER
Moses figure from
The Well of Moses

with which she supports the Christ Child on her hip achieve at the same time a monumental splendour and the most tender grace. The monastery also contained Sluter's masterpiece, *The Well of Moses*. During the French Revolution it was partly dismembered, for the upper part with the *Crucifixion* is now but a damaged fragment, leaving only the group of six prophets (*plate 6*) surrounding the pedestal. These astonish by the qualities of intense observation of nature and deliberate inflation of style, by the massive bulkiness of the figures and the way in which this results in the absorption of distracting detail. If they are compared with Broederlam's use of delicacy and fineness of detail, then it is the same contrast, broadly speaking, as that presented by the confrontation of Gentile da Fabriano and Masaccio, and the most striking parallel with the arts in Florence a few years later.

Perhaps the most successful and famous of all works of the International Gothic ascendancy is the manuscript known as the *Très Riches Heures*, made for the Duke of Berry, uncle of Charles VI of France and brother of Philip the Bold of Burgundy. Most of this manuscript was completed before 1416 by three brothers, Pol, Hennequin, and Herman de Limbourg (*plate 7*). These three are first mentioned as children in the accounts of the Duchy of Burgundy for about 1400, so that it is not surprising that the stylistic characteristics of the Broederlam altarpiece and the illuminations by the Limbourg brothers should have a great deal in common. These works are essentially the products of a Court art; the content of the pictures is expressed in a style which in itself is an elaboration of something fundamentally old-fashioned and therefore more easily acceptable because more easily assimilable. The thin and elegant figures have no real weight and the artist has been more concerned with the rich and elaborate costumes than with any attempt to represent figures in three dimensions. Moreover, the dresses, and especially the hats of the ladies, are in the height of fashion—Burgundy at this time set the fashions for the whole of Europe. The horses and dogs are drawn with great realism of detail, but figures and animals are set against a tapestry-like background, rather than in a three-dimensional space, and it is precisely this which distinguishes International Gothic from the heroic style which is associated with the great Florentine artists of the early fifteenth century. It is easy to understand that works displaying these decorative characteristics would be appreciated by wealthy patrons who knew little and cared less about the nobler qualities of painting and sculpture, and this ready appeal explains the speed with which the style spread across Europe.

Its arrival in Florence is demonstrated in Lorenzo Monaco, whose works in 1414, and even somewhat later, were entirely in the Giottesque tradition. Lorenzo, who was probably born about 1370–72 and died probably in 1425, was a Sienese who settled in Florence and became a Camaldolensian in the Monastery of S. Maria degli Angeli, where there was a famous school of manuscript illuminators. He was a typical late fourteenth-century painter whose art was based on the descendants of Giotto and on Sienese art of the beginning of the fourteenth century. This purely traditional style, which was the

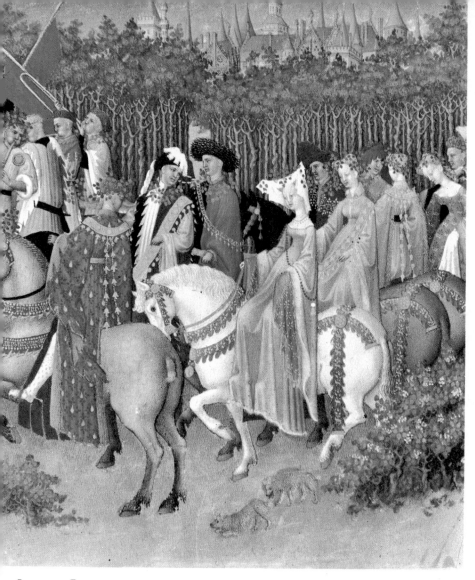

7 LIMBOURG BROTHERS
The Month of May from the Très Riches Heures of the Duke of Berry

dominant style in Florence at the time, can be seen in his two versions
of the *Coronation of the Virgin* (*plate 10*); one is dated 1413 (1414 by
modern reckoning), and the other, very similar, is probably of about

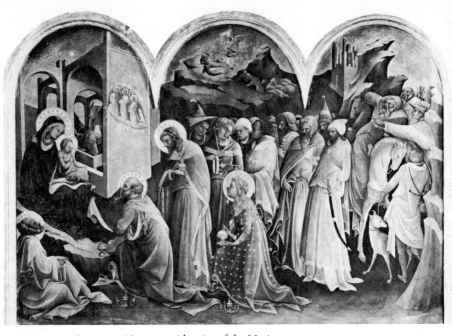

8 LORENZO MONACO *Adoration of the Magi*

the same date. Both are typical Trecento altarpieces with gold backgrounds and flat figures silhouetted against them so as to form bright two-dimensional coloured patterns with only a limited and conventional representation of space in the picture or solidity in the bodies. The impact of International Gothic is obvious in Lorenzo's *Adoration of the Magi (plate 8)*, which is undated, but which must be among his last works. Here he has created something entirely different, but clearly dependent upon Gentile da Fabriano.

The full triumph of International Gothic can be precisely dated with the arrival in Florence of Gentile da Fabriano (*c.* 1370–1427). He was commissioned by the immensely rich Palla Strozzi to paint an *Adoration of the Magi (plate 9)*, which was finished in May 1423, and it is probably this picture which influenced Lorenzo Monaco's *Adoration*. Lorenzo's picture is equally divided by the three arched divisions of the frame. The Madonna holding the Infant Christ on her knees, and with St Joseph sitting at her feet, is pushed to the far left, where an oddly formal geometrical construction represents the

stable in which the beasts of the Nativity munch contentedly. The other two panels are filled with the Magi and their crowd of retainers, dressed in an exotic assortment of peaked hats and turbans, crimped beards, trailing embroidered robes and long curved scimitars. There are horses, dogs, and camels merging into the wild and jagged mountain peaks lit by the flare of light surrounding the angel appearing to the shepherds and by the pale glow of dawn on a many-towered town clinging to the side of the distant hills. The space inhabited by the figures is too small to contain so large a cohort, and their poses as well as their accoutrements betray the new ideas of courtly art which have now arrived from the North. In fact, the exotic quality of the Magi's followers suggest not only a realism of detail chosen for its extravagance of effect, but the impact of tales of Eastern origin—the adventures of Marco Polo turned into the backcloth of everyday Christian imagery, and the translation into religious art of the literary fantasy of the *novelle* and the *fabulae*.

Gentile left Florence in 1425 and went to Rome by way of Siena and Orvieto. By 1427, when he died, he was working on a series of frescoes in S. John Lateran, but these, like his earliest works, the historical frescoes in the Doge's Palace in Venice, have been destroyed. The works in the Doge's Palace were finished by Antonio Pisanello, who was born probably in 1395, and who perhaps worked under Gentile, since he not only succeeded him in Venice between 1415 and 1422, but also at the Lateran in 1427. Pisanello's passionate interest in birds, animals, and costumes makes him perhaps the supreme exponent of International Gothic until his death in 1455 or 1456, but he was by no means the only one. The *Paradise Garden* (*plate 13*) may even be by Pisanello rather than Stefano da Verona, who was possibly Pisanello's master before he went to Venice. There is a similar enchanting *Paradise Garden* (*plate 11*) by an unknown German master working about 1415 which shows exactly the same charming and graceful style with its tenderness of sentiment and delicacy of detail unaffected by any austere aesthetic ideals. Pisanello's interest in detail made him an expert portrait painter, and he was one of the first as well as one of the greatest of portrait medallists, his earliest datable medal being of 1438.

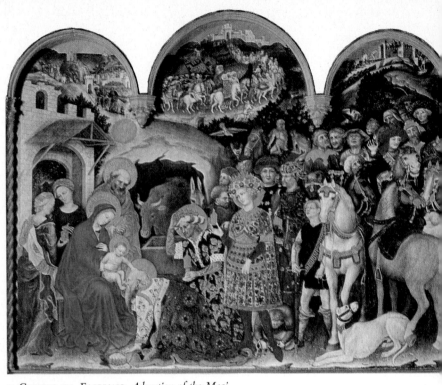

9 GENTILE DA FABRIANO *Adoration of the Magi*

10 LORENZO MONACO *Coronation of the Virgin*

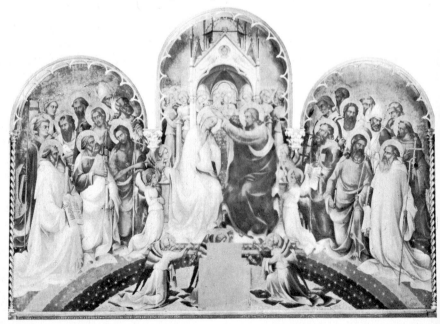

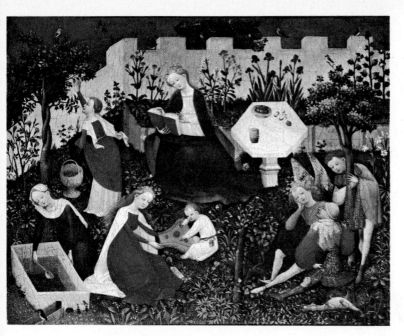

11 GERMAN MASTER *Paradise Garden*

One of the interesting points about the International Gothic painters is the use they made of drawings. No drawings by Masaccio survive at all, while those by Pisanello, for instance, are very numerous. Clearly the painter used his drawings not as a trial ground for compositions but as the raw material for the details of his pictures. The Vallardi Codex (Louvre) contains hundreds of drawings; many are by Pisanello himself and the remainder are copies and drawings by pupils and other artists—horses, dogs, wild animals, costumes (*plate 12*), heads of Mongols and Tartars, plants, men dangling on the gallows—all assembled as a mine of useful material from which the elaborate details of paintings could be quarried.

The crucial difference is that between the two styles which sought to replace in Florence at the beginning of the fifteenth century the dying Giottesque tradition, and of this difference the outstanding contrasts are those between Gentile and Masaccio, and Ghiberti and Donatello. In fact, this difference became the Great Divide in the fifteenth century, and a close comparison of two major instances will help to make its fundamental nature clear.

27

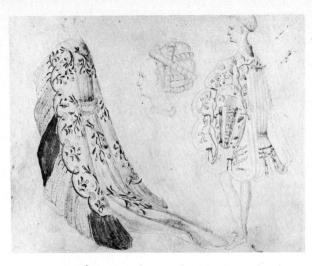

12 PISANELLO
*Designs for Court Dress,
Two figures and a Head*

After completing the Strozzi *Adoration*, Gentile painted the now
dismembered Quaratesi Altarpiece, completed in May 1425; origin-
ally it consisted of a central *Madonna and Child* (*plate 14*) flanked by
two saints on either side. It has the charm, the flatness, the decorative
quality, the elaboration so dear to, and so typical of, the International
Gothic painter. Against a dark brocade strewn with flowers, the
gentle, bland-faced Madonna sits holding a beautiful Child, and on
either side small angels peer from behind the background curtain.
The flesh tones are tender, pallid, the expression almost vacant. The
four saints also have the same kind of elegant stylized clothes with
rich patterns, wavy, fluted edges, and heavy embroideries.

13 PISANELLO *or* STEFANO DA
VERONA *Paradise Garden*

The Masaccio *Madonna and Child* (*plate 15*), once part of the Pisa Polyptych, is quite different. Like the Quaratesi Altarpiece it has been dismembered, and fewer fragments survive. The central panel is immediately striking in its utter contradiction of all the things which Gentile stood for. The Madonna is not beautiful and the Child is ugly, but she sits firmly on the throne and her heavy draperies increase the volume of her figure, the strong light falling from the left making cast shadows so that the sense of recession and of internal depth within the picture is complete. On the front of the throne sit two small angels playing musical instruments and they too, by the strength of the light falling on them and the shadows it casts, increase this sense of depth and of recession, so that with the two other small angels standing behind the throne, half concealed and half in shadow, they create for the first time the illusion of a coherent internal space. The chiaroscuro plays across the Madonna's features and across the Child's body so that He does not recline as a flat pattern against His mother's blue cloak but forms a solid, sculptural, block that sits heavily on her knee. The saints that once flanked the Madonna also have this powerful stress on light and shadow so that despite their gold grounds they stand out vividly and with the striking realism of heavy, unidealized features and massive bulk. The crucial point lies in this change of feeling from an interest in purely decorative naturalism to a new and vivid realism, but it must not be imagined that International Gothic perished as a result: far from it. Despite Masaccio's enormous prestige and despite the influence exercised by his frescoes in the Brancacci Chapel, where all the artists of the next generation came to study, it is quite clear that Ghiberti represents a continuation in sculpture of International Gothic ideals which are no more than brought up to date by incursions into realistic detail and, later in his career, into perspective.

The contrast between Ghiberti and Donatello is as great as that between Gentile and Masaccio except that Donatello introduces a further factor—his highly charged emotional quality. The influence of Gothic on Donatello survives in his use of dramatic silhouette, but in him all is permeated by an ultra-powerful realism and even by a cult of ugliness used for expressive reasons.

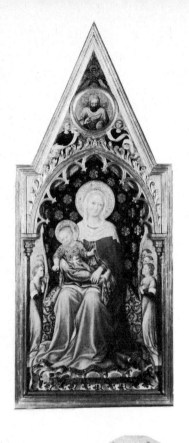

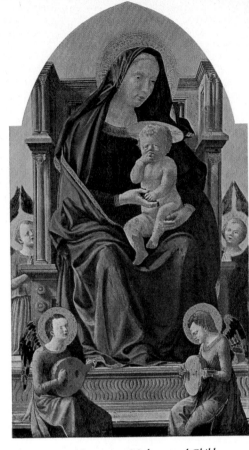

15 Masaccio *Madonna and Child*

14 (*above left*) Gentile da Fabriano *Madonna and Child*

16 Masaccio *Madonna and Child with St Anne*

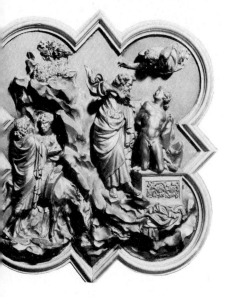 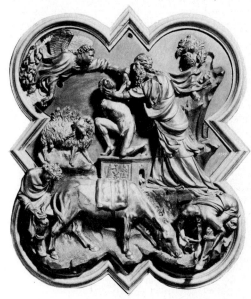

17 GHIBERTI *Sacrifice of Abraham* 18 BRUNELLESCHI *Sacrifice of Abraham*

Ghiberti was born in 1378 and is therefore of the same generation as Gentile. In 1401 he won the competition for a new pair of doors for the Baptistery in Florence, his principal competitors being Brunelleschi and Jacopo della Quercia. Both the Ghiberti and the Brunelleschi trial panels have survived (*plates 17, 18*). The scene set was the *Sacrifice of Abraham*, and both are within the stipulated quatrefoil framework taken over from the earlier pair of Andrea Pisano doors. In the Brunelleschi panel the action is vehement, even violent. The allusions to the antique (one of the foreground figures is adapted from the classical figure of the Spinario) are indicative of his training and the trend of his mind, but technically the panel nowhere equals the smooth modelling and the brilliant surface of Ghiberti's rendering of the scene. The Brunelleschi was made in a number of pieces and put together afterwards; the Ghiberti was a technical triumph in that it was cast in one piece. In it the action

31

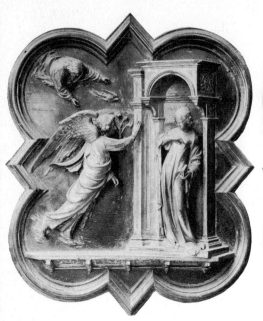 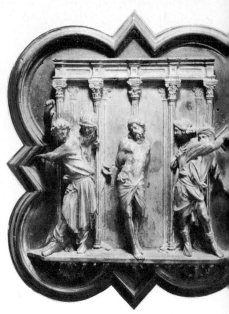

19 GHIBERTI *Annunciation*　　　　20 GHIBERTI *Flagellation*

flows smoothly; the angel glides down from heaven to arrest the
patriarch's knife; the beautiful, classically inspired, nude figure of
Isaac turns with relief both towards his father and the angel, where
Brunelleschi's distorted and terrified Isaac struggles against the knife,
and the plunging angel with vehement gesture arrests Abraham's
hand at the very last second. The same qualities of grace and charm,
of brilliant workmanship, of sinuous use of pattern and line, of
silhouette, appear in the doors which were begun by Ghiberti in
1403 and finished in 1424. For instance, in the panel of the *Annuncia-
tion* (*plate 19*) the Virgin, in her little aedicule, has the typical Gothic
sway and with a gesture of infinite delicacy both welcomes and
retreats before her heavenly visitant. Sometimes a more modern note
creeps in; for instance, the Christ of the *Flagellation* (*plate 20*) is almost
a pure classical figure, but the executioners, symmetrically arranged
about him, still use the forms of counterpoised pattern and grace

32

inherited from the past. In Ghiberti's own 'Commentaries', which he wrote late in his life and which are one of the main sources of knowledge of his career and his contemporaries, he records triumphantly his own account of his success: 'The palm of victory was conceded to me by all the experts and by all my fellow competitors; by universal consent and without a single exception the glory was conceded to me.' During the years of the execution of his first pair of doors he also made a number of other works, chief among them being the two statues on the façade of Orsanmichele. *St John the Baptist* (1414) (*plate 21*), enclosed in his highly decorated Gothic niche, still speaks the language of International Gothic. His draperies fall in heavy folds arranged for their linear rhythm, and even the rough hair-shirt has the same studied refinement as his locks of hair and the graceful curls of his beard. The features are sharp and stylized, the whole attitude one of elegance and distinction. *St Matthew* (1419–22 but dated 1420) (*plate 22*) shows a greater interest in the antique: he is the classical philosopher slightly Gothicized. There is, it is true, the same interest in elegance, the same disposition of the folds of draperies to create interesting zigzag patterns of light and shade, but the quality of the head is far closer to antique sculpture, and the pose, though almost identical with that of the *St John*, is just sufficiently more upright to leave it elegant without weakening it into the softer grace of the earlier statue. This interest in the antique, this modification of his Gothic line, is one of the first qualities which strikes one in the pair of doors which he executed between 1425 and 1452 and which were a continuation of his first commission. These are the doors which Michelangelo described as the Gates of Paradise, and in them Ghiberti departed utterly, first from the original brief which was given him, and secondly from the example of his first pair. Instead of the twenty narratives and the eight single figures which fill the little quatrefoils of the first pair, the second pair is divided into ten large panels each containing an Old Testament scene of great complexity and elaboration. In the *Creation and Fall of Man*, for instance, five separate episodes from Genesis are represented and the use of varying depths of relief to suggest recession is of the utmost refinement. In the scene of *Jacob and Esau* this use of the subtleties of relief allows Ghiberti to set the different incidents of his narrative

33

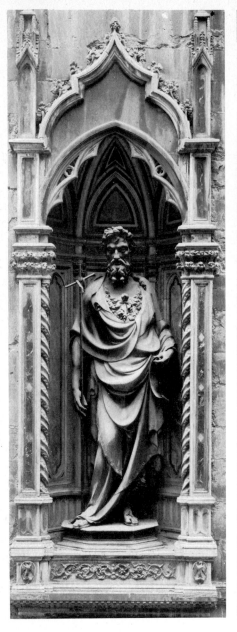

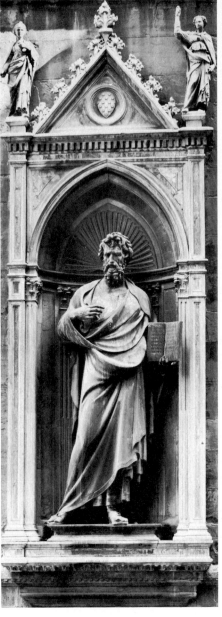

21 GHIBERTI *St John the Baptist* 22 GHIBERTI *St Matthew*

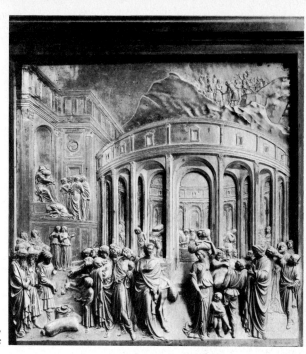

23 GHIBERTI *The Story of Joseph,*
from the second Baptistery Doors

within an architectural framework receding into an infinite distance, and yet enables him to do so without violating the structural unity of the surface. In *The Story of Joseph (plate 23)* a huge crowd takes part in the main action before the circular building which forms the background, yet despite the number of actors the scene combines coherence and unity with delicate, sinuous charm, but the new interest in a perspective setting imparts a new logic and a new order. It is futile to speculate how much Ghiberti was influenced in this by Donatello, for by now Donatello had supplanted him as the major Florentine sculptor, and, in fact, as the major force in Florentine art. He was eight years younger than Ghiberti, and despite the fact that Vasari included him in the list of competitors for the Baptistery doors competition in 1401, his youth makes it unlikely that he participated, though he probably worked on the doors, since he was apprenticed to Ghiberti until 1406. He then went into partnership with Nanni di Banco, and in the *Prophets* which they executed jointly for the cathedral they are barely distinguishable from each other. By the end of the decade, however, he emerged as an independent personality, and rapidly developed into the major Florentine artist of

35

the fifteenth century, uncontested in his supremacy after the death of Masaccio in 1428. The ramifications of his influence not only permeated Florentine sculpture and painting, but worked powerfully throughout northern Italy and Ferrara, and even touched Venice through its repercussions upon Mantegna.

The statue of St George (*plate 24*), made for a niche on the outside of Orsanmichele about 1420, is one of the key works in his development, not so much for its importance as a free-standing figure personifying the Christian virtues of knighthood, as for the small relief under the statue (*plate 25*): it is this which is the herald of things to come. In it St George on horseback slays the dragon, while the princess, praying watchfully, stands before an arcade on the right, and this arcade and the dragon's rocky lair on the opposite side are treated realistically and with an infinitely sensitive use of the gradations of relief, so as to confer upon the marble plaque the pictorial qualities of recession into space and an imaginative feeling for an actual setting. Moreover, the architectural framework is proportioned to the figures, so that the three-dimensional space is related to them, making the pictorial illusion complete.

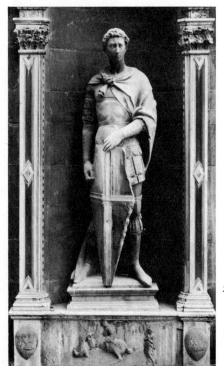

24 Donatello *St George (copy) in the original setting at Orsanmichele*

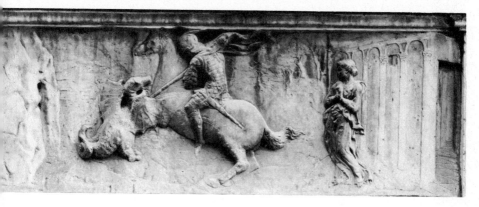

25 DONATELLO *Relief of St George Slaying the Dragon from Orsanmichele*

The climax was reached about 1425, at the moment when Gentile
had completed the Quaratesi Altarpiece, Masaccio was working on
the Pisa Polyptych, and Donatello began a series of works which
included the bronze panel of *The Feast of Herod (plate 26)* for the font
in the Siena Baptistery. The history of the Siena font was a chequered
one: it had originally been commissioned in 1416 from several minor
sculptors and Ghiberti's advice was sought in 1417; it was later
divided between Donatello, Jacopo della Quercia, Ghiberti, and two
Sienese goldsmiths. Donatello's panel represents the moment when
the Baptist's head is presented to Herod at the feast. It strikes an
entirely new note technically, and the rendering of the scene has an
intensely dramatic quality. Herod shrinks back in horror, one guest
expostulates, another recoils, hiding his face behind his hand, a third
clings to his companion, and yet another has fled from the table, the
little *putti* next to Herod fall over each other in their effort to escape
from the ghastly trophy presented to the King, and even the trium-
phant Salome is abashed at her own exploit. Behind the table of
feasters is an arcade, and in a room beyond it musicians play, and in
another room beyond that figures can be seen through the open
arches, so that there are a number of spatial elements one behind the
other, perfectly proportioned to each other and to the figures within
them. The illusion is achieved by minute gradations in the depth of
the relief and by a brilliant use of the devices of central perspective.

37

The contrast between the drama in the foreground and the unawareness of the figures in the rooms beyond increases the psychological tension, and creates a new visual world of tremendous consequence. Donatello's gift for infinite gradations of relief can be seen to an even greater degree in the little panel of the *Ascension* (*plate 27*), for in this work there is barely any break in the surface, and the planes of the modelling are reduced to such an infinite thinness that the figures are hardly more than drawn upon the marble surface. Ghiberti also exploited this use of delicately graded depth of relief in his second pair of doors, and he used it also in the relief of the *Baptism of Christ* (*plate 28*) which he made for the Siena font, though never with the same degree of refinement as Donatello himself.

26 DONATELLO *The Feast of Herod*

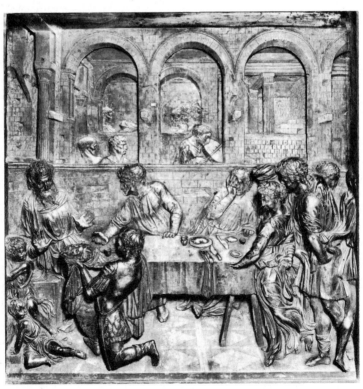

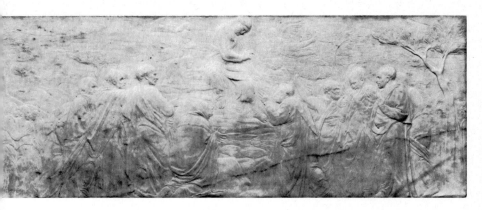

DONATELLO *Ascension*

28 GHIBERTI *Baptism of Christ*

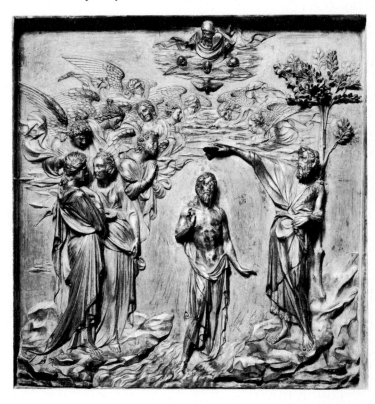

The point that emerges is both a similarity and a dissonance between Masaccio and Donatello; for the first, there is the creation of an ideal space and of a complete illusion of a true world, and this identity of purpose between the painter and the sculptor coming at about the same moment marks perhaps more clearly than anything else could have done the break between the older forms represented by Gentile and the new ideas developed by the artists of the Renaissance. The main distinction between Masaccio and Donatello lies in the sculptor's dramatic quality, found from his earliest works onwards, and this passionate sense of tragedy was to become the hall-mark of his later style, while his use of line and silhouette was to stamp itself indelibly on Florentine art. A striking instance of this is his pair of bronze doors for the Old Sacristy in S. Lorenzo, made in the 1430s. Each of the panels of which they are built up contains two prophets. The figures gesticulate vehemently, and all their expressiveness is concentrated into the swinging movement of their robes and the force of their gestures, silhouetted in low relief against a plain ground (*plate 30*). Donatello here turns the tables on Ghiberti's exploitation of his idea of pictorial perspective in low relief, by abandoning his own invention in favour of dramatic movement and expression alone.

Between 1431 and 1433 he was in Rome, where presumably he was absorbed in the study of the remains of classical antiquity. He was never seduced by the grandeur of the classical past into attempting a re-creation of its forms, and its impact on him is effective through his absorption of it as a tradition, as something he could use. His later work is never superficially antique in appearance, but it shows more real understanding of antique art, particularly of Roman portrait sculpture, than any other fifteenth-century artist except perhaps Mantegna. Certain classical themes appear after this journey: the nude *David*, inspired by the Antinous marbles of the second century; the equestrian statue of Gattamelata, inspired by the Marcus Aurelius now in front of the Capitol; the more skilful use of classical architectural details in capitals and ornament, though this never becomes a slavish imitation and always remains intensely individual and even wayward in character; the increasingly important use of the *putto*, the chubby, playful infant, found so often in classical friezes

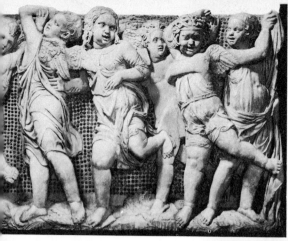

29 DONATELLO *Cantoria, detail of the Putti*

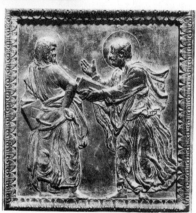

30 DONATELLO *Arguing figures from bronze doors, S. Lorenzo*

and mosaics, grappling with weapons, sacrificial instruments, or bunches of grapes amid vines, and which, like Early Christian artists before him, he adapted to Christian iconography and used freely in the most sacred contexts.

The *David* (*plate 31*) was the first nude figure cast in bronze since classical times. The easy, relaxed pose, the tender modelling of the forms, rippling softly, smoothly, under the bronze skin, sharply shadowed under the strange peaked hat, curling richly in the twisted locks of Goliath's severed head, are ringing echoes of Roman art. The *David* is also evidence of the rebirth of the classical past, and of the final emergence of that new spirit which was to inform the Renaissance: the sense, not of a lesson learned by rote, not of a model to be imitated, but of a parity of creation, of equality with the tradition

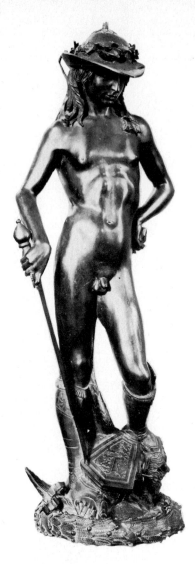

31 DONATELLO *David*

that inspired it, of continuity of thought and feeling, even though the purpose to which the art was dedicated was entirely different. But these moments of elegiac serenity were rare in Donatello. His temperament returned quickly to the stimulus of dramatic effects, and the great commissions executed in Padua during the years from 1443 to 1453 open a new chapter in his art, and also determined the character of North Italian art for the next half-century.

Two great works survive from the Paduan period: the equestrian statue of the *condottiere*, known as *Gattamelata*—the Honey-cat (*plate 32*), and the main altar of the Santo, the Basilica of St Anthony. The heavy figure of the successful mercenary soldier, relaxed and confident in his conqueror's pose on his huge and richly harnessed horse, stems ultimately from the Imperator type of Roman portraits, and the ugly face, full of character, derives patently from the astonishing realism of Roman funerary busts. The Santo Altar has been much reconstructed, and the various parts of it—the free-standing Madonna and Child and six flanking saints, the three reliefs of the miracles of St Anthony, and the *Pietà* in bronze, and the sandstone relief of the *Lamentation over the Dead Christ* now in the back of the altar—have been moved out of their original positions and contexts.

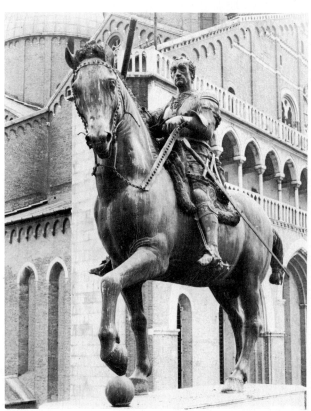

32 DONATELLO
Gattamelata

33 MASACCIO *Trinity*

34 DONATELLO *Miracle of*

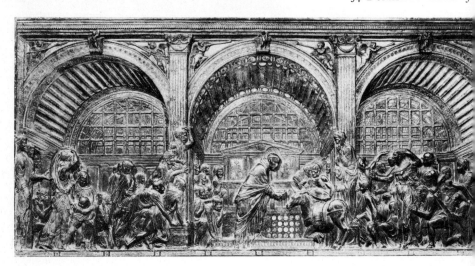

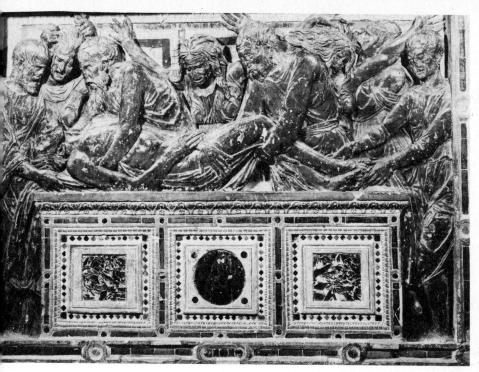

35 DONATELLO *Lamentation*

The main characteristic of the reliefs is their amazing exploitation of perspective, very low relief, and dramatic effect. The background of huge barrel vaults in the *Miracle of the Ass* (*plate 34*), receding steeply into the picture plane, the curious arrangement of sheds and steps in the *Miracle of the Irascible Son*, which delimits as narrowly as stage scenery the space for the dramatic action, recall in the one case the elaborate and brilliant space construction in Masaccio's *Trinity* (*plate 33*) in Sta Maria Novella, and in the other his own world-within-world construction of the Siena *Feast of Herod* (*plate 26*). Huge crowds surround the saint, and press forward to gaze upon his miracles, climbing up the columns and buildings, so that their bodies project beyond the picture plane determined by the architectural framework and create an extra spatial element by impinging upon the world of the spectator. The bronze *Pietà* relief has an unusual stillness; the heavy, nude body of the dead Christ is supported

45

by tearful *putti*, but their sorrow is a timeless weeping, and is of another order of feeling from the passionate, shrieking grief of the Magdalen in the sandstone *Lamentation* (*plate 35*). But the tautness of dramatic tension is rarely far away; in the squat-faced Child clutched fearfully to His Mother in small Madonna reliefs; in the playful, music-making *putti* of the *Cantoria* (*plate 29*), only a hairbreadth from fisticuffs; in the baldpated prophet whom the artist abjured with violence to speak to him, and whose gaunt, deeply lined face and angular pose suggest the harsh gutturals of the Tuscan dialect; in the sagging flesh and sunken eyes of the aged Magdalen (*plate 2*), haggard and emaciated in the shaggy pelt that blends so closely with her tangled hair that it is difficult to distinguish animal from human. Even in his unfinished last work, the bronze reliefs on the pulpits in S. Lorenzo, the Christ of the *Resurrection* (*plate 36*) is no youthful Saviour transfigured in glory, but a massive and sullen figure, climbing heavily from His tomb, still hung about with grave-clothes, so that His movements seem weighed down by the mortal body He is transforming.

36 DONATELLO *Resurrection*

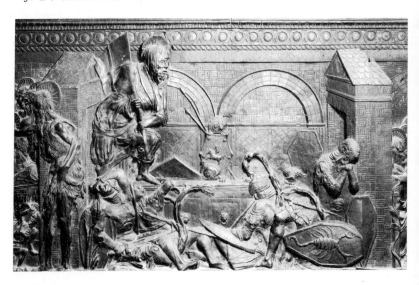

So immense was Donatello's personality that he exhausted in sculpture the forms and style he invented and exploited. His successors were painters; they took over his wiry line, his drama and tension, and the emotional possibilities of his use of distortion and extreme ugliness. Castagno's harsh saints, Pollaiuolo's strained muscular executioners, and the hard, metallic outline enclosing even Botticelli's tense, taut figures, Venuses, Madonnas, Graces, and Judiths alike, are the acknowledgment of his impact. The sculptors of the next generation concentrated on the anti-Donatellesque—on softness, on sentiment, on delicacy, even though line rather than mass was the means of their expression. It is because of Donatello's long life and huge production, because of the inescapable force of his example, that the lessons taught by Masaccio fell on ears that heard but could not properly assimilate his teaching. The grandeur of the Brancacci Chapel frescoes was given the lip-service of recognition and superficial imitation, but their real teaching lay fallow, until the impetus given by Donatello finally petered out in meaningless confusion.

Masaccio was born in 1401 and entered the Guild of Painters in Florence in 1422. In 1427 he is recorded in the first income-tax returns made in Florence, the so-called Catasto. These tax returns, made every few years, provide a good deal of information about Florentine artists and their economic circumstances; they almost invariably contain cries of poverty and distress that can be largely disregarded, but in the case of Masaccio it seems that he and his younger brother had their widowed mother to support and that they lived in great poverty. Soon after this, Masaccio went to Rome, probably for a commission, and died there at the age of twenty-seven. The extraordinary thing is that in five or six years' work he was able to revolutionize Florentine painting and to create for himself a fame which was kept alive in the next century by Michelangelo and Vasari, and which has never been allowed to die. It is clear, however, that this fame was largely confined to other painters, and that he never enjoyed the popular esteem accorded to the bright and realistic work of Gentile da Fabriano. Because Masaccio died so young he left only a handful of works, and some problems of attribution have had to be cleared up before a full understanding of his achievement could be arrived at.

His two major works are the polyptych painted for the Carmelite church in Pisa in 1426–27, and the series of frescoes in the Carmelite church in Florence. The Pisa Polyptych is known from documents to be by him, and Vasari saw it and described it, but, unfortunately, it was dismembered long ago, and can now be reconstructed only in part from a number of panels, scattered in various museums, which have been identified largely because of their stylistic identity with those parts of the Brancacci Chapel frescoes which are attributed to Masaccio. The most important panel, the *Madonna and Child* (*plate 15*), which has been cut at the bottom, is so badly damaged that the green underpainting shows through in many places, and large areas have been lost, but which, nevertheless, provides direct evidence of his style in 1426–27—at a moment, that is, when Gentile da Fabriano's Quaratesi *Madonna* (*plate 14*) was at most a couple of years old. Some further panels from the Pisa Polyptych have come to light, the most notable being the *St Paul* which is in Pisa, and the *Crucifixion* (*plate 37*) in Naples. When the polyptych is reconstructed, it can be seen that it retains several Trecento characteristics, such as the use of a plain gold background, and the treatment of each of the figures as a separate unit, like statues in niches. On the other hand, it differs entirely from contemporary sub-Giottesque altarpieces on the one hand and Gentile da Fabriano's International Gothic style on the other, in that all the figures are thought of as three-dimensional forms occupying a definite position in space, all lit from the same point and all subject to the same laws of perspective. It is probable, for example, that the haloes in the London *Madonna* (*plate 15*) are the first to be treated as intangible circles seen in perspective rather than the simple gold plates hanging behind the heads in such an altarpiece as Lorenzo Monaco's *Coronation of the Virgin* (*plate 10*). Much of this realism derives from sculpture; Masaccio was probably influenced a great deal by the pulpits by Nicola and Giovanni Pisano in the Baptistery and Cathedral in Pisa. Also, he was younger than Donatello, and it was Donatello and Brunelleschi who made the original important experiments in perspective at a time when Masaccio was a boy of fourteen or fifteen. In short, the Pisa Polyptych shows a return to a monumental style which had not been seen in Italy since the death of Giotto.

48

37 MASACCIO
Crucifixion

The frescoes in the Brancacci Chapel in Sta Maria del Carmine in Florence (*plates 38/41*) are even more important than the polyptych; they were painted probably between 1425 and 1426 and his departure for Rome about 1428, and are therefore contemporary with the polyptych. However, the frescoes are not all by Masaccio, and about one-third of the whole cycle was destroyed by fire in the eighteenth century. It is also possible that some of the portrait heads were left unfinished when Masaccio went to Rome. From early sources it is known that three painters worked in the chapel: Masaccio, Masolino, and Filippino Lippi; since Filippino Lippi worked there in the 1480s it is comparatively simple to discern his late Quattrocento style and to identify his share in the chapel as a whole. This leaves us with a number of frescoes to be divided between Masaccio and Masolino, and at this point in his career Masolino, though an older man than

49

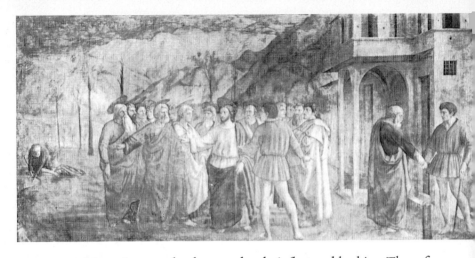

Masaccio, was clearly very deeply influenced by him. Those frescoes which accord with the solemnity of style of the Pisa Polyptych are attributed to Masaccio, and those which are more International Gothic in style are allotted to Masolino. Thus, the traditional works by Masaccio, and especially the most famous fresco of all, the *Rendering of the Tribute Money* (*plate 38*), can be used on the one hand to confirm the reconstruction of the Pisa Polyptych, and on the other to act as a touchstone separating the works of Masaccio from those of Masolino. Masaccio's style is grand and simple; above all, it is adapted to the technique of fresco painting in that he relies very little on outline and builds up his massive figures in simple contrasts of tone and colour. His groups, too, are built up with an internal coherence, each figure being related to the others and yet, though retaining its own identity, being conceived as part of a larger whole. In the *Tribute Money*, Christ is the natural centre of the group, physically and psychologically, yet He forms but one element in a structure that would be meaningless were He moved or altered. This is the first time since Giotto that the quality of complete coherence was revived—that is, that no part can be changed or removed without damaging irretrievably the significance of the whole. Most important of all, and most revolutionary, is the way in which his groups are set in a landscape, as in the *Tribute Money*, in such a way that the figures and the landscape obey the same laws of perspective (in contradistinction to Gentile da Fabriano's *Adoration of the Magi* (*plate 9*)), and all the forms are lit from the same point which, in

50

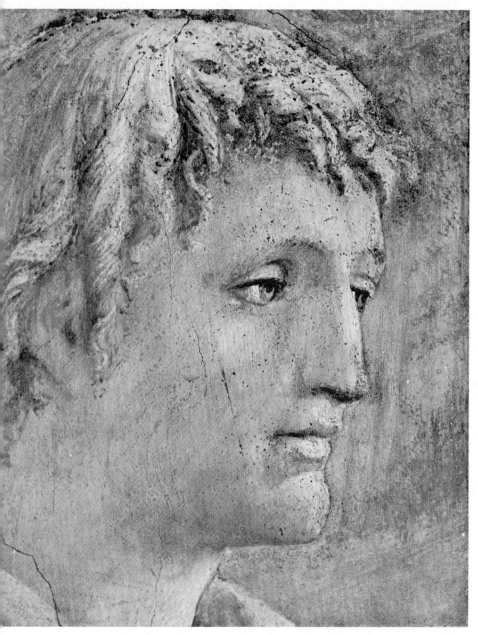

39 MASACCIO *Head of St John from the Rendering of the Tribute Money*

38 (*above left*) MASACCIO *Rendering of the Tribute Money*

the case of the Brancacci frescoes, corresponds to the actual window of the chapel. This use of the pictorial light coming from the same source as the actual light gives a convincing three-dimensional quality to all the figures in his frescoes. Their dramatic quality is evident in the details of the heads, which show strong characterization, so that individual Apostles can be distinguished (*plate 39*).

40 MASACCIO *Expulsion of Adam and Eve* 41 MASACCIO *The Lame Man healed by the shadow of S*

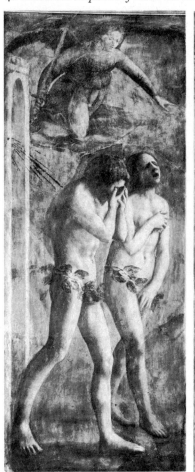
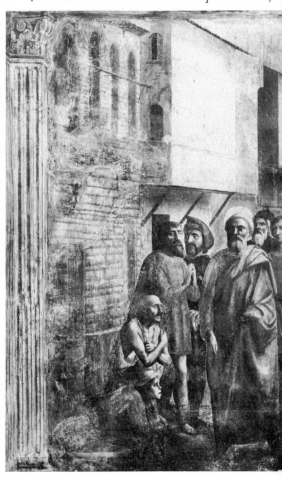

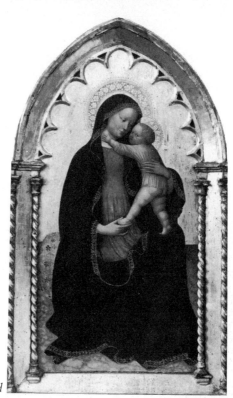

42 MASOLINO *Madonna and Child*

The frescoes attributed to Masolino have a liveliness and realism which derive directly from Masaccio, but they lack his consistency and severity of style. Masolino was born in 1383 and probably worked on Ghiberti's first pair of Baptistery doors. On the face of it, it would seem likely that he was Masaccio's teacher, as Vasari thought, but this seems to be disproved by the fact that he did not enter the Florentine Guild until 1423, the year after Masaccio, and the rules of the Guild laid down that no master might take pupils until he had registered and paid his dues. Masolino seems to have been a traditional Giottesque artist who was influenced by Masaccio —and not vice versa—for a few years between 1423 and about 1426, when he went to Hungary, and that later on his style changed once more and he became a painter of the International Gothic circle, something much more in keeping with what one would expect of his beginnings. The first datable work by him, a *Madonna* (*plate 42*) in Bremen of 1423, shows no trace of Masaccio's influence, but is a

simple Late Trecento Madonna rather like those by Lorenzo Monaco. His work in the Brancacci Chapel shows, therefore, the highest point of Masaccio's influence on him, but even there, in the elegant young men strolling across the background of *The Raising of Tabitha* (*plate 44*), it is evident that he had an interest in costume and in narrative details more characteristic of Gentile da Fabriano than Masaccio.

44 (*right*) MASOLINO *The Raising of Tabitha, detail*

43 MASOLINO *Herod's Feast*

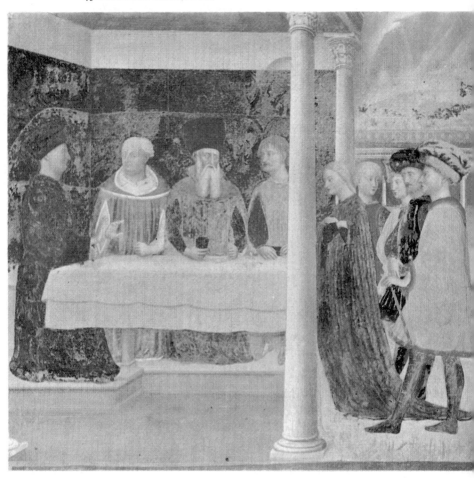

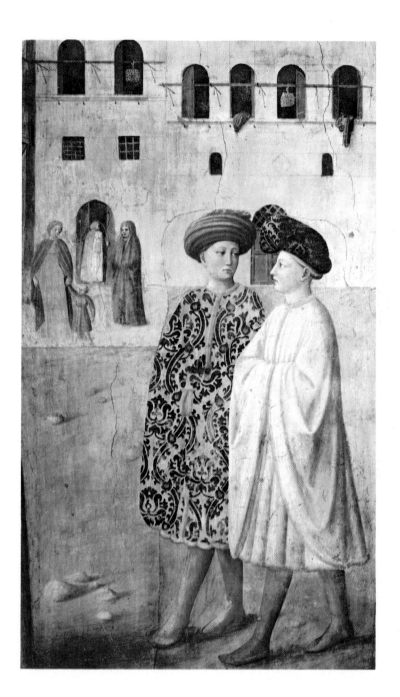

Again, a simple comparison of similar heads by Masaccio and Masolino shows very clearly that he was entirely lacking in Masaccio's feeling for three-dimensional form and for modelling in light and shade. His International Gothic characteristics are better displayed in the work which he did after Masaccio's death. The most important of these are the frescoes in S. Clemente in Rome, and the series in the small town of Castiglione d'Olona near Milan, where there is a signed work in the Collegiata and where one of the series in the baptistery is dated 1435. In these frescoes International Gothic has completely regained the ascendancy and the figures in *Herod's Feast* (*plate 43*) are directly comparable with works like Gentile da Fabriano's *Adoration* (*plate 9*) or Pisanello's costume drawings. They are quite different from works such as Masaccio's fresco of the *Trinity* (*plate 33*) in Sta Maria Novella in Florence, where Brunelleschian architectural forms are used to create a convincing setting in depth for the figures, although Masaccio has made the figures of the donors conform to the perspective of the architecture, while those of the supernatural figures do not conform to the same perspective system and have, therefore, the effect of floating in the air. The relationship between Masaccio and Masolino still presents many problems, one of the most· puzzling being the pair of panels acquired by the National Gallery in London in 1951 as by Masolino, but which are now generally believed to be one by Masolino and the other by Masaccio, for one has the flaccid indefiniteness of form and the lack of solidity consonant with Masolino, while the other has the directness of lighting and the clarity of spatial position which is fundamental to Masaccio.

The other great factor controlling the revival of the arts in Florence in the fifteenth century was the influence of the architecture of Brunelleschi, and of the writings and architecture of Alberti. Brunelleschi's great achievement was the building of the dome of Florence Cathedral (*plate 45*), a work which he could never have brought to so triumphant a conclusion had it not been for the knowledge of Roman constructional methods which he gained from his study of the ruins of antiquity. Born in 1377, and trained originally as a goldsmith, he was a strict contemporary of Ghiberti, yet he was never touched by those qualities of smallness and preciousness that characterize International Gothic. All his thinking was large in scale,

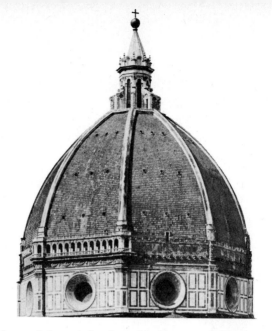

45 BRUNELLESCHI
*The Dome of Florence
Cathedral*

even in his smallest works, and though he drew his forms and details from the repertory of classical Roman architecture he, like Donatello, absorbed and re-created those forms without being slavishly bound to the sources that inspired him. The great dome is more a feat of engineering than of architecture, for the huge cavity demanded for its covering qualities beyond those of architecture alone.

The first Renaissance building in Florence, properly speaking, is the foundling hospital, the Ospedale degli Innocenti, begun in 1419; here, too, Brunelleschi is still indebted to forms adapted from the classical and Romanesque past, for the colonnaded loggia (*plate 47*) facing a square is a form with a long history. It is in the skilful use of simple proportions that the loggia is so satisfying in itself and so full of significance for the future. The arches of the arcade are based on the size of the column of the order, and these measurements not only control the height and width of the arcade itself, but are extended in depth by the proportions of the bays, which break with tradition in their use of domes instead of cross-vaulting. This type of lucid and almost elementary relationship is also the basis of the design of the Old Sacristy of S. Lorenzo (*plate 46*), where the centrally planned, domed chapel—a cube with a smaller domed choir proportionate to the main structure—initiates a form which reaches

57

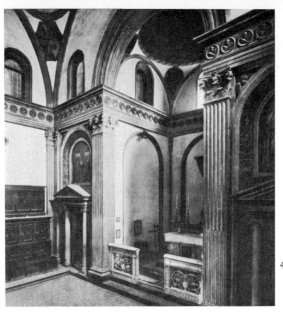

46 BRUNELLESCHI
*Interior of the Old
Sacristy, S. Lorenzo,
Florence*

far into the Renaissance as a model for continuous emulation. Brunelleschi pursued the form further in the rather similar Pazzi Chapel in the cloister of Sta Croce, extending the basic central space by sections on either side—they could be considered as small transepts or aisles—and placing a loggia outside, with a domed porch section corresponding to the domed choir on the other side of the central space. His interest in classical details governs his use of coffered barrel vaults in the loggia and the transeptal extensions, but his entirely personal treatment of architectural detail is clear from the wonderfully delicate carving of the window arches and soffits, and in the glazed coloured terracotta decorations of the frieze inside the chapel, and the lovely roundels of the little dome of the loggia, made by the della Robbia workshop.

S. Lorenzo, built·much later than the Old Sacristy, and Sto Spirito (*plate 48*), his last work, finished long after his death in 1446, represent successive stages in his development of simple planar geometry as a basis for planning. Both use the crossing square as the unit of measurement, the nave, choir, and transepts being so many repetitions of the central space, and the aisles, side-chapels, and the spacing of the nave arcades being subdivisions of the main unit. In Sto Spirito, he designed the aisles to run all round the church, with

7 BRUNELLESCHI
Loggia degli Innocenti, Florence

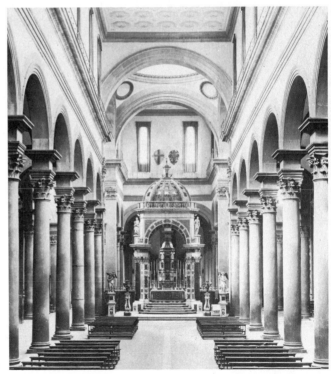

48 BRUNELLESCHI
Sto Spirito, Florence

an altar under the dome over the central space; he worked out a simple proportion for the heights of the parts of the nave elevation —the arcades, the wall section over them, and the clerestory area—so that the impression created is one of supreme lucidity and control, and a sense of space and harmony rarely equalled and never surpassed.

The commonest materials of Florentine architecture contribute largely to the effect of simplicity and restraint, for the general usage was white plaster walls with the richer details of arcades, window frames, door cases, cornices, coffering, and so on, in the lovely fine-grained *pietra serena*, which ranges in colour from a pale bluey-grey, through a darker grey-green, to a muddy brown, and which can be carved with great delicacy and precision. Black-and-white effects (in reality the marbles of which they are composed are closer to creamy- or pinkish-white and dark grey-green) were imitated occasionally from earlier buildings such as the Baptistery, S. Miniato al Monte, and the cathedral: Alberti used them in his refacing of Sta Maria Novella, but this was because the original fourteenth-century façade which he was reconstructing had been built in this way.

Leon Battista Alberti stands somewhat outside the close-knit group of Brunelleschi, Donatello, and Masaccio, since he was not born until about 1404 in Genoa, and was the last to die, in 1472. Also, in social background—he came of a wealthy merchant family—in temperament and training he was from another world from the highly professional artists whom he frequented after his exiled family returned to Florence in 1428. Humanist, scholar, latinist, lawyer, papal civil servant, Alberti became an architect through his interest in the theory of the arts, and he was never a practical builder as Brunelleschi was, but employed a competent man to deal with the technicalities of construction—Matteo de' Pasti on the Tempio Malatestiano at Rimini, Bernardo Rossellino in Florence, and Fancelli at Mantua. Little of his work is in Florence, though that little includes his first building, the Palazzo Rucellai of 1446, where he was the first to work out the articulation of a façade of several storeys with a classical order of pilasters, following distantly yet clearly the system of the Colosseum and the Theatre of Marcellus.

His architecture was always closer to classical examples than Brunelleschi's: he was the first to adapt to the Christian church the

60

temple front of Roman origin, just as he was the first, in S. Andrea in Mantua, designed two years before his death, to revive the coffered barrel vault for the whole of a seventy-foot nave span.

His vital importance lies in his writings. In 1435 he wrote a treatise on painting, which he dedicated to Brunelleschi, Donatello, Ghiberti, Luca della Robbia, and Masaccio (the only painter among them, and already dead at that)—in other words, to the most advanced and significant artists of the day. In it he established two great principles: that naturalism could be achieved by the use of perspective, and that figures should be composed into dramatic groups so as to make the narrative clear, rather than to form pious tableaux. Alberti's importance as an innovator is attested by the consistency with which these two principles are worked out in Florentine fifteenth-century painting and sculpture. His influence on architecture was strengthened by his treatise, 'De Re Aedificatoria' written probably about 1450 and circulating in manuscript until its first printing in 1485. It became the first theoretical work on the subject since the Roman Vitruvius whose writings, then recently rediscovered, had been Alberti's own inspiration.

Both Brunelleschi and Alberti represent a transition from wall architecture to space architecture, and in both men this change in their understanding of their art came late in their careers. Brunelleschi, in the Loggia degli Innocenti, the Old Sacristy, or the nave of S. Lorenzo, treats the wall as the most important element: the arches of an arcade are but sections cut away from the plane of the wall. Alberti does the same in the Palazzo Rucellai, where he concentrates on an elevation as a solid piece of masonry, the parts of which are co-ordinated so as to stress the coherence of the plane surface, and in the Tempio Malatestiano in Rimini, built from about 1450 onwards but never finished, where the side-arcades of arches borne on piers instead of columns, stress the continuity of the wall area. In his un-finished, and now virtually destroyed, Sta Maria degli Angeli in Florence, built probably after his return from Rome in the early 1430s, Brunelleschi demonstrated a quite different attitude in that he then concentrated on the shapes of the spaces to be enclosed by the walls: it is the richness and complexity of the internal space that is important, and the wall is merely the means by which this is

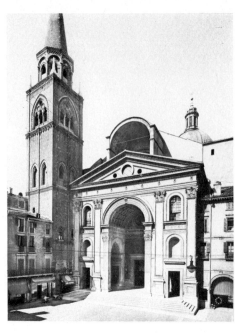

49 ALBERTI *S. Andrea, Mantua*

manifested. Sto Spirito is the best example. Here the elements are the same as those used in S. Lorenzo, but the feeling is quite different. The use of half-columns instead of pilasters between the side-chapels, and the curve of the wall at the back of the chapels, create a succession of undulations; the vistas of receding arches one within the other in the aisle elevations, and the recession of the aisles themselves as they form an ambulatory round the church and enclose the central large cruci-form space within their smaller and more complex units, all create an impression of spaces flowing out of each other and being conceived by the architect for their spatial significance, instead of the concen-tration on a wall as a limiting and defining element. In S. Andrea in Mantua (*plate 49*), Alberti links the forms of the façade, those of the loggia immediately within it, and those of the interior of the church in one sequence of interlocked shapes, each part being significant through its relationship to another, and not as individual elements.

It is through the sophisticated understanding of volumes and relationships that architecture achieves its controlling position as the greatest of the arts, and these experiments and discoveries laid the foundations for the High Renaissance concept of a building as an organic whole.

St Francis died in 1226 and was canonized in 1228. St Dominic died in 1221 and was canonized in 1234. The two great Orders founded by these men were, in a sense, missionary orders; they fell outside the framework of existing religious life, in that their concern was for the laity rather than the religious. In many things similar—in their rule of poverty, their dependence on charity, their adventurousness in travel and exploration—they yet differed radically in that the Franciscans concentrated on preaching and missions, and the Dominicans, who eventually abandoned the rule of corporate poverty without any of the dissensions that rent the Franciscan Order on the same account, concentrated on education, learning, and the extirpation of heresy. For both, however, their special stress on preaching and on the encouragement of a more demonstrative type of spirituality helped to fill the void left by the decline, through its unworthy secularization of aim, of the impetus of religious enthusiasms that had prompted and supported the Crusades. The new direction of religious revival led, on the one hand, to practical issues resulting from a renewal of the social conscience, and, on the other, to the rise of a new and more popular type of mysticism among religious. One of the forms this took was the production of a new kind of devotional book which amplified the Gospel and accompanied its narrative with comment and meditations. These were frequently highly picturesque in their detail, and led to the elaboration of a new iconography of the Life of Christ and, in particular, of the Life of the Virgin, which assumed a new importance through the intensification of her cult that accompanied the spread of the Mendicant Orders.

The great devotional books of the period stretch over about a century and a half: the 'Golden Legend' by Jacopo da Voragine written between 1255 and 1266, the 'Meditations on the Life of Christ' by an anonymous Italian Franciscan (though it was for long attributed

to St Francis's official biographer, St Bonaventura), written towards the end of the thirteenth century, the 'Life of Christ' by Ludolf the Carthusian, written at about the mid fourteenth century, the several books by Jan van Ruysbroeck which include his 'Mirror of Eternal Salvation', written in the second half of the fourteenth century, and the supreme 'Imitation of Christ' by Thomas à Kempis, first known in 1418. All these circulated widely in manuscript—about two hundred manuscripts of the 'Meditations' are known—and enjoyed enormous popularity and influence. In the case of Jan van Ruysbroeck, this influence was intensified by his hermit life at the Abbey of Groenendael near Brussels, where he died in 1381, and by his connexion with the lay confraternity of the Brethren of the Common Life, founded at his instigation by Geert de Groote about 1380 at Deventer in Holland. The Netherlands became in the late fourteenth and early fifteenth century a particularly lively centre for religious revival among the laity, with a strong parallel influence among clergy working from the Abbey of Windesheim, near Zwolle in Holland, established in 1387 by one of de Groote's disciples, and growing eventually into an important order of many houses, particularly famous for its contemplatives and mystics.

It is difficult to define precisely the impact of the Devotio Moderna on the art of the century. The clearest influence is in the new iconography, and this must in part at least stem from the importance of mystery plays. These have a much longer history than the surviving texts suggest, but whatever their role before the thirteenth century, they had a considerable importance from then onwards and appear to have expanded from dramatic representations of the Easter Sepulchre and the Christmas Crib into complex Biblical plays. Much of the narrative detail in religious pictures derives from their extensive use of the Apocryphal Gospels, which contain tales of the childhood of the Virgin, of her education in the Temple, of the disappointment of her suitors when it was the elderly Joseph's rod that blossomed, of the midwives at the Nativity, and the healing of the unbelieving one's withered hand, of the pagan statues falling as the Christ Child passed them by on the way to Egypt, and a host of similar details, charming, naïve, homely, evocative, highly pictorial, but scarcely canonical. This was the very stuff of popular drama. The

legends and miracles of the saints also fed the appetite for wonders, and the didactic aspect of their lives was made more vivid by the envelope of the marvellous.

The emergence of the new iconography was preceded in Germany and Bohemia by the long aftermath of Italian Trecento painting. Like a leaven working through the whole lump, so the outstanding quality of Italian—of Tuscan—art during the fourteenth century slowly permeated the whole of Western European painting, and the styles that emerged in the more active artistic centres such as Prague are in the main directly derived from Florence and Siena. In the process of assimilation by, for instance, the Master of the Vyšší Brod cycle, Duccio's coherent narratives and the attenuated forms of Simone Martini's sophisticated elegance become more spiky and contorted, and the Master of the Trebon Altarpiece (known in German as the Master of Wittingau) achieves a slightly Expressionist form of Agnolo Gaddi—that is, his colour is darker and richer, his forms less clear, and his sense of internal space more distorted, but his rather wilting poses and his sense of pattern derive from Florentine sources. In Master Theodoric, whose largest complex is the Crucifixion and Pietà surrounded by heads of saints in the chapel of Karlstein Castle, executed in the second half of the fourteenth century, the figures have much of the weighty directness and solidity of form of the Lorenzetti. Later forms of this Italianate influence are touched but slightly by the greater directness and naturalism of International Gothic. The Madonnas with curly, golden hair, small, tight features in round faces with high bland foreheads, tenderly sweet smiles, languid eyes, and long, thin, boneless fingers which seem hardly able to bear the weight of their plump, sprightly Infants: these types survive right down to the mid-fifteenth century, becoming weaker as the original inspiration is more worked out. Their type-name of *Schöne Madonnen*—Beautiful Madonnas—adequately describes the genre.

In France and in Flanders a complete break with the current flowing from Italy is marked by the emergence of Claus Sluter, working in Dijon in the last fifteen years of the century. Sluter's style of large, bulkily clothed figures, highly naturalistic in their details of beard, hair, facial expressions, is found in his sculpture for Champmol near Dijon and descends ultimately from the portal

sculpture of French cathedrals. The majestic amplitude of his prophets in *The Well of Moses* (*plate 6*), the splendour and richness of his handling of drapery, has its counterpart in painting in the works attributed to the mysterious Master of Flémalle, where the heavy folds of long, thick dresses and cloaks lie heaped in angular masses about the feet of his Virgins. One of the characteristics of the change from the Soft Style current in Germany and Bohemia, and the International Gothic which generally succeeded it there and spread so widely over the rest of Europe, to the realistic vision of the Master of Flémalle and Jan van Eyck, is to be found in this treatment of drapery—in, that is, the change from soft, flowing folds trailing gracefully around willowy bodies to angular clusters of stiff material enveloping much more thick-set figures. In German, this is described quite simply as 'der eckige Stil'—the angular style. Of the most telling examples of this new angularity one is the small triptych by the Master of Flémalle representing the Entombment in the centre panel with the Resurrection on one wing, and Golgotha and a donor in the foreground on the other. Not only are the figures extremely realistic, and is there a coherent spatial system within the picture, so that there is a sense of depth, of recession from the mourning women in the foreground to the weeping woman at the back of the group round the tomb, but there is also a new unity of feeling, of heart-rending emotion running through the whole compact mass of figures. The angel wiping away the tears with the back of his hand, the St John straining to support the grieving Mother leaning over her dead Son, the stricken woman holding the headcloth, these sound a new and urgent note of dramatic realism. The Resurrection plunges much deeper into pictorial space than the centre panel. The iconography is quite familiar; the angel seated on the cover of the tomb set slantwise across the empty grave from which the Christ steps awkwardly; the gaudily dressed soldiers about the tomb lying in gawky attitudes, the little wattle fence which seems to have survived from German fourteenth-century representations of the scene: these in different arrangements remain the constant parts. What survives from the past is the gold ground patterned in a delicate raised tracery of tendrils; what is new is the concern to re-create the scene itself, to stimulate the emotion of the beholder, to make him participate

50 MASTER OF FLÉMALLE *St Joseph, detail from the Mérode Altarpiece*

in the drama unfolded before his eyes to suggest to him the very sounds of grief, to involve him in the suffering, so that he meditates upon the price of his salvation.

One of the great mysteries of Flemish fifteenth-century painting concerns the identity of the Master of Flémalle and the personality of Robert Campin. Campin is well documented. He was born about 1378/80 and died in Tournai in 1444, so that he was probably a few years older than Jan van Eyck and survived him by three years. He may have worked in Tournai from 1406 onwards, and he certainly became a citizen of the town in 1410, which means quite clearly that he was not born there; he held the official appointment of Painter in Ordinary to the town, and had a considerable workshop with apprentices. He became Dean of the Painters' Guild in 1423, and was swept into local politics as a result of a revolt in the town, but in 1428 he retired again into private life. In 1432 he was in a different kind of trouble because of his irregular life, but although he was often at loggerheads with the authorities, he kept his popularity and his position as the town's major artist, and remained prosperous until his death. However, the tantalizing fact is that no signed, documented, or even traditionally attributed work survives.

A considerable body of work is attributed to the Master of Flémalle, a name derived from the belief, itself erroneous, that some of his works came from Flémalle in the Netherlands. There is also a large and important triptych of the *Annunciation*, with wings containing on one side two donors, and on the other the enchanting scene of St Joseph making mousetraps (*plate 50*), attributed for want of a better name to the Master of Mérode (whence the altarpiece came). But the Mérode altarpiece has so many affinities with the works of the Master of Flémalle that the two are generally considered to be by one man. The characteristics of this man's style are a certain vivid realism and angularity of form, a striving for emotional effect, the use of heavy draperies falling in thick folds like crumpled blotting-paper, and an interest in the minute details of an interior. There are also certain physical characteristics: long faces, heavily lidded eyes, small rounded chins under straight, thin-lipped mouths, rather thick-set figures, dumpy proportions, fairly strong colour, and a gift for landscape painting. In 1427 Rogelet de le

51 JACQUES DARET *Nativity*

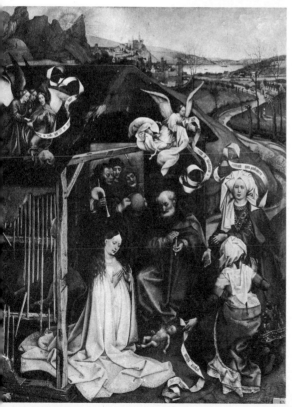

52 MASTER OF FLÉMALLE
Nativity

Pasture and Jacquelotte Daret were entered in the Guild records of Tournai as apprentices to Robert Campin, and in 1432 they both became Masters, Jacques Daret being made Dean of the Guild on the same day. Both were natives of Tournai, where Jacques Daret, the son of a woodcarver, was born before 1400. In 1418, when living in Campin's house, he entered Holy Orders, and he must have continued working as Campin's assistant until the end of the formal apprenticeship without which he could not practise as a Master on his own. In 1434/5 Daret was working for the Abbey of St Vaast, near Arras, on a fourfold altarpiece containing a *Nativity* (*plate 51*), now in the Thyssen Collection. This *Nativity* contains many features drawn from the Apocryphal Gospels, particularly that of the pseudo-Matthew, which recounts the story of the two midwives, Zelomi who believed in the Virgin birth, and Salome who did not, and whose hand withered as a result of her expressions of contemptuous incredulity. It also has the figure of St Joseph shielding the candle with his hand, and the half-scale angels surrounding the ruined hut in which the Virgin kneels before the naked Infant lying on the ground. All these features are to be found in a *Nativity* attributed to the Master of Flémalle (*plate 52*), and the similarities between these two works suggest that Jacques Daret derived his picture from the one by the Flémalle Master, which would suggest a connexion between the well-documented Campin by whom no pictures are known, and the considerable œuvre of the unidentified Master.

The interior of the room in the Mérode *Annunciation* (*plate 53*) contains a wealth of vividly portrayed detail: the water-pot hanging in the alcove with the embroidered towel beside it; the latticed and shuttered window, the long bench against, rather than upon, which the Virgin sits; the book, the guttering candle, the lily in the vase upon the table, tipped awkwardly in an uncertain attempt at perspective. Many of these details reappear in another work, clearly by the same hand: these are the wings of the Werl Altarpiece—the only surviving parts—one containing the clerical donor presented by the Baptist (*plate 54*) and the other the Virgin seated reading before the fire in a room at the back of which an open window looks out upon a landscape (*plate 55*). The interiors in the Werl Altarpiece are far more competently managed than the gauche perspective of the

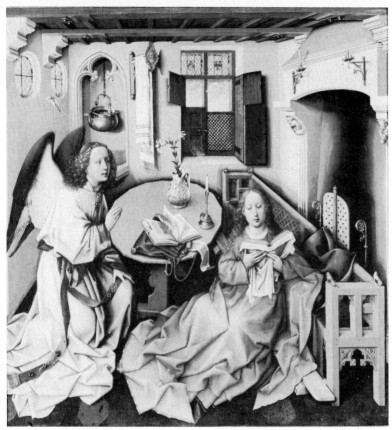

53 MASTER OF FLÉMALLE *Annunciation, central panel of the Mérode Altarpiece*

Mérode *Annunciation*. The same device of the open door to join the two scenes is used as it was to include the donors in the *Annunciation*, but behind the Baptist is a convex mirror reflecting the scene. This is clearly a reference to the mirror image in Jan van Eyck's *Arnolfini Marriage Group* (*plate 62*), and that this is an imitation is borne out by the fact that the Werl wings are dated 1438; it also suggests a development within the Master of Flémalle's works. The patterned gold ground and the compressed frieze of figures in the Entombment show the evolution of new forms still within the framework of an older non-naturalistic tradition; the uncertain perspective of the Mérode *Annunciation* indicates an increasing concern for realism in setting and character; both these pictures suggest an artist who is leading rather than following, for the nearest approach to them is in

71

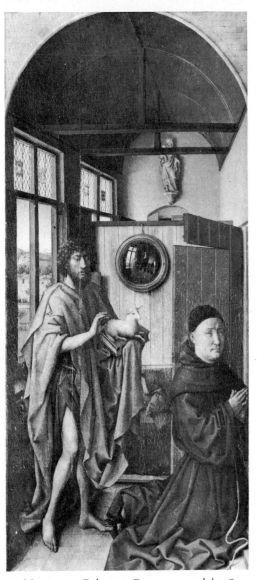

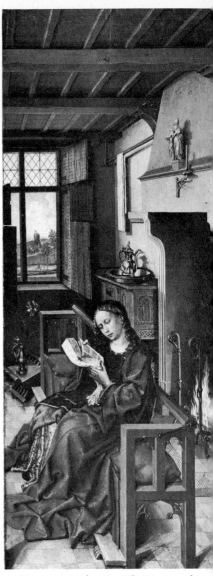

54 MASTER OF FLÉMALLE *Donor presented by St John the Baptist, wing of the Werl Altarpiece*

55 MASTER OF FLÉMALLE *The Virgin reading, of the Werl Altarpiece*

Van Eyck in the 1430s. But the Werl wings support the opposite view: a painter who has knowledge of the Van Eyck *Arnolfini* portraits of 1434, and is using that knowledge in combination with a more studied solution of his own earlier spatial problems.

A great deal is known about Jan van Eyck from 1422 onwards, but nothing earlier, even his birthplace being doubtful and the year of his birth unknown. It is possible that before this date he had been connected with the Court of Count William of Holland, for in 1422 he was working for the dead Count's usurper brother in The Hague. It is also possible that he may have worked on the illumination of a Book of Hours that was later split up and finished by several hands, and of which the part that came to be known as the *Hours of Turin* was burnt in 1911 in the fire which destroyed the Royal Library in Turin. Fortunately, the pages containing the miniatures had been photographed, and therefore can be compared, if only inadequately, with other surviving pages from the same manuscript now in the Turin Museum (*plate 56*), but known from their original home in the Trivulzio Collection as the *Hours of Milan*. The outstanding characteristic of the lost pages attributed to the Van Eycks are the shimmering quality of the light, a magic blend of realism and poetry in the treatment of nature, and a use of certain perspective devices which reappear in some of Jan's later works. There is also the point that one of the miniatures represented Count William, and part of the manuscript is known to have been in his possession.

56 *Attributed to* JAN VAN EYCK
*Birth of St John the Baptist
from the Hours of Turin*

In 1425 Jan van Eyck entered the service of Duke Philip the Good of Burgundy, and served him until the end of his life. He was not only a Court painter, but also a confidential servant, for his master sent him on several secret diplomatic journeys, at least two of which were connected with his various marriage negotiations in Spain and Portugal. He lived in Lille until 1429, and then in Bruges, where he bought a house, and where he was visited by the Duke in 1433. In 1441 he died in Bruges.

The bald framework of his documented life-history is supplemented by a number of signed and dated works, and by others that can be confidently attributed to him and that are datable by analogy with those for which a date exists. What is so astonishing is the consistency in his production, its continuously high level, and the relatively small development to be found in it. This, it is true, may be because the earliest dated works are the Ghent Altar and the small portrait of Tymotheos, and because he only lived another nine years after painting these, what development there was must largely have preceded his dated works.

Then there is the problem of Hubert. On the frame of the Ghent Altar is a Latin quatrain which may roughly be translated: 'The painter Hubert van Eyck, than whom none was greater, began it; Jan, second in art, having completed it at the charge of Jodocus Vyd, invites you by this verse on the 6th May to contemplate what has been done'. The last line of this verse is a chronogram expressing the date 1432. The inscription implies that Hubert was Jan's elder brother, and states specifically that he began the altarpiece. Presumably, he must have executed other works as well. Hubert is barely documented at all, and the four exiguous references supposed to relate to him in the Ghent city archives do not incontrovertibly refer to him. It has therefore been advanced that Hubert was an invention, a piece of local patriotic propaganda produced in Ghent in the sixteenth century to offset the enormous prestige of Jan in Bruges, that the quatrain is a fake, and that Jan alone existed and painted the whole of the great work. But there is no overriding reason for doubting the genuineness of the inscription, and there is, besides, a small group of works which, while they can be related to Jan's known paintings, yet do not appear to be entirely by him. *The Three*

57 *Attributed to* HUBERT VAN EYCK *The Three Maries at the Sepulchre*

Maries at the Sepulchre (plate 57) has many points in common with the Ghent Altar, and hence with Jan's dated or datable works, but, like some of the miniatures in the *Turin Hours*, it also has a markedly International Gothic character. The clumsy perspective of the tomb, the elegance of the three holy women, the caricature types of the sleeping soldiers, the precious jewel delicacy of the angel, the undeveloped spatial system of the composition, with the walled and towered city and the splendid sunrise as a flat backcloth to the drama of the Resurrection—all these are still part of the sophisticated complexity of the very early fifteenth-century approach to naturalism, and all suggest a less factual mind than Jan's, a richer vein of poetry and imagination. Also, the elaborate symbolism of *The Three Maries at the Sepulchre* is paralleled in the Ghent Altar, and finds many

75

echoes in Jan, though he rarely achieves the same depths, the same multi-layers, of meaning. But from this, and other works, in which it is reasonable to assume that he participated, Jan's own personal style certainly developed.

The Ghent Altar is a large and complex polyptych, some sixteen feet across when fully open, by some twelve feet high, and about eight feet by twelve feet when the folding wings are closed. One of the first things that strikes one on looking at it is the absence of coherence between the various parts, although there is a medieval tradition which justifies the arrangement of the central panels of the Deësis above with the Paradise scenes below. When closed, the altarpiece has on the outside of its wings a large *Annunciation* (*plate 58*) and, below it, the portraits of the donors and their patron saints, while the topmost sections contain four small figures of sibyls and prophets with texts on floating ribbons. Another striking thing is the

76

59 VAN EYCK Deësis, *Adoration of the Lamb and the inside of the wings, Ghent Altarpiece*

disparity in the scale of the various figures: no less than four changes of scale exist between the three divisions of the outside of the wings, and similar disparities are present between the upper and lower parts of the inside of the altarpiece. There are also curious disparities in approach; some parts are almost prosaically factual, others almost visionary in their intensity. The angel and the Virgin of the *Annunciation* are separated by two small panels, one with the representation of an arched window looking out upon a city square, and the other with a wash basin and ewer set into a niche and a white towel hanging from a rail beside it. The symbolism of the ewer and basin is clear, but that of the city view is not; in the same way, the lighting system within these scenes is also odd, since both the Virgin and the angel are lit from the right, and the open window in the centre and the little arched windows at the back of the figures do not in any way modify the lighting within the picture; nor does the light from

77

these windows fall in any logical way across the bare floor space between them, so that they have been treated sometimes as insertions. The donor and his wife kneel beside the figures of their patrons, the two Sts John, who are represented as statues and painted in grisaille. This introduces not only a disparity of scale, but also one of vision, for three orders of reality are now present: a narrative representation of a sacred subject, two highly factual donor portraits, and two simulated sculptures. The portraits of Jodocus Vyd and his wife have the same closely detailed approach to living form that Jan shows in, for instance, the *Man in a Red Turban* (*plate 61*) or the Tymotheos in the *Leal Souvenir* (*plate 60*). Yet there is a strong attempt to impose a uniform framework on these disparate elements through the governing factor of the light, which falls uniformly in all the panels from the right, and also through the use in the upper panels of a beamed ceiling running through the whole scene, and, in the lower panels, of the same cusped trefoil arches to frame the figures. On the inside of the altarpiece (*plate 59*) the main disparities lie in the scale and the viewpoint. The upper row contains figures of four different scales, the largest in the centre being that of God the Father, though this disparity can easily be a survival from a medieval tradition of importance indicated by size. The detail is superb in quality, but the minute handling of jewels, crowns, brocades, never overwhelms the grasp of the structure of the whole figure. There is also a passionate interest in facial expression and in character; instances of this are in the open mouths of the singing angels, and the difference in treatment between the supernatural figures and those of Adam and Eve which stand on the outside edges of the uppermost panels and appear as figures from another world, physically as well as spiritually.

Below the *Deësis* is the panel of *Adoration of the Lamb*, the various iconographical elements of which may be analysed almost indefinitely in ever deepening layers of meaning and symbolism. The sacrificial Lamb stands upon the altar, and the chalice catches the blood pouring from its breast; the instruments of the Passion are upheld by little angels kneeling round the altar, and in the foreground of the flowery hill-side the pilgrims approach, both towards the altar and the Fountain of Life which gushes in the foreground. They come in long processions—prophets, martyrs, popes, virgins, pilgrims, judges,

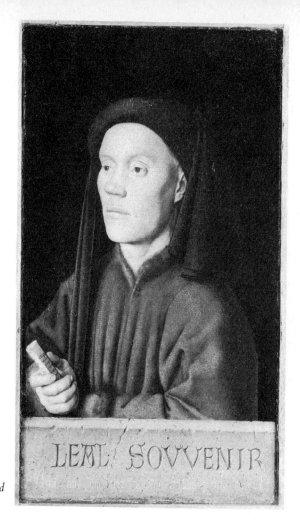

60 JAN VAN EYCK
Tymotheos, inscribed
Leal Souvenir

knights, hermits, wending their way across a landscape of such
fantastic detail and such luxuriance that this seems to be the repre-
sentation of an earthly as well as a celestial paradise.

The next firmly dated work by Jan is the portrait of the unknown
Tymotheos which bears the inscription 'Leal Souvenir' and the
signature and date 1432 (*plate 60*). Its clarity of organization, the
simplicity of the lighting, the minute handling of the detail, connect
it clearly with the donor portraits in the Ghent Altar, and the same
features also appear in the *Man in a Red Turban* (*plate 61*), which
bears, in addition to the signature and the date 1433, the proud if

79

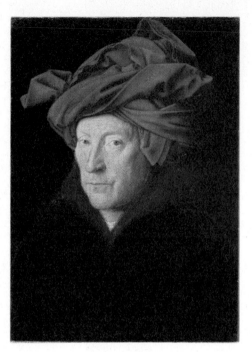

61 Jan van Eyck
Man in a Red Turban

62 (*right*) Jan van E
Arnolfini Marriage G

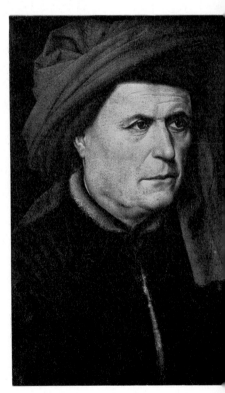

63 Master of Flémalle
Portrait of a Man

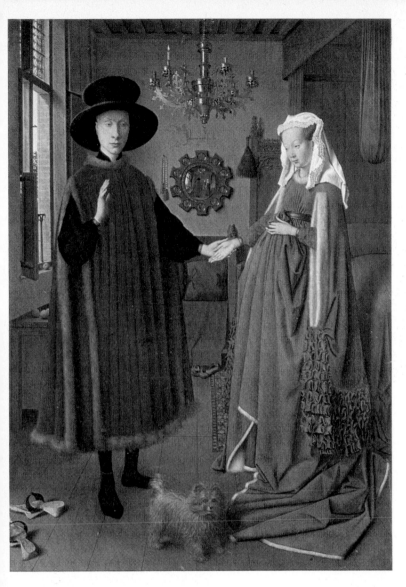

ambiguous device of 'Als Ich Kan'—As I can. It is instructive to compare the *Man in a Red Turban* with the *Portrait of a Man* (*plate 63*) by the Master of Flémalle. The two problems are virtually the same; both artists have made great play with the decorative patterns of the headgear; both have examined with the most minute intensity the facial forms of their sitters, even to the depiction, in Jan's head, of

the stubble of the beard. It is through his minute examination of surface forms that Jan van Eyck achieves the comprehension of a total form, and in this Flémalle was not his equal since the face of his turbanned man is more empty, and the features appear more the portraits of individual parts of a head than as a total form. In few of his other portraits, with the exception of the *Arnolfini Marriage Group* (*plate 62*), does Jan achieve quite these heights of excellence. The *Arnolfini Marriage Group* is one of the world's most fascinating and involved pieces of iconography, and can qualify for the unusual role of a painted marriage certificate, for the Italian merchant is clearly at the most solemn moment of his vows, as is proved by the lighted candle above his head signifying the presence of God, while at the feet of his young wife stands the small dog emblematical of marital fidelity, and behind them is the marriage bed. On the wall at the back of the room above the mirror which reflects the scene the artist has signed the work and affirmed his presence at the ceremony —'Johannes de Eyck fuit hic 1434'.

Here again it is the realism, the minute concentration on appearance that is so striking. The perspective system of the room, the window, the floorboards, is not based on any of the scientific theories of optics which, at the same date, were current in Florence; it is purely empirical, but so perfect is the observation that the illusion of reality within the room is complete. The perspective of the Dresden *Virgin and Child with Saints* is equally based on a reality founded apparently on observation, although no church interior corresponding to this one has ever been identified, so that the reality must in large part be a creation of the painter's imagination, and derived from a use of architectural forms for symbolic purposes. What is complete is the sense of actuality, so that Jan van Eyck appears to be approaching the idea of the general through a heightened realization of the particular. In this he is worlds away from Roger van der Weyden, and even from the Master of Flémalle, whose starting-point was, it is true, reality, but a reality suffused by emotion and drama—the approach from the generalized feeling, from the state of mind, to the particular and the statement of fact. Nowhere in Jan van Eyck is there any drama. At most there is a vague, half-hearted movement, as in the St George in the *Madonna of Canon van*

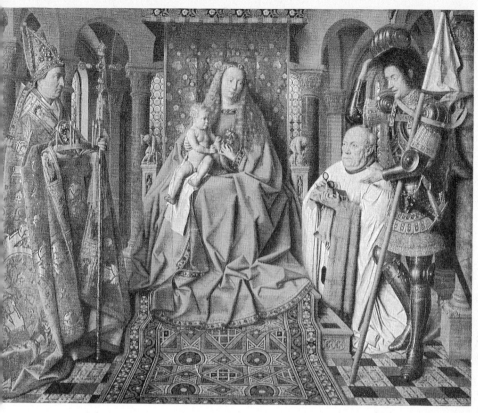

64 JAN VAN EYCK *Madonna of Canon van der Paele*

der Paele (plate 64), accompanied by a frozen smile, or a half-smile of discreet contentment and pride in the face of the Madonna looking down on her Infant in the tiny panels where she sits, like a grand lady, half-enthroned under a canopy of state, half-*bourgeoise* upon the floor in a modest room.

The tradition that the Van Eycks invented oil-painting has long been abandoned. The amazing technique of Jan's works does, however, suggest that he must have invented or perfected a better, purer varnish or oil medium, for his paint has a fluid quality, an absence of brush-strokes, and a jewel-like clarity of colour which give it the appearance of being floated almost magically upon the panel. Jan's colour and the consistency of his paint are much more subtle, more transparent, more luminous than the Master of Flémalle's more

83

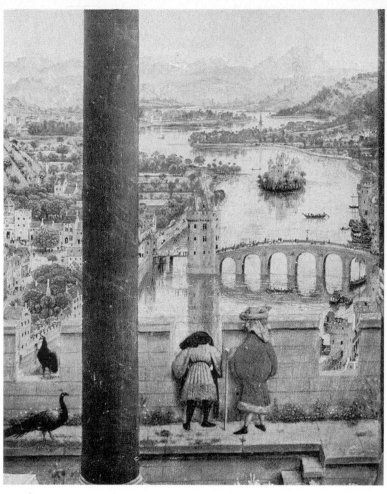

65 JAN VAN EYCK *Rolin Madonna, detail*

pastose *matière*; but he never achieves the tender, pallid luminosity of Roger. The Flemish technique of the oil medium is demonstrably ahead of the use of oil paint elsewhere—in Italy, for instance— because the nature of northern painting confined the art to easel pictures, whereas the first requirement of the Italian patron was for fresco, so that tempera became the easel picture medium, since it resembled fresco in its colour and demanded the same qualities from the executant. Like fresco, tempera requires promptness of hand and execution, and does not readily allow repainting and retouching; oil

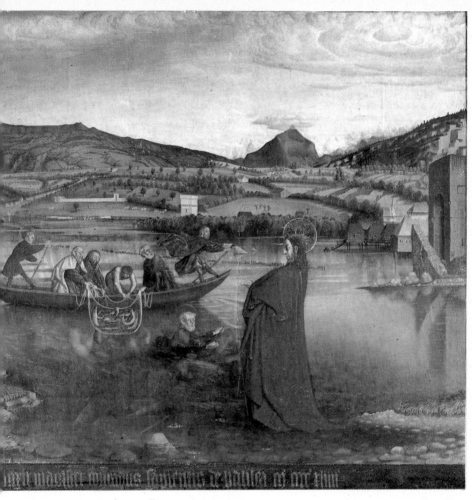

66 KONRAD WITZ *Christ walking on the Water*

permits a slow, deliberate approach, requires time for drying
thoroughly during the phases of execution, and allows for second
thoughts. Despite his virtuoso qualities, and perhaps because of them,
Jan van Eyck's influence did not penetrate nearly so widely as that of
Roger through Europe, particularly in Germany. Lucas Moser, for
instance, in the Tiefenbronn Altarpiece (*plate 145*) stems more from
Flémalle than from his great contemporary, and Konrad Witz, in the
Christ walking on the Water (*plate 66*), of 1444, has, it is true, the acute
realism of Jan in that his landscape background is recognizably a

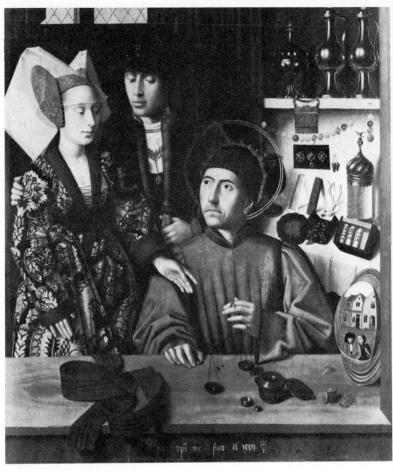

67 PETRUS CHRISTUS *St Eligius and the Lovers*

particular site on the Lake of Geneva, but in its treatment it is closer
to the wide and tender landscape of the Flémalle Dijon *Nativity* than
to the more visionary ones at the back of either the Ghent Altar or
the *Rolin Madonna* (*plate 65*). In fact, the lamentation of poor Moser,
'Cry, Art, cry and lament loudly, nobody nowadays wants you. So,
alas, 1431', painted on the frame of his altarpiece, suggests that the
new style was making but slow headway against the insinuating
qualities of the older Soft Style.

After the death of Jan van Eyck in 1441, the most important Bruges painter was Petrus Christus, who has usually been considered as a pupil of Jan, despite the fact that he is not certainly recorded in Bruges until 1444. Stylistically, he comes the closest to Jan in his realism and in his rather dispassionate quality, though he never achieves the same virtuosity. He borrows from Jan, for instance in the *St Eligius and the Lovers* (*plate 67*), of 1449, where the saint is represented as a goldsmith selling a ring to a young couple, and where the mirror and the details of the interior directly recall the *Arnolfini Marriage Group* (*plate 62*)—to which, incidentally, it is also linked in theme, for this is clearly a betrothal picture. The *Lamentation* (*plate 68*) shows the stiff poses, and the empty, lumpish forms he favoured, perhaps because of a certain attempt at stylization; it also shows him leaning, or rather pushing himself, not very successfully, in the direction of Roger's pathos, but he is defeated by the coarse forms of his draperies and his perfunctory sentiment. He is at his best in portraits, for there he seems sufficiently interested to push his

68 PETRUS CHRISTUS *Lamentation*

analysis beyond superficial statements about the features, and to interest himself in the flow of light from more than one source. The little *St Jerome* (*plate 69*) has long been argued over; the date 1442 which it bears is not above suspicion, and cannot be used to support the argument that this is a Jan van Eyck that Petrus finished, although evidence of style would suggest it. It has been claimed, also, that this is the Jan *St Jerome* mentioned in the Medici inventory of 1492; it may be. That a picture of this type did exist in Florence is borne out by the pair of philosopher saints by Ghirlandaio and Botticelli in Ognissanti, clearly based on just such a prototype. It has also been advanced that the brilliant, if a little mechanical, handling is due to the fact that it is a later fifteenth-century copy of a lost Van Eyck original.

69 PETRUS CHRISTUS
St Jerome

Masolino is an excellent example of what happened to an artist trained in the International Gothic tradition who found himself attracted to the new realism of Masaccio. To a large extent his case is typical of what happened to most of the Florentine artists working at about the middle of the fifteenth century, but on the whole they tended eventually to be more influenced by the aggressively dramatic realism of Donatello than by the more classical forms of Masaccio himself. In different ways this twofold aim can be seen working in artists varying as much in age as in accomplishments, and best of all in the major figures of the period, Fra Angelico, Fra Filippo Lippi, Uccello, Domenico Veneziano, and Castagno.

It used to be thought that Fra Angelico offered a perfect parallel to Masolino, although his works were more lyrical, or indeed more sentimental. This view, which has something to commend it, was based on two things: the first was the supposed date of Fra Angelico's birth at around 1387, which made him precisely contemporary with Masolino and with Donatello; the second factor was the existence of his earliest certainly datable work, the altarpiece painted for the Cloth Guild (the *Linaiuoli Madonna*) (*plate 70*) in 1433. This picture seems to have a definite connexion with the work of Masaccio, and the influence can be substantiated in Angelico's later work. It now appears more likely, however, that Fra Angelico was born as late as about 1400, so that the influence from Masaccio is rather to be reckoned as that of one contemporary on another, and is therefore more closely paralleled by the influence exerted by Masaccio on Fra Filippo Lippi. Here again, until comparatively recently, it was customary to assume that Fra Filippo started his career as a painter of rather sweet devotional images and that his work became progressively more austere and more realistic. This was due to a preconceived notion of the idea of development, according to which it was

89

70 FRA ANGELICO
Linaiuoli Madonna

believed that a more realistic painting was necessarily more accomplished, and therefore necessarily later, than a less realistic work. There is, of course, no reason in logic why this should be so, and the arts in Florence in the period from about 1430 to 1460 show that the development of ideas was rather more complicated. Fra Filippo's development can be plotted fairly precisely since the rediscovery in the cloister of the Carmelite church in Florence of some fragments of frescoes which can be dated about 1432. Fra Filippo was an orphan who was put into the Carmelite monastery in Florence in 1421, when he was still a child, by his aunt, presumably to get him off her hands. During the mid 1420s Masaccio was painting the Brancacci Chapel in the church; in 1430 Fra Filippo is recorded in a document as a painter. Since the Carmelites were an enclosed Order, it seems probable that Filippo was Masaccio's pupil, and the battered fresco fragments, which were mentioned by Vasari but later covered with whitewash and rediscovered only in 1860, confirm this impression entirely. The next dated works, the *Tarquinia Madonna* (*plate 73*) of

1437 and the Barbadori Altarpiece (*plate 71*), commissioned in 1437, both show a trend away from Masaccio and are rather nearer to Donatello. This is perhaps more discernible in the *Tarquinia Madonna* (so called from its original home), for the compactness of the group-ing, the architectural background in layers receding into the distance, the fat and really very ugly child, suggest that Donatello's Siena Font *The Feast of Herod* (*plate 26*) and the vigorous *putti* of the Prato pulpit and the *Cantoria* (*plate 29*) were in Fra Filippo's mind. In the Barbadori Altarpiece the composition is easier and less compressed. The setting is still architectural, but only a simple panelled room, containing a large, tabernacle throne. Although the faces of the little angels leaning over the balustrade still recall the ferocious expressions of Donatello's *putti*, the inspiration seems better assimilated, and the emotional impact of ugliness less stressed. The Barbadori Altarpiece is important for two other reasons. It is one of the earliest datable examples of the Sacra Conversazione, that form of the Madonna and Child group where the saints are so placed as to suggest the intimacy

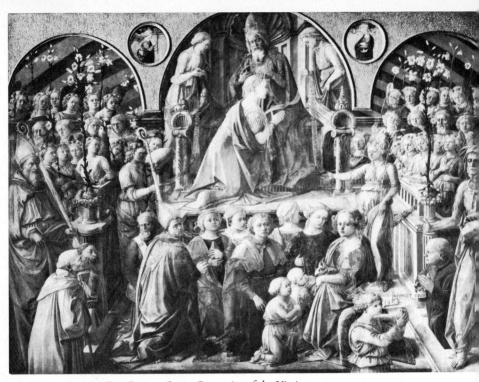

72 FRA FILIPPO LIPPI *Coronation of the Virgin*

of a Holy Conversation piece. This became an increasingly popular composition, replacing almost entirely the older types of the Virgin enthroned in majesty, or with the saints in separate compartments flanking a central Madonna group. The second reason is its prophetic quality in the increasing complexity of individual forms; the draperies fall in small folds, and many different textures are particularized—the thin gauze of the Madonna's headcloth, the embroidered copes, the finely feathered angel's wings, the marbled panelling and floor, the carvings on the throne—until there is barely a square inch of the picture surface that is not broken up into a different form and colour. The effect of this can be seen in the *Coronation of the Virgin (plate 72)*, commissioned in 1441 but probably not finished until 1447. The concept of internal space has been abandoned in order to achieve the maximum richness of surface, and even the rational ordering of scale has also gone: the central figures of God and the Virgin, and the two angels flanking them, are

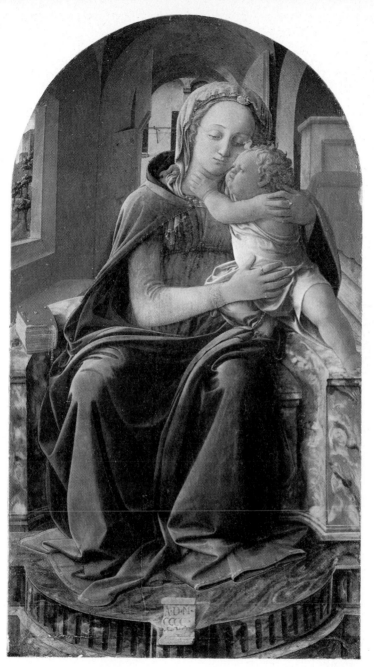

73 Fra Filippo Lippi *Tarquinia Madonna*

relatively larger, taking the effects of perspective into account, than any of the angels in the groups on either side, and even than the kneeling figures in the foreground. Also the multiplicity of detail is more pronounced. The heads of the angels offer a pointer to the influence of Fra Angelico which impelled Fra Filippo towards a competition in sweetness; with him it took the form of a stronger linearism, paler, brighter colour, and a retreat from the realism imposed by Masaccio.

The frescoes in the choir of Prato Cathedral, begun in 1452, bear the date 1460, although it is unlikely that they were finished before 1464. He was extremely dilatory over the work, perhaps because the delays furthered his romance with Lucrezia Buti, a nun in a convent of which he was chaplain, who became the mother of his son Filippino in 1457 or 1458, and perhaps also because of the damage to his health caused by his being racked in 1450 in order to extract from him the truth over his embezzlement of his assistant's wages. The *Funeral of St Stephen* and the *Feast of Herod* which form part of the series show the artist concentrating on movement and dramatic narrative at the expense of coherence. The *Funeral of St Stephen* contains a bold perspective vista of the interior of a church, a type of setting which was by now common, since it provided an opportunity for the display of knowledge and ability in what was now a *sine qua non* of any up-to-date artist's repertory, and in the *Feast of Herod* (*plate 78*) the use of continuous representation—the device of several successive incidents being shown as occurring simultaneously so as to make the narrative plain—is pushed almost beyond the limits of reason, so that the naturalism of the perspective setting and the telling contrast of Herod's horror and Herodias's impassivity is vanquished by the unreality of the presentation. Donatello's relief of the same subject is the source, but it also shows by how much a superficial acceptance of his influence is detrimental to internal coherence.

A similar development can be found in the Madonna and Child groups. The *Madonna of Humility* (*plate 74*), a very early one, has a strong emphasis on light and shadow derived from Masaccio, and the ugly faces, the rather *outré* realism taken from Donatello; the late ones—the *Pitti Tondo* (*plate 75*) of 1452 with the Madonna and Child against a background of the story of St Anne, and with the famous figure of the Maenad striding purposefully with her basket upon her

94

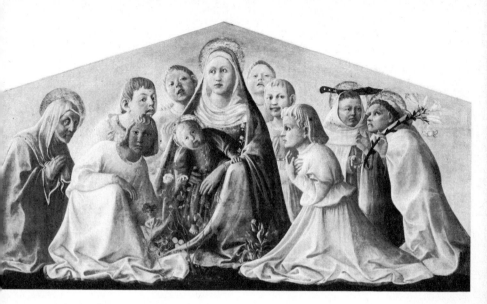

A FILIPPO LIPPI *Madonna of Humility*

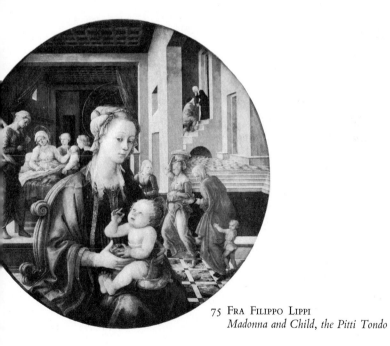

75 FRA FILIPPO LIPPI
Madonna and Child, the Pitti Tondo

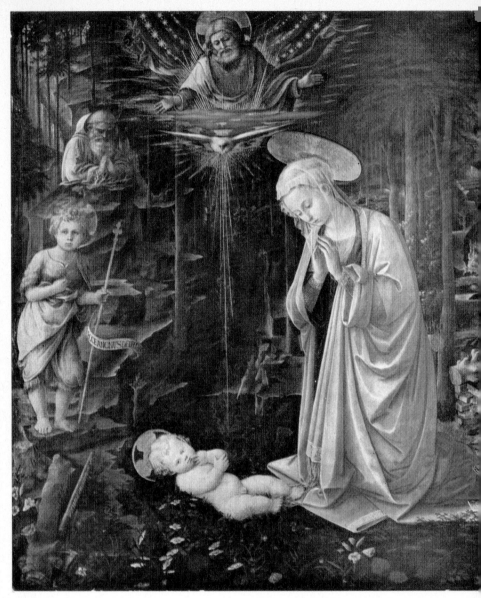

76 FRA FILIPPO LIPPI *Madonna Adoring Child in a Wood*

77 Fra Angelico *Madonna and Child with Saints and Angels*

head, and the enchanting one of about 1455–57 with the tender
Madonna adoring a Child upheld by a grinning imp of mischief—
describe the change in his style resulting from the sweetening and
softening of his realism in favour of a poetry derived ultimately from
an entirely different inspiration. The *Nativities* are also evidence of
this change. One (*plate 76*) was the altarpiece for the chapel in the
Medici Palace frescoed by Fra Angelico's assistant Benozzo Gozzoli

with the famous procession of the Magi in which the younger members of the Medici family figure. These *Nativities* have an entirely poetic quality, being more meditations upon, rather than representations of, the scene. The gloomy background, the shadowy witnesses, the insubstantial angels, the soft beauty of the Madonna and the rather cloying sweetness of the Child, lying, finger-sucking, on the ground (*plate 76*), are the measure of the transition in the mid-century from the realism of Masaccio and the emotion of Donatello to that tenderness and grace which characterized the sculptors of the second generation. The surprising thing is to find Fra Filippo as the herald of this change.

Fra Angelico's development appears to have been quite different, but his early career is still obscure, and he probably did not start painting until quite late in the 1420s. He became a Dominican at a comparatively early age, but, unlike Fra Filippo, he did so from conviction, and as a member of the Order of Preachers he deliberately used his art for didactic purposes. For this reason, his style is always simple and direct, and possibly also somewhat conservative. The little reliquaries that are usually ascribed to him, and which are all known in coloured reproductions, may be early works by him, but the first firmly dated work is the *Linaiuoli Madonna* (*plate 70*), commissioned in 1433. It is best looked at in relation to the *Madonna and Child with St Anne* (*plate 16*) by Masaccio, and the *Madonna of Humility* (*plate 74*) by Fra Filippo. The Masaccio and the Fra Filippo are both naturalistic in vision, but the Masaccio is infused with classical grandeur, and the Fra Filippo with emotional feeling. Fra Angelico retains much of the hieratic quality of the Masaccio, its solidity and three-dimensional form, but in some ways he is closer to the International Gothic ideal of the beautiful Madonna while the Child is straight out of a medieval or Byzantine model, merely brought up to date by slight concessions to light and shadow.

The *Madonna and Child with Saints and Angels* (*plate 77*), the altarpiece of the Monastery of S. Marco in Florence, where Fra Angelico spent most of his working life, and was in charge of the workshop, was painted probably between 1438 and 1440. It is therefore comparable, as a Sacra Conversazione, with the Barbadori Altarpiece (*plate 71*); the composition is more open, less cluttered in internal space

78 FRA FILIPPO LIPPI *Feast of Herod*

than Fra Filippo's, and it uses the same type of compositional devices
—the antithesis of the kneeling figures, the exact balance of the stand-
ing saints and angels, the plants, garlands, and hangings—but the
throne is more classical in shape, derived ultimately from the niche
by Michelozzo on Orsanmichele, made to contain Donatello's *St
Louis*, and now containing Verrocchio's *Incredulity of St Thomas*.
As a general rule, however, Fra Angelico's works can be dated from
the progress of the works in the Monastery of S. Marco, which is
decorated with a large number of frescoes, one in each cell, and
larger, more ambitious ones in the chapter house, on the landings,
and in the passageways. The ones in the more public places, like the
Madonna and Child with Eight Saints (*plate 81*) in the upper corridor,
or the *Annunciation* (*plate 82*) facing the stairs, are quite direct in their
treatment of the subject. The Madonna fresco is probably fairly late
in execution, and may not have been painted until after Fra Angelico
returned from Rome in 1449, which would mean that he continued
to work in his old convent after he had been appointed Prior at
S. Domenico in Fiesole. Compared with the altarpiece, the frescoed
Madonna and Child group is much simpler in composition, even
rather bare. Four saints stand in each group on either side; four
pilasters decorate the wall which flanks the simple niche-throne, the

99

Madonna is a formal, yet tender, hieratic figure, holding an equally formal, yet very beautiful, Child, one hand raised in blessing, the other holding an orb. The lighting is curiously illogical: the pilasters cast long, spiky shadows on the plain wall, the niche is shadowed inside and has a shallow cast shadow on the wall, the faces also indicate the light coming from the left—the true direction of light in the corridor. But none of the groups casts any shadow on the ground, so that despite the effect of recession created by the figures of the saints in echelon, the picture remains a flat composition. The same irrational, but artistically sound, solution is used in the *Annunciation*, where the interior of the arcaded loggia is evenly illuminated, despite the fairly strong light coming from the left. In the frescoes in the cells, the iconography is less direct and the subjects are not entirely realistic: the *Mocking of Christ* takes place on a dais above unseeing contemplatives, and the hands of the buffetters, the head of the spitting soldier, the stave forcing the crown of thorns on to Christ's head, are represented as apparitions beside His blindfolded face. In the *Noli me tangere* the brilliance of the early morning is real enough, but the irradiating light, the floating rather than walking figure of Christ, the wealth of natural detail in the garden, are for devotional reasons and intended to stimulate the meditation of the monk who lived in the cell. In this huge series the workshop played a large part.

In 1447, or perhaps earlier, Fra Angelico was in Rome, where he painted the private chapel of Nicolas V with scenes from the Lives of Sts Lawrence and Stephen, frescoes which sum up the whole trend of his work. They possess a logical realism in their perspective settings, clarity of scale and narrative content, and restraint in their vigour. The colour is limpid, but with sufficient use of chiaroscuro to give substance to the figures; the use of continuous representation is kept to a minimum by the division of the scenes through differences in their architectural setting, but nowhere is the search for realism in the use of lighting effects allowed to destroy the unity of the whole, or the sense of the plane of the wall. The stories are told with a wealth of circumstantial and colourful detail: for instance, the allusion to the Pope's decision to declare 1450 a Jubilee Year is shown by the two soldiers about to break down the walled-up door on the

79 DOMENICO VENEZIANO
St Lucy Altarpiece

80 FRA ANGELICO *Scenes from
the Lives of Sts Lawrence and
Stephen, detail, St Lawrence
Receives the Treasures of the
Church*

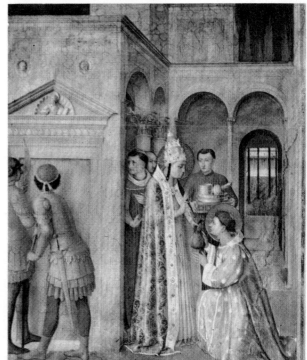

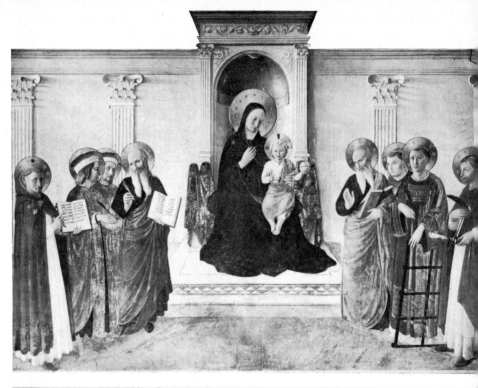

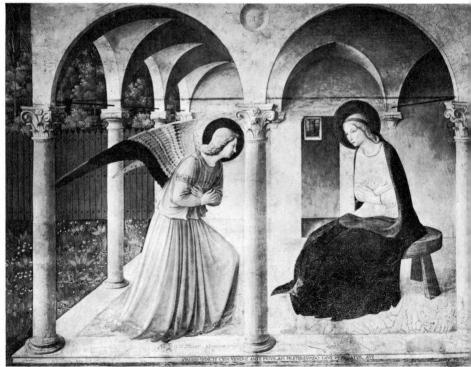

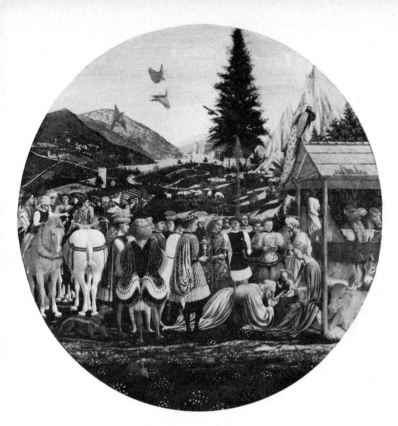

83 DOMENICO VENEZIANO *The Adoration of the Magi*

81 (*above left*) FRA ANGELICO *Madonna and Child with Eight Saints*

82 (*below left*) FRA ANGELICO *Annunciation*

left (*plate 80*) but even a detail of this kind is never intrusive or merely included for decorative richness, but is at the heart of the narrative. Compared with Fra Filippo's late frescoes, the difference is striking, and it is striking because it is the man who started in a backward-looking style who finally understood what Masaccio was really driving at, and not the man who began as his pupil.

The other great Sacra Conversazione of the period is the St Lucy Altarpiece (*plate 79*) by Domenico Veneziano. Very little is known about this artist, and he seems to stand slightly outside the main stream of Florentine art. On the other hand, the St Lucy Altarpiece is clearly one of the major works of the middle of the century, and

in some ways is more subtle than any of those by Angelico or Lippi. It is not known when Domenico Veneziano was born, and he signed himself as a Venetian. The very problematic *tondo* of the *Adoration of the Magi (plate 83)* is often held to be evidence of an International Gothic phase dating from the late 1420s or early 1430s, but the first certain fact is that in 1438 he was in Perugia and wrote to Piero de' Medici, then in Ferrara, to ask for work. His letter is dated 1 April 1438, and the crucial part of it runs: 'I have heard at this time what Cosimo has decided to have done, which is to paint an altarpiece, and that he wants a magnificent work. This gives me great pleasure, and it would please me even more if it were possible that I through your intervention were to paint it, and if that came about I have hope in God to show you wonderful things, seeing that there are there [in Florence] good masters like Fra Filippo and Fra Giovanni [that is, Fra Angelico, whose name in religion was Giovanni], who have a great deal of work to do. And especially Fra Filippo a picture which is to go to Sto Spirito, the which even if he works at it day and night he will not do in five years, so great a work it is. [This is the Barbadori Altarpiece, destined for Sto Spirito.] But, however, the great and good wish I have to serve you, makes me presumptuously offer myself, so that if I were to do it less well than any one else, I should be grateful for every valuable correction to give you every proof that I can do as fine work as any. And if by chance the work were so big, that Cosimo thought of giving it to several masters, or more to one than to another, I beg of you, so that I may as far as possible serve that noble lord, that you will be so good as to use your offices in my favour and to help that I may have some part of it. So that if you knew the desire I have to do some famous work, and especially for you, you would be favourable to me in this. . . .' Presumably, he was successful, because he is recorded as working on some frescoes in Florence in 1439–45, but only a few tiny fragments of these now survive. The most important thing about them that is known is the fact that he had as an assistant Piero della Francesca, who must then have been making his first contact with Florentine works. It is certain that Domenico's unique interests in colour and in the play of light were of fundamental importance in the development of Piero's style, and therefore on all painting outside Florence

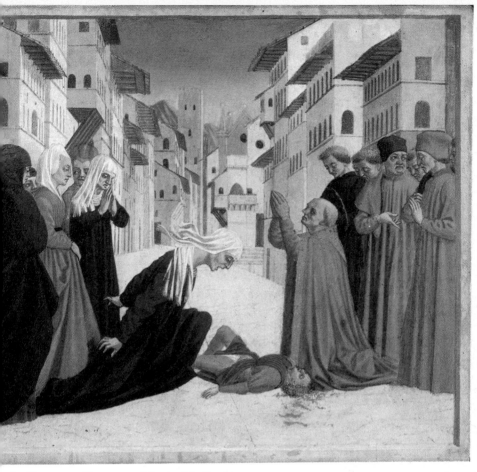

84 DOMENICO VENEZIANO *Miracle of St Zenobius*

itself. Only two works are quite certainly by Domenico; both are
signed. They are the *Madonna* with fragments of two saints, and the
St Lucy Altarpiece, the main panel of which is in the Uffizi and the
predella panels scattered between Berlin, Cambridge, Washington,
and elsewhere.

The frescoed Madonna and two saints—the *Carnesecchi Madonna*
in London—are the surviving fragments of a street tabernacle, so
called from their original site. They probably date from after 1438,
the date of Domenico's letter to Piero de' Medici, which presumably
is a *terminus post quem* for any of his works in Florence. Even its very

bad state of preservation cannot conceal that it is a work of noble simplicity, and the two fragments of heads of saints are direct and broad in treatment. This is an artist with a gift for massing in blocks of light and shadow, for creating large simple shapes which tell through their silhouette and their contrasts of colour. The St Lucy Altarpiece is possibly more clearly organized spatially, with as much care given to the perspective of the architecture, and to the proportions of the figures within it, as any of the Sacre Conversazioni that preceded it; the light is paler, cooler, the colour more limpid. St Lucy's pink gown, St Zenobius's green cope, the Baptist's red shirt, and St Francis's greenish-brown habit, the pink and green tiles in the pavement, the green shadows under the vaulting of the pink arcade, or in the shell-niches behind the throne, all these alternations, picked out with the sharp black marble inlays, and set off by the gentle blues of the sky, the robes of the Madonna, St Lucy, and the Baptist's cloak, give for the first time the impression of a man starting with a composition in colour as much as in form or spatial geometry, and organizing his picture, not for its richness of effect or its variety of movement or emotion, but purely in visual terms, with all else subordinated to that end. In Domenico's work, the organization of masses, and the blond and limpid colour that becomes the hall-mark of Piero is plainly to be seen, but the kind of calm and deliberation they represent had little appeal for the Florentines, since Domenico ended in the workhouse, where he died in 1461. The only other important picture attributed to him is the fresco of *St John the Baptist and St Francis (plate 86)* in Sta Croce, which is totally unlike the early attributed *Adoration* and is very similar to the work of Castagno. It is possible, therefore, that he developed from the International Gothic *Adoration* in the 1420s, through the two signed pictures in the 1440s and 1450s to the harsher, linear realism of the *St John and St Francis* very shortly before 1461. It used to be believed that Domenico was murdered by Castagno, but one of the very few things known with certainty about him is that this is untrue, since he died in 1461 and Castagno died of the plague in 1457. Nevertheless, there may be something in the circumstantial story of a friendship, or at least an acquaintance, between the two men. Castagno was, in some ways, the most important Florentine painter after Masaccio since his rather

ferocious brand of realism, which may be partly responsible for the image of him as Domenico's murderer, is due to the fact that he entirely abandoned the three-dimensional forms and painterly treatment of Masaccio in favour of the linear rhythms of Donatello, which he translated into terms of painting. This linear quality seems to have agreed with Florentine temperament since its development was maintained throughout the rest of the century, and the colour and the light effects of Domenico Veneziano were totally ignored. The date of Castagno's birth is not known, although it has been placed anywhere between the late 1390s and the most usually accepted 1423. He was certainly in Venice in 1442 when he signed and dated some frescoes which he had painted in collaboration with an unknown painter called Francesco da Faenza. From the 1440s until his early death in 1457 he painted numerous works in Florence, including the frescoes of the *Last Supper* and the *Scenes from the Passion*, as well as the *Famous Men and Women* with their elaborate perspective effects. (These were once in the Villa Legnaia outside Florence, but have now been transferred to the Castagno Museum in the former convent of S. Apollonia, for the refectory of which the *Last Supper* (*plate 85*) and the *Scenes from the Passion* were painted.) The *Last Supper*, a traditional refectory subject, is a curious mixture of grandeur and harsh realism, simplicity and elaboration. The room is projected as an eye-level extension of the actual room with the floor, ceiling, and walls covered with patterned marble inlays; the diffused light from windows at the end of the room and from two immediately above the fresco have caused the artist to insert a painted two-light window into the right wall, so that he may use the strongest light and shadow in delineating Christ and the Apostles. The old iconography of Christ, seated centrally, slightly inclined towards the sorrowing St John, with Judas as the only figure on the wrong side of the long table, allows him the most dramatic contrast both visually and psychologically. The strongly marked eyebrows, the heavy lids, the dark hair, the haloes like highly polished metal plates reflecting the heads they crown, the formalized pleats and folds of the draperies, all combine to create a vivid and harsh reality, with the deepest undercurrent of feeling. In Castagno is to be found another facet of the acceptance of Masaccio's unity of form

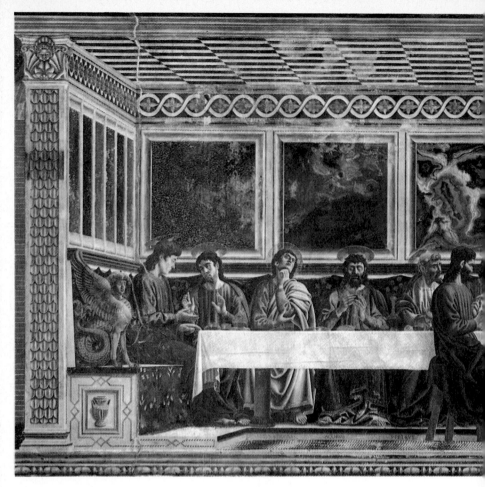

85 Andrea del Castagno *Last Supper*

and setting that governed Fra Angelico's work from the 1440s on-
wards; Castagno uses Masaccesque means only in so far as they can
be made to express an emotional response similar to that surging in
Donatello. The *Scenes from the Passion* are vehement, violent even;
the lighting effects are of a kind never before realized, in that the
crucified Christ is lit from below—from the direction of light from
the real windows; the Christ of the *Resurrection* (*plate 87*) rises
triumphantly, heroically, from the tomb, not with the leaden
struggle of Donatello's last rendering of the scene, but irradiated
and serene, the embodiment of victory. Never before had such

108

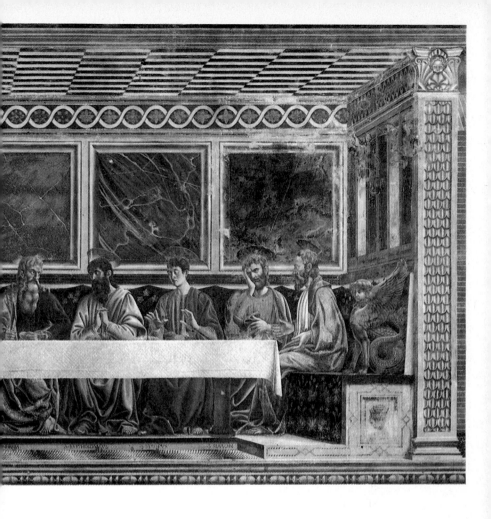

draughtsmanship been seen; no movement is too complicated, no form too difficult, for his strong, wiry line to explore, analyse, and define; no limb in perspective, no group of bodies interlocked, that is not made precisely and perfectly clear; his knowledge of anatomy is purely visual, but he sees with perfect understanding, and his forms have an almost tangible solidity. Nor is his colour always the dark, stormy tone of the *Last Supper*, for the splendid single figures of the *Famous Men and Women* glow with light and brilliance against their dark, painted marble niches. The allusion to Donatello's *St George* in the warrior *Pippo Spano* (*plate 93*), and to the disputing prophets of

86 DOMENICO
VENEZIANO
*St John the Baptist
and St Francis*

the Old Sacristy doors in the confrontation of *Dante* (*plate 88*) and *Petrarch* cannot be accidental, and in his last dated work, the frescoed equestrian figure of Niccolò da Tolentino (*plate 92*), painted in 1456 in the cathedral as a pendant to Uccello's painted memorial to Sir John Hawkwood (*plate 91*), the effect of Donatello's *Gattamelata* is both obvious and intended to be so. More flamboyant than Donatello's statue—it had to be to make an impact despite its being a mono-chrome painting—eccentric in its perspective (the sarcophagus is seen from a quite different position from the horse and rider surmounting it), it remains in every sense of the term painted sculpture.

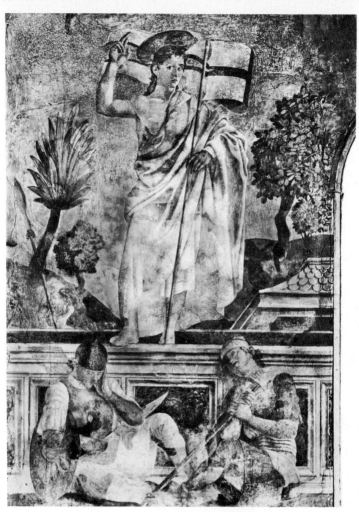

87 ANDREA DEL
CASTAGNO
Resurrèction

The most difficult of Castagno's works is the *Assumption* (*plate 90*),
known from documents to have been painted by him in 1449–50,
but it is not impossible that the strange composition of the Virgin
rising from her rose-filled tomb in a *mandorla* like a brilliant sunset
borne by four half-sized angels, and flanked by the easy, even noncha-
lant, figures of St Julian and St Miniato, was partly dictated by the
commissioner, for the tiny angels are highly reminiscent of Inter-
national Gothic, while the drawing of their bodies and draperies is
Castagno at his most energetic and uncompromisingly modern.
There might here be a point of contact with the early *Adoration*

88 ANDREA DEL CASTAGNO *Dante*

89 UCCELLO *Deluge*

believed to be by Domenico Veneziano, but against this there is the fact that the sky in the *Scenes from the Passion* contains six angels, distraught with grief, of the same half-scale type, and that the great Florentine model for an Assumption is the sculptured *Porta della Mandorla* of the cathedral, where the use of the traditional small angel is also to be found. The survival of International Gothic systems would not be so surprising if the artist were not so advanced in other respects.

The other major painter of this generation was Uccello, who was actually the oldest, since he was born in 1396/7 and lived until 1475. He worked on Ghiberti's first baptistery doors from 1407, and was therefore trained in the International Gothic style which appears to have been his true spiritual home. He is known to have entered the Painters' Guild in 1415, but no pictures by him are known for something like fifteen years after that. In 1425 he went to Venice, and worked on the mosaics of St Mark's for about five years, which means that he was out of Florence during the creative years of Masaccio's life. When he returned about 1431 he seems to have worked in a somewhat Masolinesque style, but during the 1430s he became fascinated by the new ideas in perspective and foreshortening, although he never really mastered the full implications of the system,

113

90 ANDREA DEL CASTAGNO *Assumption*

which became for him, eventually, no more than another form of elaborate pattern-making. Even when the impact of the new ideas was fresh, his treatment of them was quite arbitrary, as can be seen in the monochrome fresco in the cathedral of the equestrian figure of the *condottiere* Giovanni Acuto—who was in reality an English adventurer, Sir John Hawkwood—painted in 1436 (*plate 91*). This has two separate viewpoints, one for the base and another for the horseman (a system which Castagno later followed); a similarly irrational approach was also used in his *Four Heads of Prophets* of 1443 in the roundels in the corners of the clock of Florence Cathedral.

Recent careful restoration has made it possible to see his most famous work, the *Deluge* (*plate 89*), painted largely in greenish

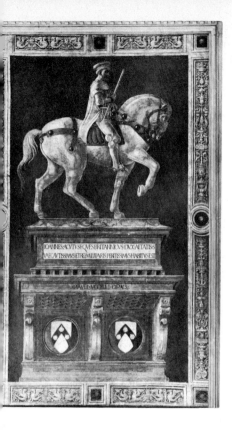

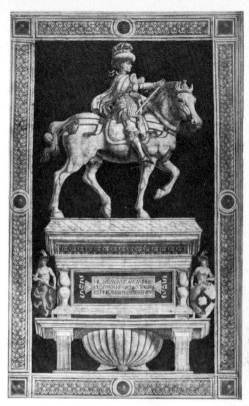

UCCELLO *Sir John Hawkwood Memorial*

(above right) ANDREA DEL CASTAGNO
Niccolò da Tolentino Memorial

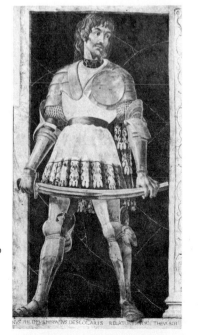

93 ANDREA DEL CASTAGNO *Pippo Spano*

monochrome in the cloister of Sta Maria Novella about 1445. The importance of monochrome, and its corollary, the very great stress on the kind of light and shade effects that produce the extremes of relief in a painting, as in Castagno's heads, are not only derived from the Florentine feeling for sculptural form, but also stem directly from Alberti's analysis of what is most desirable in painting. In *Della Pittura*, his essay on painting which circulated from about 1435 onwards, he advocates the use of monochrome: 'But I should like the highest level of attainment in industry and art to rest . . . on knowing how to use black and white,' and his further comment 'I almost always consider mediocre the painter who does not understand well the strength of every light and shade in each plane. I say the learned and the unlearned praise those faces which, as though carved, appear to issue out of the panel, and they criticize those faces in which is seen no other art than perhaps that of drawing', goes a long way towards explaining why Domenico Veneziano had so little success. Uccello takes Alberti quite literally, not only in the use of monochrome, but in the way in which he manages the draperies of his figures and includes the head of the wind-god to explain the gale that blows among them: '. . . It would be well to place in the picture the face of the wind, Zephyrus or Austrus, who blows from the clouds making the draperies move in the wind. Thus you will see with what grace the bodies, where they are struck by the wind, show the nude under the draperies. . . .' Another of Alberti's *dicta* which probably contributed towards producing the pictorial confusion which later afflicted Florentine painting is to be found in his commendation of abundant variety of detail: '. . . copiousness and variety please in painting. I say that *istoria* is most copious in which in their places are mixed old, young, maidens, women, youths, young boys, fowls, small dogs, birds, horses, sheep, buildings, provinces and all similar things.' It is true that he recommends a certain moderation, and goes on to blame '. . . those painters who, where they wish to appear copious, leave nothing vacant. It is not composition but dissolute confusion which they disseminate. There the *istoria* does not appear to aim to do something worth while but rather to be in tumult', but only too often his counsels were followed and his caveats ignored, so that eventually chaos ensued.

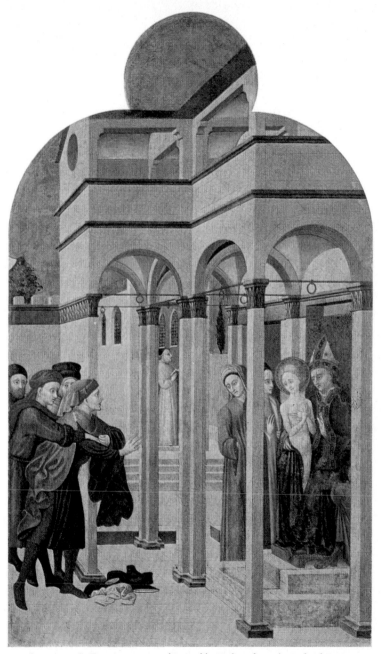

94 SASSETTA *St Francis renounces his earthly Father, from the Life of St Francis*

Uccello's three big battle pieces, painted about 1454–57, are conceived as decorative patterns first and last (*plate 95*). They certainly follow the advice about copiousness, for the field is littered with horses, riders, lances, corpses, pieces of armour, and the hill-side beyond the rose-hedge is covered with the variegated shapes of fields dotted with little soldiers running about. The rocking-horse chargers bear riders in superbly patterned clothes, the lances and banners stress the tapestry effect, and the colour is as irrational as the composition is fantastic. This becomes the keynote of his late works: the *Hunt* and the extraordinary predella commissioned by the Confraternity of the Holy Sacrament in Urbino, which was painted between 1467 and 1468 and recounts the story of the profanation of a Host, stand quite apart from painting of the period, and in their fantasy parallel the marvellously complicated perspective drawings of facetted goblets and *mazzocchi* (a wooden framework for supporting the elaborate hats favoured by the dandies of the day) on which he is said to have passed his midnight hours. In 1469, in filling in his tax return, he declared: 'I am old, infirm, and unemployed, and my wife is ill.' Despite the influence of Uccello's late works on the decorative painters of the period, by the 1460s and 1470s two things had happened: firstly the moment of gentle and rather sweet pictures like Fra Filippo's *Nativities* had passed, and secondly the younger men were interested in problems of anatomy and movement that could best be solved in terms of the rather harsh linearism which was the heritage of Castagno and Donatello.

Outside Florence four separate strands have to be followed: Siena, where the main currents are derived from Florence; Central Tuscany and Urbino with Piero della Francesca; Padua and Mantua with Mantegna; and Ferrara, where the line of development ran through the Padua of Donatello and Mantegna, and reflected the influence of the lost Ferrarese works by Piero.

During the fourteenth century, Siena had been as great a fountain-head as Florence itself; the influence of Duccio, of Simone, and the Lorenzetti was as decisive in Florence as it had been in Siena, and even more so, for it was their style that determined the course of late fourteenth-century painting in Florence, and that spread far and wide across Europe to return eventually transmuted into the courtly

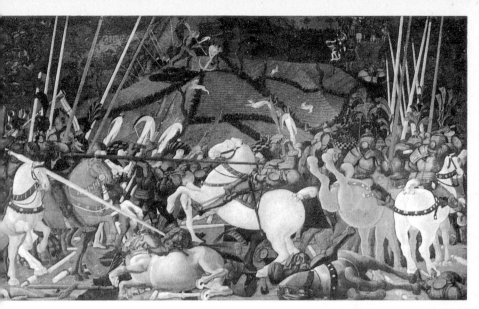

95 UCCELLO *The Rout of San Romano*

grace of International Gothic. In the fifteenth century it was Floren-
tine art that determined the developments in Siena. Domenico di
Bartolo (*c.* 1400–47), in the *Madonna of Humility* dated 1433, reflects
Masaccio and Donatello, and in his big fresco cycle (painted 1441–44)
in the Spedale della Scala, where he describes with a wealth of cir-
cumstantial detail the succouring of the poor and the care of destitute
children, his development takes much the same line as Fra Filippo's
did, starting from the same premises. Sassetta (*c.* 1400–50) and
Giovanni di Paolo (1403–83) retain the imaginative subtlety of
colour, and the slender, elegant forms of the Trecento masters, but
adopt Florentine perspective systems, though often with a distinctly
wayward reflection of the reality their use implies. In Sassetta's series
(1437–44) of the *Life of St Francis* (*plate 94*) the narrative is really
made no clearer by the attempts at a logical setting, for the haunting
loveliness of each of the scenes lies in the use of pattern, of magical
colour, of delicate detail, and of the expression of mood. Giovanni
di Paolo's realism is of the same etherealized order. His blessed in
Paradise have come straight from an elegant Burgundian Court fête;
St John entering the Wilderness (*plate 97*), from a series painted

probably just after the mid century, goes into a fantasy world where scale, proportion, representational form, and colour are abandoned for the creation of dream world more real, because more important than the everyday world. Sano di Pietro (1406–81) modernizes only slightly the graceful, tender Madonnas of the previous century, and debases their richness of feeling into a tedious, standardized production of pious imagery. Vecchietta (*c.* 1412–50) achieves, perhaps, the greatest versatility for he was both painter and sculptor, but his painting is that of a tardy follower of Simone Martini influenced by Fra Angelico, and his sculpture, which displays with ability the Sienese art of wood-carving, is an offshoot of the realism of Donatello, watered down by the traditional elegance of Sienese art. Matteo di Giovanni (1435–95) closes the century. He, too, continues the simple, pious type of Madonna image, and he, too, looks to Florence for new ideas to bring his traditional art up to date. His huge *Assumption* (*plate 96*), probably of about 1475, shows that he found them in an unexpected combination of the search for movement and energy of form of Castagno and the tender colour and grace of Angelico. What he does contribute is the beautiful idea of the angels hovering as if in a celestial ballet while they play their musical instruments, an idea which later develops into Botticelli's skein of circling angels revolving with breathless speed and incomparable grace.

Piero della Francesca was born in the decade between 1410 and 1420, most probably round about 1416. Nowadays, he is perhaps the most highly regarded of all the fifteenth-century painters; this was certainly not so in his lifetime and after, and for centuries his great masterpiece, the fresco cycle in the Church of S. Francesco at Arezzo, was almost entirely neglected. It can be argued that the admiration now felt for him is largely due to the conditioning of modern aesthetic appreciation by the discipline of Cubism, for the serenity and calm of his art, obtained by large, simple, geometrical shapes and pale, flat colours which to earlier eyes seemed unrealistic, and a certain austerity of sentiment, make him now far more popular than Fra Angelico or Fra Filippo or even Botticelli, all of whom were so much admired in the nineteenth century. Piero's lack of fame in his own generation was partly fortuitous, since the *Life* by Vasari shows

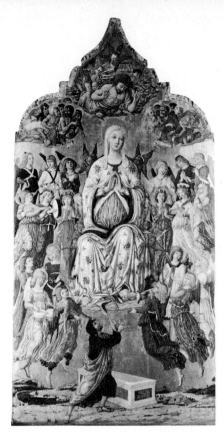

96 MATTEO DI GIOVANNI *Assumption*

that he was regarded as an important figure, and, in particular, as one
who had done a great deal towards the codification of perspective.
Vasari, however, came from Arezzo, and it is likely that he was
predisposed to favour Piero as, almost, a fellow townsman. Much of
Piero's obscurity was due to the fact that he never worked as a mature
painter in Florence, that he was hardly influenced by Florentine ideas,
that he seems deliberately to have sought to remain in the retirement
of his native hill-town of Borgo San Sepolcro, and that most of his
best works were executed either there or in Arezzo, with the great
exception of the works he did for the Montefeltro at Urbino, and the
lost frescoes in Ferrara and Rome. He was in Florence in 1439, but
only as an assistant to Domenico Veneziano on the large fresco cycle
in the Hospital of Sta Maria Nuova, the loss of which has left one of

97 GIOVANNI DI PAOLO *St John entering the Wilderness*

the great gaps in fifteenth-century Florentine painting. In 1442 he was back in Borgo and was made a town councillor, which suggests that he was better educated than one might have expected of a fifteenth-century painter. His choice of Domenico Veneziano as a master was singularly fortunate, since Domenico's study of light and his interest in colour made him the ideal teacher for Piero, and indeed the small predella panel of the *Miracle of St Zenobius* (*plate 84*) might almost have been painted by Piero. Or was the choice of Domenico Veneziano fortuitous? Did he rather deliberately seek out a master who was a non-Florentine, and was not his own artistic background Sienese rather than Florentine?

The altarpiece of the *Life of St Francis* by Sassetta, the subsidiary parts of which included *St Francis renounces his earthly Father* (*plate*

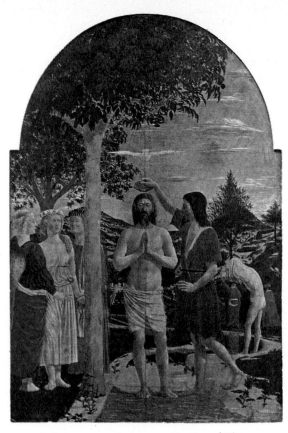

98 PIERO DELLA FRANCESCA *Baptism of Christ*

94), was painted for the church at Borgo between 1437 and 1444, and
it was laid down in the contract that the picture should be painted in
Siena and sent to Borgo; the very choice of a Sienese rather than a
Florentine painter suggests that in art the affiliations of Borgo were
with Siena rather than Florence, and this is also supported by the fact
that Matteo di Giovanni, whom no one would ever think of except
as a pure Sienese painter, was actually born in Borgo. Moreover,
when Piero came to paint the big polyptych commissioned by the
Confraternity of the Misericordia in Borgo in 1445, he designed it
in the old-fashioned form of a central Madonna flanked by saints,
each in his individual panel, like the Sassetta Altarpiece and very
much closer to the type of Masaccio's Pisa Polyptych, rather than in
the newer form of the Sacra Conversazione, which he must have

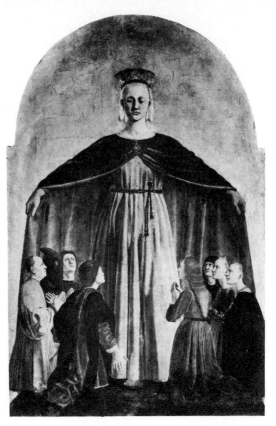

99 PIERO DELLA FRANCESCA *Madonna of Mercy*

encountered in Florence. If a hint of the new type exists in what is
frankly a very old-fashioned design, it is in the kneeling circle of the
members of the Confraternity sheltering under the Madonna's cloak
(*plate 99*). The final payments for this picture were not made until
1462; this may mean that the stipulated three years for its execution
were exceeded by a large margin, or merely that the Confraternity
paid by instalments, but the presence of St Bernardino, in the panel
on the far right, suggests that completion of the work was delayed
beyond 1450, since the saint was only canonized in that year. Very
much stronger connexions with Sienese painting can be adduced
from the *Baptism of Christ* (*plate 98*), yet, equally, these links are as
much with Domenico Veneziano. The solemn nobility of the figures,
the confrontation of absolute frontality with absolute profile, the

stressing of the column-like figure of Christ by its juxtaposition with the bole of the tree, the majesty and repose of the three angels, these are Piero's own inventions, distilled from his own temperament and his understanding of Masaccio. The pale, bright colour, the evenness of the light which suffuses all the forms yet casts almost no shadows, these stem surely from Domenico, just as the neophyte struggling out of his shirt and the detailed landscape background stem from Florentine example. The picture probably dates from the 1440s, since the theme of the fantastic hats worn by the robed figures in the background is derived from the representatives of the Greek Church who came to Florence for the Council of Florence held in 1439; the impression made by these exotic figures and by the Byzantine Emperor himself was reflected in many works of art produced about the middle of the century.

The frescoes which he painted in Ferrara early in the 1450s have unfortunately not survived; the fresco portrait of Sigismondo Malatesta, painted in S. Francesco, Rimini, is much restored; the next major work is the cycle of frescoes which he began about 1452 in S. Francesco, Arezzo, depicting the Story of the True Cross. The narrative is highly complicated, since it is based on at least two different stories in the Golden Legend, and Piero has treated it in such a way that the events are represented out of sequence for aesthetic reasons, so that, for instance, the two battle scenes face each other in the bottom row on either side of the choir. This passion for symmetry can be seen many times: in the division about a central axis of such scenes as the two with the Queen of Sheba, those of the *Finding of the True Cross (plate 100)*, its *Restoration to Jerusalem* and the *Annunciation*, and in the reiteration of the contrast between figures full face and those in profile. And with this quest for symmetry goes the insistence on stillness. Even in the plunging angel in the *Dream of Constantine (plate 102)*, or the tightly packed chaos of the battle scenes, the rejection of movement, and of the drama of extreme gestures or of facial expressions, remains constant. Neither is there any attempt to persuade the spectator to look into the depth of the wall, or to treat the fresco as a window on to a distant pictorial space; simple flat forms and the pale even colours stress the plane of the wall. This is in sharpest contrast to the trend typified by

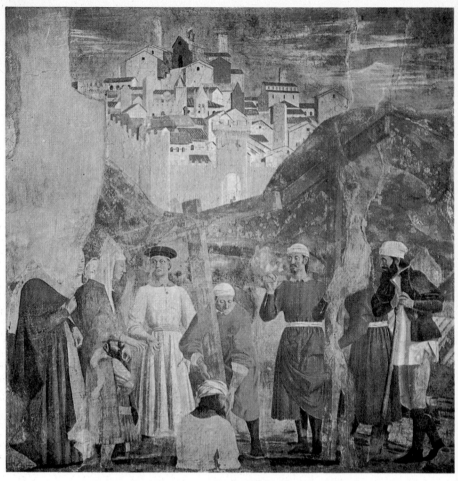

100 PIERO DELLA FRANCESCA *Finding of the True Cross, detail*

Fra Filippo, whose Prato frescoes are of exactly the same date. In them the search for movement and drama impedes the narrative, and confuses the spectator by opening infinite perspectives within what common sense declares must be a flat surface. There is no stylistic change in Piero's frescoes, despite the years over which the work extended. The widening of his artistic horizons implied by a journey to Rome, where he is recorded in 1459 in the Vatican working on some frescoes which disappeared without trace, is suggested only by the battle scenes which derive from Roman battle sarcophagi; there is, however, a clear reminiscence of Agnolo Gaddi's frescoes on the

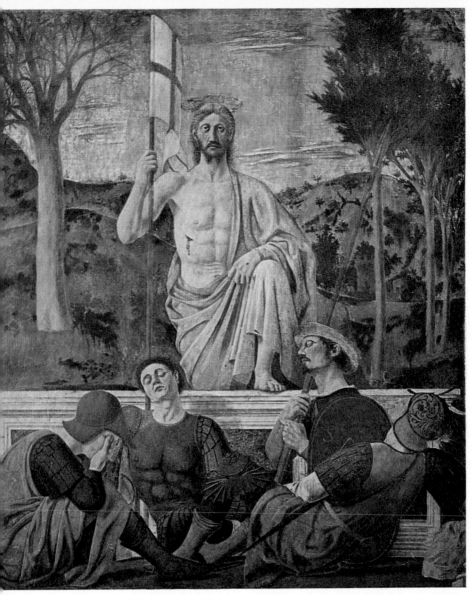

101 PIERO DELLA FRANCESCA *Resurrection*

same subject in Florence in the *Dream of Constantine*, where the night
scene with the sleeping Emperor exploits the same light effect.

It was probably at the end of his work at Arezzo that Piero painted the *Resurrection (plate 101)* at Borgo. Basically, it is the same composition as Castagno's *Resurrection (plate 87)*, but Piero stresses the frontality more than Castagno does, makes his landscape background more explicit, more local, than Castagno's stylized shrubs, places his rising Christ deeper into the tomb so that His movement is more deliberate, more inward, and so designs the tomb itself that it becomes like an altar with, therefore, overtones that the Castagno's perspective effect misses. The early morning light is pearly, the thin air sharpens the forms, the sleeping soldiers slump uneasily, pointing the contrast between unawakened humanity and the effulgent moment of salvation that passes unheeded.

102 Piero della Francesca
Dream of Constantine

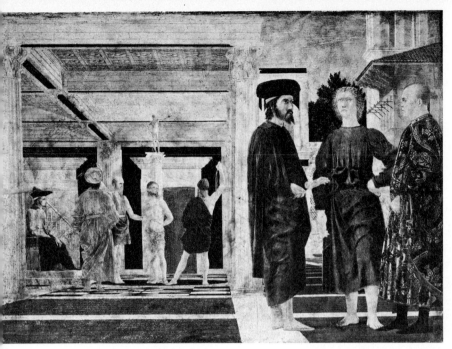

103 Piero della Francesca *Flagellation*

Signed works are very few. One of them is the *Flagellation*, which dates from the late 1450s or early 1460s, and which may be connected with Piero's stay in Urbino, the chief fruits of which were the double portraits of the Duke and Duchess, the large *Madonna and Child with Saints and Angels*, and his considerable researches into perspective. The *Flagellation* (*plate 103*), a small panel, painted with great richness of colour and the most painstaking technique, is iconographically a mystery. The likeliest explanation of the three figures—so much more prominent than the actual subject—is that they are witnesses, like the three voices singing the Passion on Good Friday, or the commentators in a Passion Play, such as the one performed in Florence in 1439. Pictorially, the painting has the same kind of symmetrical composition as the *Queen of Sheba* scenes at Arezzo, and the consistent use of frontality. This also pervades the double portraits (*plates 104, 105*), which date more probably from about 1472 than the 1465 formerly suggested on rather slender grounds. The Duchess died in 1472, and it is possible that her portrait is a commemorative one. Both

129

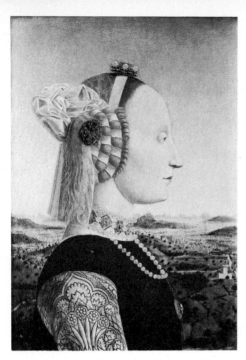
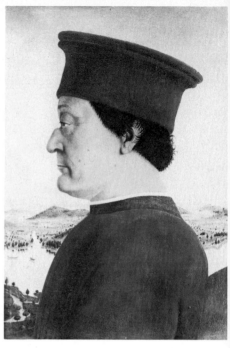

104 PIERO DELLA FRANCESCA
The Duchess of Urbino

105 PIERO DELLA FRANCESCA
Federigo da Montefeltro, Duke of Urbino

portraits have a markedly Flemish character, except in so far as the profile portrait, a descendant of the Roman portrait medal, had long been superseded in Flanders by the more realistic type of three-quarter face view. But for Piero's hieratic purpose, and for an artist of his temperament, the profile suited his purpose best, not only for stylistic, but also for practical reasons: Federigo of Montefeltro had received a serious and very disfiguring facial injury which involved his right eye and had distorted his nose. Clearly, the portraits owe something to the interest taken for some time past in Flemish oil-painting technique in Italy in general, but in Urbino in particular, for Joos van Ghent came to work there in 1473/74 on a commission which had originally been offered to Piero himself. It must have been here at Urbino that Piero discussed perspective and mathematics with Alberti, and probably also architecture; it is also possible that Bramante, born just outside Urbino in 1444, was his pupil at this time. The mysterious picture of a town in elaborate perspective, still in the palace at Urbino, must be by Piero and is certainly inspired by Alberti's ideas.

During this time he was working on a large altarpiece for the Augustinian church in Borgo, commissioned in 1454. Originally the polyptych must have consisted of a Madonna and Child enthroned in the centre panel with two saints on either side, and with six small panels of half-length saints at the edges, and a predella below, of which the *Crucifixion* alone seems to have survived. The four main panels of saints have been identified as those in Lisbon, London, the Frick Collection in New York, and the Poldi-Pezzoli Museum in Milan, and three of the six half-length figures have also been identified. Like the earlier altarpiece for Borgo, this one dragged on for a long time, for it was not finally paid for until 1469; it appears to have been broken up in the mid-sixteenth century. Piero's latest style is in sharp contrast to the very old-fashioned form of the altarpiece, and displays a mastery of Flemish technique and a concern for a highly detailed finish. Yet, this interest in the lesser qualities of painting in no way affected the simplicity and grandeur of his conception of masses, and the changed technique, although it imparted a great richness to his colour, hardly influenced his cool, limpid tones. His last two pictures are the large Sacra Conversazione in the Brera in Milan which can be dated about 1475 or slightly earlier, and the unfinished *Nativity* which seems to have been among his effects at his death. Both these pictures show marked Flemish influence. This is particularly strong in the *Nativity* (*plate 107*), where the choir of angels sings, mouths open, and the Madonna kneels adoring the naked Infant lying on the skirt of her robe on the ground before her. The Portinari Altar by Hugo van der Goes, which arrived in Florence about 1475, has been suggested as a possible source for, or reinforcement of, this Flemish influence, but this would necessarily imply that Piero revisited Florence after that date. Being unfinished, it is particularly useful as an example of his technique.

The Brera Altarpiece (*plate 106*)—The *Madonna and Child with angels, and six saints, adored by Federigo da Montefeltro*—is still more important, for it is one of the earliest of the fully developed type of the Sacra Conversazione with an architectural setting which is treated as a continuation of the actual architecture of the chapel in which it was set, thus creating a spatial setting involving the spectator within the compass of the altarpiece. This was a form developed by

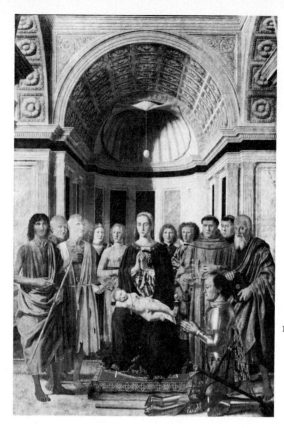

106 Piero della Francesca *Brera Altarpiece, Madonna and Child with angels and six saints, adored by Federigo da Montefeltro*

Antonello da Messina and Giovanni Bellini in Venice during the same years in the middle of the decade, but of the two works of this type which parallel the Piero, the Antonello has survived only in fragments, and the Bellini, burnt during the nineteenth century, is known only from inadequate copies. The composition presents several unusual features besides this new spatial concept. The scene is the crossing of a small church, with a flood of light coming from a dome just beyond the upper edge of the picture, with transepts opening out on either side, and the Madonna and Child seen against the background of the choir, with an egg—probably a symbol of eternity—suspended over them. The horizontals are strongly marked, from the Duke's baton and gauntlets upwards through the line of the dais continuing the feet on either side, the arm and hand of the Baptist pointing to the Child and continued through the praying hands of the Duke, the even line of heads, the strongly marked frieze

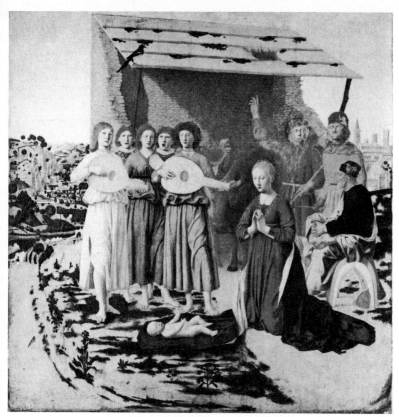

107 Piero della Francesca *Nativity*

of the architrave to the final closing line of the triple cornice mould-
ing over the coffered vault, and these are all intersected by equally
strong verticals running through the figures and the panelling of the
architectural setting. There is also the question of the portrait of the
Duke. It has been claimed that his hands, and to some extent his
head, are in a more minutely detailed style than the rest of the
picture, and for this reason these parts have been attributed to a
Spanish painter, Pedro Berruguete, who is supposed to have been
working in Urbino in 1477, and who is thought to have painted the
twenty-eight figures of Philosophers which at one time decorated
the Duke's study in the palace at Urbino. There seems, however, to
be little reason for this extra elaboration of authorship.

At this time Piero was much interested in mathematics and in their
application to perspective. He wrote two treatises, one on the Five

Regular Bodies, a dissertation on pure mathematics, and the other a treatise on Perspective in Painting. So far as can be ascertained, Piero continued painting up to at least 1478, but in the last fourteen or fifteen years of his life he does not seem to have painted anything, and the last document referring to him records his death in 1492. It is said that he was blind in his last years, but his will drawn up in 1486 contains the usual phrase about being sound in mind and body; there is also a note which appears to be in his handwriting attached to the will, and some notes in one of the treatises also appear to be autograph. The classic tendency of his art derives from the cast of a mind obviously in sympathy with Alberti, and to which the more common form of an impassioned curiosity in the actual details of Roman antiquities made little appeal. This aspect of classicism was that adopted by his younger contemporary, Andrea Mantegna, whose response to the details of classical archaeology stimulated his extremely romantic interpretation of the past.

Mantegna was probably born about 1431, which makes him the contemporary of Antonio Pollaiuolo, and also of his brother-in-law Giovanni Bellini, who may have been a year or so younger. He grew up in Padua, where Donatello's Santo Altar (*plate 35*), and the classically inspired *Gattamelata* (*plate 32*), were formative influences on him while he was still in his 'teens. His early interest in Antiquity was partly the outcome of his relationship to Francesco Squarcione (1397–1468), an archaeologist, and probably a dealer in antiquities, as well as a painter, who had travelled in Greece as well as in Italy. Only two works by Squarcione are known: a signed *Madonna* which is in Berlin and an altarpiece in Padua, finished in 1452. These are close to Mantegna in style, probably because both artists took as their starting-point a combination of Donatello and classical sculpture. Squarcione seems to have been a difficult character, and Mantegna himself was equally prickly. Certainly they quarrelled violently, and a lawsuit finally terminated the apprenticeship and also the adopted-son relationship between the two men. Mantegna was extremely precocious, since he is known to have been working on the important fresco cycle in the Ovetari Chapel in 1448, when he was only about seventeen—at the same time, that is, that Donatello was working on the Santo Altar.

134

Padua was the great university city of the north of Italy, and deeply interested, in the second half of the fifteenth century, in the study of Latin and Greek literature, and in the life of the antique world. As a result of living in this atmosphere the natural austerity of Mantegna's taste was channelled into archaeology, and his response to the rational and Humanist ideas of Donatello was reinforced by an interest in the exact details of classical Antiquity of an intensity to which Donatello himself seldom aspired.

In 1454 Mantegna married Giovanni Bellini's sister. The currents of influence worked both ways, and while his classicism and his illusionistic interests were introduced into Venice, in Bellini's hands they were much softened and humanized.

His frescoes in the Ovetari Chapel in the Church of the Eremitani were almost entirely destroyed in 1944, but photographs of the complete cycle exist. Mantegna worked there during two different periods, at first on some of the vaulting frescoes and on the left wall, which contained, by him, four scenes from the life of St James taken from the *Golden Legend*, and later on the right wall, where only the lowest fresco of the *Martyrdom of St Christopher* is by him. The apse has an *Assumption* by him, and the commissioner's objections to it ended in a lawsuit, so that a great deal of knowledge about the artist and the progress of the work is derived from the evidence given in court. Only the *St Christopher* and the *Assumption* have survived. The four frescoes of the Life of St James are arranged in two tiers; the top two of *St James baptizing Hermogenes when on the way to Martyrdom* and *St James before the Judge* form a pair balanced about a central void. The perspective is based at the eye-level of a spectator imagined to be immediately in front of the frescoes (that is, suspended in mid-air before them); the lower pair have the line of sight at the foot of the fresco, so that *St James on the way to Execution* (*plate 109*) and the *Martyrdom of St James* (*plate 108*) are seen in much sharper recession. There are also virtuoso tricks played with the spectator's relation to the world within the fresco, since in the *Martyrdom* one of the soldiers leans over the wooden railing which apparently delimits the most forward plane of the picture space, and thus impinges upon the spectators' world. All the frescoes contain evidence of what was to become one of Mantegna's main obsessions:

his passion for archaeological exactitude, for the armour and the triumphal arches are obviously correct down to the last detail. In fact, so accurate was he as a recorder of classical remains that one of the inscriptions recorded in the *Corpus Inscriptionum Latinorum* is included in it solely on his evidence. The hardness of his forms derives very largely from Donatello, but he was certainly conditioned to this type of vision by Squarcione, who is also the source of the garlands, often with *putti* disporting themselves among them, not only in Mantegna, but in many other Paduans. His colour veers unexpectedly between the extraordinarily intense and an almost monochromatic subtlety, his handling of detail is almost painfully precise, as in the lines and creases of his facial expressions, or in the clinging and convoluted folds of his draperies. The influence of Donatello is not only formal; the reliefs of the Santo Altar also governed Mantegna's creation of consistent pictorial space and his use of rather sharply inclined foreshortening to create dramatic effects. These stylistic features appear slightly modified in the *Martyrdom of St Christopher* on the opposite wall, which was probably completed by 1457. In it, the two sections of the narrative are united by a common architectural framework. Despite the terribly damaged state of the fresco it is still possible to see that the handling has become a little more mellow.

Between 1456 and 1459 Mantegna painted the large altarpiece for the Church of S. Zeno in Verona (*plate 110*), which is one of the decisive breaks with the older type of polyptych, and continues the development begun in Florence of the Sacra Conversazione in a unified *pala*. Mantegna's link with this development is patently through Donatello, and the source of the inspiration was the high altar of the Santo, which used in bronze the painted form of the Sacra Conversazione that was just being evolved in Florence when Donatello left for Padua in 1443. The Madonna sits dreamily upon a high throne, clustered about with musician child-angels, and in the panels on either side stand her attendant saints, reading or talking among themselves. A common architectural framework unites the three panels in the form of an open loggia through which a rose-hedge and the sky appear. The three panels are both divided and united by the frame, which completes the loggia by becoming

136

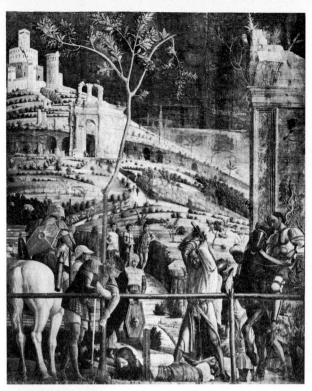

108 MANTEGNA
Martyrdom of St James

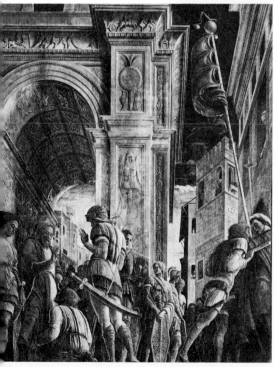

109 MANTEGNA
*St James on the way
to Execution*

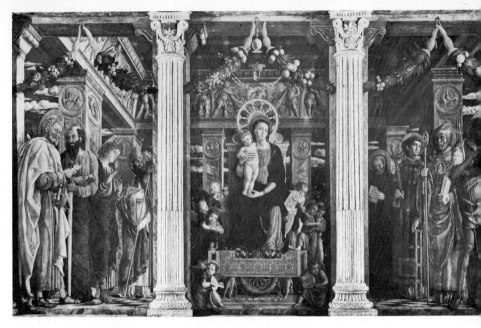

110 MANTEGNA *S. Zeno Altarpiece*

virtually its foremost member, each of the pilasters of the frame being echoed by a painted one within the picture space, and from the front architrave hang garlands of leaves and fruit, stretching across from one panel to the next. The multiplicity of minute detail in the sculptured frieze and the roundels on the piers, the draperies, the elaborate throne, recall the concern with all-over finish that becomes so strong a feature of Florentine painting. He is not interested in light, beyond creating an even illumination with just sufficient direction to it to make the picture space and the position of the figures within it logical and immediately clear. His tendency to make his flesh tones so cool and his forms so harshly detailed that they appear to be of stone or metal can be seen in the Louvre *Crucifixion*, which once was one of its predella panels, and in the *St Sebastian* in Vienna which Vasari actually described as being 'in his stony manner'. This offers a curiously moving combination of rather arid archaeology and Christian pathos, in the contrast between the suffering martyr and the ruined classical triumphal arch; similar ideas pervade the other, huge *St Sebastian* in the Louvre, and the very slightly smaller one in Venice which, much simpler,

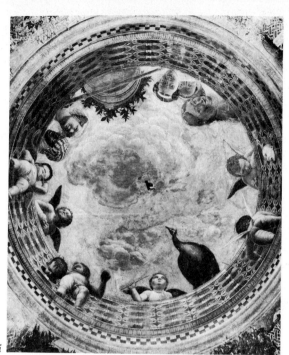

III MANTEGNA
*Ceiling of the
Camera degli Sposi*

omits the classical overtones and concentrates on the pathos of suffering, with the motto *Nihil stabile est nisi divinus*.

In 1460 Mantegna settled in Mantua, as Court Painter to the Gonzaga, and in the palace there he painted the *Camera degli Sposi*, a cycle which was completed in 1474, and, according to the inscription, seems to have been as much for his own as for their glorification. It is the first completely consistent illusionistic decoration of the Renaissance, since two walls are covered with frescoes representing events connected with the Gonzaga family, painted in such a way that the fireplace and the other architectural elements of the room are incorporated in the composition. The scene with the family surrounding the ruler and his wife, which is painted over the fireplace, appears to have the figures actually standing and seated upon the mantelpiece, which is thus converted into a dais, and the leather curtains which were part of the original hangings of the room are echoed in the painted curtains that close off some of the scenes. The ceiling is the most surprising part of all, for it apparently opens to the sky beyond a balustrade over which figures lean and peer down into the room (*plate 111*), and the final touch of illusion is

given by three small *putti* perched on the wrong side of the balustrade, and by a tub of plants, balanced on a bar and projecting into the void, immediately above the spectator's head. This the first foray into complete illusion in interior decoration; it lay fallow for nearly a half-century, possibly because it was in the private part of the palace, and it was not until the sixteenth century that perspective illusionism of this *di sotto in sù* type became one of the elements of the decorator's art. One of the other frescoes has a very fine landscape background, behind the figures of the Marquis greeting his son Francesco, arriving from Rome as a newly created Cardinal (*plate 113*). The hardness of the forms is here slightly softened, and the extreme use of pure frontal and profile poses recalls something of Piero's treatment of groups. Also painted for the Gonzaga Court, between about 1486 and 1494, were the *Triumphs of Caesar*, which are probably Mantegna's most complete characterization of the antique world. They are less illusionistic and their purpose is now obscure, except that it is known that they served, on one occasion, as scenery for a Latin play. They have always been one of the greatest treasures of the Royal Collection at Hampton Court, but have unfortunately suffered much from injudicious restoration. By this time Mantegna was Court Painter, not to the potentate for whom he had come to Mantua to work, but to his grandson, and it is this Francesco who kneels before the throne in the *Madonna of Victory* painted to celebrate the inconclusive battle of Fornovo in 1495, in which Francesco claimed to have defeated the invading French. Again, this picture shows Mantegna's effective use of foreshortening for dramatic effect, and represents another stage in the history of the Sacra Conversazione, since it uses the curious device of the human figure on a smaller scale than the sacred ones, and also reflects the Bellinesque as well as the Ferrarese forms which had developed partly from his own earlier contribution to the theme. By far and away the most powerful of all his perspective effects is the famous *Cristo Scorto* (*plate 112*), which represents the dead Christ in extreme foreshortening. This strange picture was found in his studio after his death in 1506, together with the 'Nihil stabile est . . .' *St Sebastian*; the two pictures may well explain why, in his later years, he had something of a reputation as a recluse, and also give the lie to the

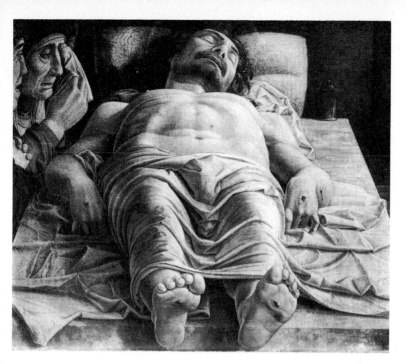

112 MANTEGNA *Cristo Scorto, the Dead Christ*

facile judgment that an extreme interest in, and love of, classical antiquity was incompatible with the most deeply sincere Christianity.

Ferrara, as an artistic centre, had an extremely short life. Despite the prosperity of the state, and the relative peace which crowned the astute and ruthless policies of its Este rulers, no particular interest in the arts was manifested there before the middle years of the fifteenth century, and by the end of the century it had relapsed into artistic insignificance. Its earliest artists came from outside: Pisanello and Jacopo Bellini in the first phase, and Piero della Francesca in the second. It was principally from the now lost Piero frescoes, executed about 1450, that the greatest impulse sprang, and the influence of Mantegna came to reinforce the austerity of Piero and to stimulate what appears to have been a natural inclination towards the craggy and spiky, the hard metallic outline and glittering surface, a blend of the primitive and the highly sophisticated that makes so special an appeal to the twentieth century. The four main painters who form the school were Cosmè Tura, who was born before 1431 and died

in poverty in 1495 after being superseded as Court Painter by Ercole de' Roberti; Francesco del Cossa, born in 1435/36, who abandoned Ferrara for Bologna, where he died probably in 1477; Ercole de' Roberti, born between 1448 and 1455, who may possibly have worked with Cossa in Bologna before settling in Ferrara and displacing Tura in 1486; and Lorenzo Costa, born in about 1460, who was trained in Ferrara, but who moved to Bologna in 1483 and settled for a milder style, closer to Francia's Umbrian softness, and eventually succeeded Mantegna as Court Painter in Mantua. Of them all, Cosmè Tura was by far the greatest. He was working for the Este Court by 1451, but much of his early work has disappeared. Mantegna was the chief influence on him, and through Mantegna Donatello, which accounts for the metallic quality of his forms, and the striking austerity of his vision, despite its surface enrichment. The influence of Piero is rather in the colour than in the forms, for their brittle brilliance is enhanced by his restricted palette. Cossa's early training is something of a mystery, for he seems to have been acquainted with Florentine work, in particular with Castagno's, before he came into Tura's orbit in Ferrara after 1456. Mantegna counted for much in his development and he presents the same type of hard form and wiry outline. The frescoes in the Schifanoia ('Begone dull care . . .') Palace celebrating in a combination of Calendar and Astrological treatise the more peaceable exploits of Duke Borso d'Este, such as hunting and lovemaking, are deliciously lighthearted, and full of revealing glimpses of the life of the Court and the countryside. When the frescoes were finished in 1470, Cossa felt that he should have been better rewarded for his work, and in his discontent he left for Bologna, where he applied himself to religious subjects in which the rather coarse quality of his forms is less pleasing than in the secular triumphs of the Schifanoia. It is possible that he had Ercole de' Roberti as a pupil or assistant in Ferrara, for one of the months—September—has affinities more with Ercole than with Cossa or his other assistants, and once settled in Bologna he sent for Ercole to be his assistant there. But his early death cut short a career and a style which promised a much larger development, and presumably after this event Ercole returned to Ferrara.

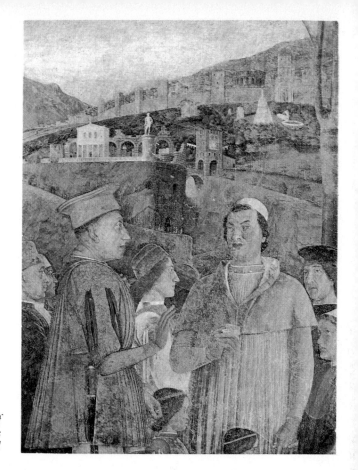

113 MANTEGNA *Meeting of Duke Lodovico and his son the Cardinal, detail*

By the time Ercole took over Tura's position as Court Painter he had developed from the very hard severity of his early manner to a rather suaver vision. The large altarpiece formerly in Berlin, painted in the late 1470s, extends the highly ornate type of Sacra Conversazione with curious devices, such as raising the Madonna's throne on stilts so that a landscape appears on the very low skyline between it and the floor, and he also follows Piero's idea of projecting the architecture of the picture into the spectator's space. In the later one of 1480–81 the same odd feature of the pierced throne is still used, but the whole atmosphere is quieter, the poses less strained, and the forms less tortured; no open connexion with Venice can be proved, but the changes are exactly of the kind to be expected from the mellowing influence of Giovanni Bellini. There were other sides to

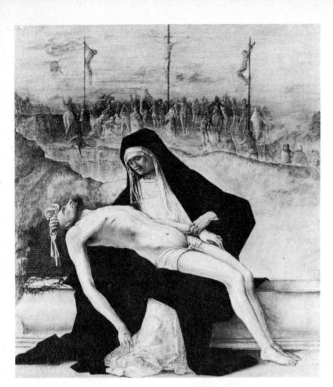

his art, however, than the provision either of grand-manner altarpieces, or the supplying of the trivia of a court painter's functions —masques, costumes, furnishings, pageants for weddings. The little *Pietà* (*plate 114*) expressed his deeply emotional response to the drama of the Passion, and his unconventional treatment of the theme suggests the agony of suffering and the immensity of sacrifice, not by representing the details of the narrative, but by evoking only the bare bones of the tragedy, and investing them with universal significance.

Lorenzo Costa is of weaker stuff. From Tura's orbit, in which he was stimulated to his best work, he shifted, when Ercole displaced Tura in favour, to the new man's circle, and thence in turn first to Bellini and then to the Bolognese Francia, with whom he was in partnership until he went to Mantua to take over the dead Mantegna's position. Isabella d'Este, who reigned in Mantua, liked artists who were sufficiently biddable to expend themselves upon the illustration of her vapid allegories, and the bloodless figures and thin forms of Costa's Mantuan style are the fitting counterpart of her pretentious gallimaufries.

It has been argued at great length that the Rogelet mentioned with so diminutive a name in 1427 as Campin's apprentice could not possibly have been the same person as the Maistre Rogier de le Pasture who, in 1426, was entertained by the city of Tournai with much honour at a wine feast. There is, however, the justification that Jacques Daret, a man in Holy Orders, was quite clearly the person referred to as Jacquelotte, and the custom of nicknames or diminutives for apprentices was a general one. It would therefore seem reasonable to suggest that Roger received some, if not all, of his training in the Campin workshop, and that some of the Master of Flémalle's stylistic features which have, it is true, a great deal in common with Roger's own work are due to his presence in the Campin workshop and to his participation in his master's works. This seems a more logical explanation than to suggest, as has been done, that the Master of Flémalle is an early form of Roger himself.

Roger van der Weyden, to give his name its Flemish form, was born in Tournai in 1399/1400, the son of a master cutler who died in or before 1426 when his son was absent from the town. In 1426 he was back in Tournai, since he attended the wine ceremony recorded in the city archives, and in the same year married a Brussels woman who may have been related to Campin's wife. Although Roger never held a Court appointment, as Jan van Eyck did, he enjoyed a certain amount of Court patronage and was Painter to the city of Brussels until his death in 1464. There are no signed or dated works, so that all the attributions to Roger rest upon the identification of a great altarpiece, now in the Prado, which enjoyed enormous fame and of which one of the earliest copies was made in 1443. The *Escorial Deposition* (*plate 116*), as the picture is generally known, has many points of contact with the Master of Flémalle's *Entombment*, notably in the long, hanging, heavy body of Christ, the echoing

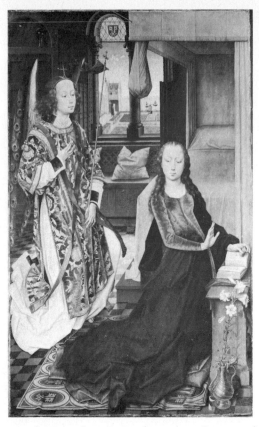

angularity of pose in the other figures, the long features of the
Virgin who has the Flémalle type of rounded chin and heavy-lidded
eyes, the deliberate realism of rich brocades in heavy folds of thick
material, and the clear but diffuse light which does not fall from any
particular direction, but spreads an even illumination over the whole
scene. The *Deposition* is a work full of emotion and tenderness of
feeling, close-knit in composition, formal in the arrangement of the
figures set as a massive frieze against the solid wall—a modernization
of the gold ground—with none of the airiness of space and atmo-
sphere characterizing so many of Roger's other works. Round this
key work may be grouped an *Annunciation* (*plate 115*) which has
links with the Mérode Altarpiece and also with many of Jan van
Eyck's smaller Virgin and Child groups, as well as with the *Arnolfini
Marriage Group* (*plate 62*), in the naturalism of the interior; linked
with the *Annunciation* is a *St Luke painting the Virgin* which also has

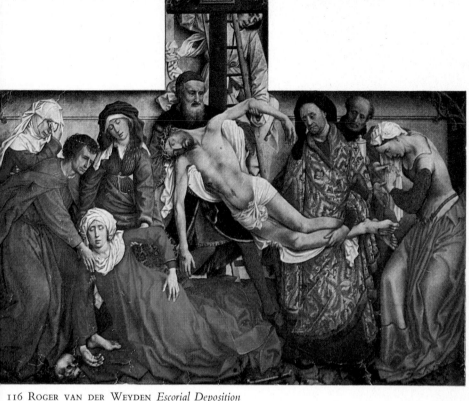

116 ROGER VAN DER WEYDEN *Escorial Deposition*

the closest connexions with Jan van Eyck's *Rolin Madonna* (*plate 65*), for in both pictures the main figures are seated in a room with a colonnaded window, opening on to a distant view of a city bisected by a river at which two tiny figures are gazing from a parapet in the middle distance. In neither is the problem of the proportions of the middle distance solved. What makes Roger so entirely different from Jan is the greater elegance of his figures, and the profound pathos of his characterizations. All Jan's works have something of the intense impassiveness of his device 'Als Ich Kan'—that motto of pure pride; it is Roger's greater ease and adventurousness of composition, his tenderness of feeling, that eventually carried the greatest weight for succeeding generations of Flemish painters. It is almost as if it were admitted that 'Als Ich Kan' was a challenge that could not be taken up; Roger's more relaxed humanity still left room for development.

Roger is said to have gone to Italy. The evidence for this visit lies in a statement by Fazio that he was in Rome for the 1450 Jubilee and there admired the frescoes by Gentile da Fabriano in the Lateran—works now lost. There are also connexions with Ferrara suggested by payments recorded in the Este accounts, and for long the portrait of Francisque d'Este was held to be evidence of a visit to Ferrara. The identification of this portrait with a member of the Burgundian Court, who happened to be an illegitimate son of the Este house, removed much of the basis for this supposed Ferrara connexion. But it is clear that some Italian association existed, for in the Uffizi is an *Entombment* (*plate 117*) which is unmistakably Roger's, and which appears to have come from the Medici Collection. The rectangular tomb in the rock in the background, the iconography of the Entombment with the body of Christ upheld and displayed in the form of the Imago Pietatis is so close to an Entombment of the same type emanating from Fra Angelico's workshop as to suggest a link, if only in the source of inspiration. There is also a *Madonna and Child with Four Saints*—Peter, the Baptist, Cosmas, and Damian—which has a coat of arms that could be interpreted as the Medici fleur-de-lis, while the four saints are the four Medici patrons. Other plausible interpretations have connected the picture with a Flemish family, but, on the other hand, the symmetrical grouping of the figures, the composition built up into a broad-based pyramid, and the general restraint, suggest a strong, if transient, Italian influence.

As a portrait painter he is supreme. The tenderness of characterization that makes the *Magdalen* (*plates 121, 122*) from the Braque Triptych so memorable appears constantly in his overt portraits. The arrogance of bearing of Charles the Bold is far clearer in his personification of one of the Magi in the St Columba Altarpiece (*plate 118*) than it is in the direct portrait (*plate 120*), but generally with Roger's realism—every whit the equal of Jan's—is blended a measure of feeling, a tincture of the vulnerability inherent in the human condition, something of the almost fearful awareness of the transitoriness of the human in face of the Divine: for most, if not all, his portraits are but one-half of a diptych, the other wing of which usually represents the Madonna and Child. Roger's sympathy rather than Jan's impassive chill was the touchstone for the next generation, in portraits as in

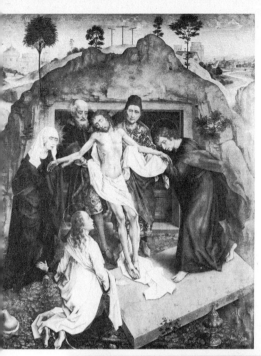

117 *(left)* ROGER VAN DER WEYDEN
Entombment

118 *(below)* ROGER VAN DER WEYDEN
St Columba Altarpiece

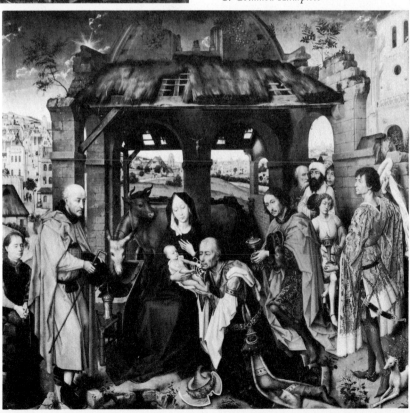

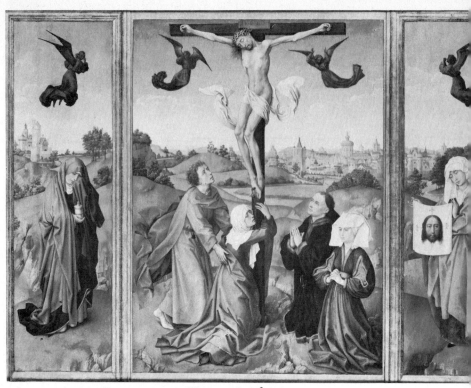

119 ROGER VAN DER WEYDEN *Crucifixion*

religious works, for one aspect of his immense strength was in his capacity to invent new forms to express the pathos of such religious subjects as the Divine suffering, as in his various representations of the Crucifixion (*plate 119*)—never as an actual scene, but in the form most in accord with the new devotional current: as a meditation, or contemplation on the theme of the Redemption.

It was not Roger's actual forms, his style, or his ideas that were so pregnant for the next generation; his power lay in his emotional quality, in the feeling that he himself released in his works and stimulated in others, and his profound humanity and sensitiveness to sorrow is one of his links with Campin, and one of the dividing factors between him and Jan van Eyck.

The influence of Dieric Bouts was more widespread than the limited number of his works would suggest. He was a Haarlem painter, born about 1415, who was working in Louvain before 1448,

120 ROGER VAN DER WEYDEN *Charles the Bold*

121 (*above right*) ROGER VAN DER WEYDEN *Magdalen, detail from the Braque Triptych*

122 ROGER VAN DER WEYDEN *Drawing for the Magdalen*

and who died there in 1475. He therefore cuts right across Roger, but was to a certain extent influenced by him in that the efforts he makes to express a stiff and reticent emotion stem from the impact of Roger's ideas and style. His figures have an unmistakably ramrod quality; his poses are ungainly; the Christ Child in his small devotional Madonnas is of a pathetic homeliness, with thin little upturned feet and a wistful peakiness (*plate 126*). But, like Roger, he has the infinite gift—which he exploits with less sophistication and a more introvert sensibility—of so presenting his ideas that the spectator is drawn to identify himself with them.

The *Five Mystic Meals* which was painted between 1464 and 1468, is a rare and unusual treatment of the Last Supper, since it is presented as an Institution of the Eucharist, and is surrounded by four smaller scenes, each representing one of the Old Testament antitypes: the Sacrifice of Abraham and Melchisedek, the Gathering of the Manna, Elijah in the Desert (*plate 123*), and the first Passover. The accurate perspective construction based on a central viewpoint is for Bouts, as it was for Roger, part of the normal constructional devices of picture space; it had not been so for Jan van Eyck, although Petrus Christus had used it. The simple *bourgeois* setting is also a means by which the impact of the event is made more telling; unlike the Easternized dresses and turbans of the Old Testament characters, Christ and the Apostles, despite the sense of separation induced by their generalized garments and their idealized faces, are seated in a monastery refectory and waited upon by the commissioner, the artist, and, in all probability, his sons. Two things in Bouts's work strike one with immediate force: the tenderness of the colour and the delicate sensitiveness of its gradations, and the beauty of the landscapes. The rocks and hills may be the conventional jagged stones of symbolism rather than reality, but the recession into infinity and the fluid, limpid, cool light are seen with an understanding which suggests a new kind of vision of the natural world.

Justice scenes were a favourite furnishing of medieval law courts. Roger had done some on the Justice of Trajan and of Herkinbald, but these, his only absolutely certain works, were burnt in 1695. Bouts began his huge pair of the Justice of Emperor Otto about 1475, for they were not entirely finished when he died and their

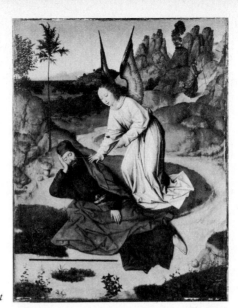

123 DIERIC BOUTS
Elijah in the Desert

valuation was the occasion of Hugo van der Goes's journey to Louvain in 1479/80. Unlike the Rogers, which represented the manifestation of Divine forgiveness for a justifiable act of violence, the Bouts's ones tell the story of how the Emperor killed an innocent man on the unjust accusation of his wicked Empress, and how the Countess vindicated her dead husband's honour by undergoing the Ordeal by Fire, with, as a consequence, the Empress being condemned to the stake. In the *Ordeal* (*plate 127*), the hideousness of the content is offset by the absence of all emotion in everyone concerned; the *Execution* lacks, in some of the figures, quite the incisiveness of Bouts's style, and is therefore believed to be the one finished by another hand. Nothing can exceed the beauty of the colour and the delicacy of the handling in such passages in the *Ordeal* as the Countess's impassive face contrasted with the grey pallor of her dead husband's severed head. The same tenderness of handling is to be found in the lovely little *Portrait of a Man*, dated 1462, bathed in the clear, pale light of the open casement.

Bouts's influence was transmitted in the North largely by woodcuts, in which the stiffness of the technique is exactly matched by the rigidity of the figures. Woodcuts had greater currency in, for instance, Holland than paintings because of the almost continuous absence of any patronage on the scale prevailing in southern Flanders.

153

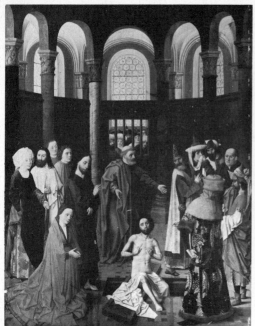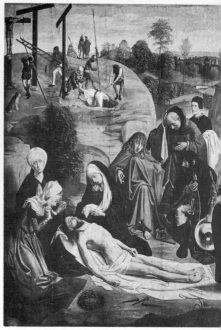

124 Albert van Ouwater *Raising of Lazarus* 125 Geertgen tot Sint Jans *Lamentation*

The Eyckian approach to the representation of nature, informed by quite another spirit of humanity, runs through the second half of the fifteenth century and well into the sixteenth, and can be seen working in artists as different as Albert van Ouwater and Geertgen, for all that the second was a pupil of the first. Ouwater, like Bouts, came from Haarlem and was probably his contemporary. His only known work is a *Raising of Lazarus (plate 124)*, depicted as taking place within the apse of a Romanesque church before an astonished concourse of the local citizenry peering through the sanctuary screen at the back. Again, this is the association of the spectator; but the actual scene remains baldly dispassionate, despite the appeal of the tender light and colour. Geertgen tot Sint Jans ('little Gerard of the Brethren of St John') is not one of the major painters of his period, but he is certainly one of the most remarkable. He too was a Dutchman, born at Leyden, and believed to have died at around twenty-eight years of age, perhaps about 1485/95, so that he would have been a strict contemporary of Memlinc. His only certain works are two large panels in Vienna, once back to back, representing the

154

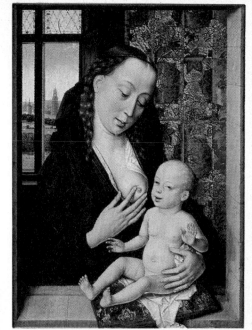

126 DIERIC BOUTS *Madonna and Child*

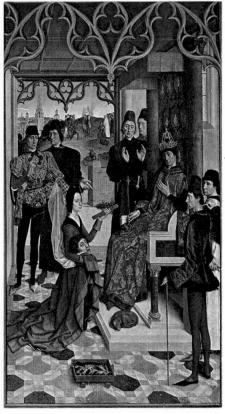

127 DIERIC BOUTS
Ordeal of the Countess

Lamentation over the Dead Christ (*plate 125*) and the *Members of the Confraternity of St John the Baptist saving the Saint's bones from being burnt by Julian the Apostate.*

The *Lamentation* is full of overtones of Roger and Bouts, but instinct also with a gift for the deliberate simplification of human forms, accompanied by an astonishing feeling for landscape, for the freshness of an earthly Paradise. At the same time, in the executioners in the background, and in the entourage of Julian the Apostate, he creates types that are patently caricatures in an attempt to convey vice and depravity. This is a deliberate loading of Bouts's rigidly impersonal onlookers, and seems to be the starting-point for the factual treatment of fantasy that runs through later Netherlandish art. By analogy with the Vienna pair, a small œuvre has been isolated, which runs from the ghastly vision of the blood-bespattered *Man of Sorrows* in Utrecht to the London *Nativity* in which a luminous Christ Child lights His mother and the angels surrounding His crib, and is contrasted with the radiant angel in the sky and the flames of the shepherds' bonfire. The interest in light has now moved beyond the limpid daylight of Bouts and has opened a new chapter in its concern with artificial light.

Roger's most important follower was Hans Memlinc, who was born at Seligenstadt, near Frankfurt-am-Main. He became a citizen of Bruges in 1465, and prospered so exceedingly that he was among the city's richest burghers by 1480; he died there in 1494. Tradition has it that he was Roger's pupil, and tradition here must be right, for Memlinc's watered-down Rogerisms betray their origin very clearly. More decorative, more consciously producing an expensive art-work, his forms thinner, the compositions less richly inventive, the narrative interest triumphing always over the significance of the event, it is only in his portraits that he rises to the level of his great predecessor. The diptych was the usual form, with a Madonna and Child on one leaf and the intercessor on the other, in three-quarter view, against a windowed wall or a wide landscape with a limpid sky. Of this he is arguably the greatest master in Flemish art, and the repercussions of his skill and happiness in this form echo as far south as Perugino, Bellini, and Antonello da Messina. The Donne Triptych (*plate 128*) used to be dated before 1469, but Sir John Donne of

156

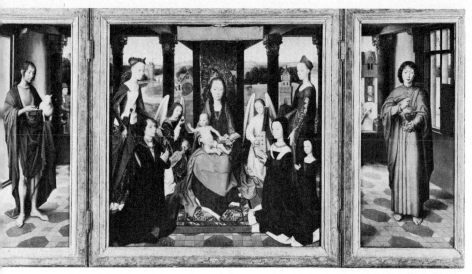

128 HANS MEMLINC *The Donne Triptych*

Kidwelly was in Flanders in 1468 for the marriage of Margaret of York to Charles the Bold, Duke of Burgundy, and again in 1477: this is the more likely date. It is an example of the Flemish form of the Sacra Conversazione that had first appeared with Jan van Eyck in the Van der Paele *Madonna* (*plate 64*) of 1436, and that Roger and Petrus Christus had both occasionally used. It has charm, delightful detail, lovely colour, superlative finish; but these beauties adorn what is now a dead end. The Shrine of St Ursula, which is in the Hospital at Bruges, is usually offered as his greatest work; it too has all the qualities that render the Donne Triptych so pleasing, plus a narrative treated with a naïve literalness that the coarser sophistication of the twentieth century patronizingly approves.

The last of the Bruges masters was Gerard David, who was born at Oudewater in Holland, but settled in Bruges by 1484 and died there in 1523. With him the great saga ended, and his placidly pious pictures were old-fashioned in his own lifetime, so much so that from 1515 to 1521 he worked in Antwerp where the new Italianate style was rapidly superseding his antiquated repetitions of the art of the mid-century. His landscape backgrounds are very lovely, and form, possibly, his most important contribution, since he helps to create the attitude towards nature that is expressed in the emergence of

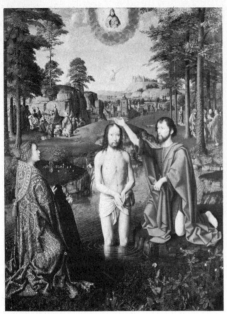

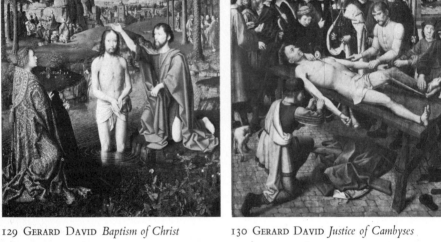

129 GERARD DAVID *Baptism of Christ*　　130 GERARD DAVID *Justice of Cambyses*

landscape as a genre on its own (*plate 129*). When faced with scenes requiring forceful expression, as he was in the grisly story of the *Justice of Cambyses* (*plate 130*), of 1498, in which the corrupt judge is eventually flayed alive, he blends mild astonishment and grimacingly ferocious expressions with charming Italianate details such as garland-bearing *putti* and the inconsequence of a little lion-dog scratching himself almost beneath the torture-table. In his Sacra Conversazione groups no more than a muted murmur between the participants breaks the stillness; but the repose which, in Jan van Eyck, was the deliberate restraint of motionlessness, or in Roger was the inwardness of contemplation, is in David no more than inanition. The canals of Bruges had silted up, the bustle and energy of trade, the excitement of large ships, the adventure of the new sea-routes had shifted to Antwerp, and Bruges and Ghent were now no more than backwaters.

Ghent, however, expired more gloriously. It had produced little since Jan van Eyck, but it is presumed that Hugo van der Goes was born there, since he entered the Ghent guild in 1467, sponsored by Joos van Wassenhoven, who later went to Urbino and became Justus

158

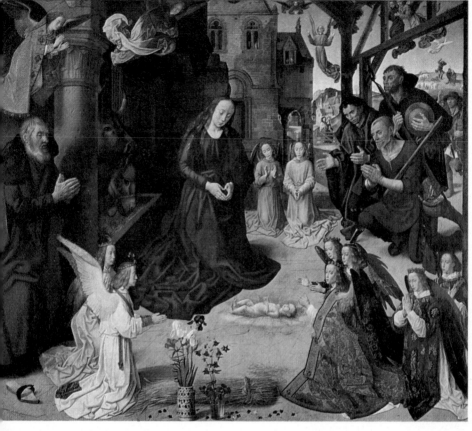

131 HUGO VAN DER GOES *Portinari Altarpiece, central panel, Nativity*

of Ghent. About 1475 he entered the Augustinian Monastery of Roode Clooster, near Brussels, as a lay-brother. This made no difference to his work—he is recorded as complaining that he had enough to keep him busy for nine years without rest—and he continued to receive patrons and visitors, including the Emperor Maximilian, and to travel. In 1479/80 he went to Louvain to value the Bouts *Justice Scenes*, and about 1481 he made a pilgrimage to Cologne. On the return journey he went out of his mind. A monastic chronicle describes the gentle treatment given him, how the prior had musicians to play to him to calm his paroxysms, the details of his symptoms, ravings, threats of suicide. Obviously, he never worked again, and in 1482 he was dead. The problem with Hugo

is not the attribution of works, despite the fact that nothing is signed and almost nothing documented. His works have such an internal affinity that his œuvre is quite clear. The problem is the chronology.

Tommaso Portinari, the Medici agent in Ghent, commissioned from him a triptych of the *Nativity* (*plate 131*) which was sent to Florence about 1475/76. It was a revelation to the Italians, who were faced with a picture executed in an alien technique, with a wealth of imagery and significant iconographical detail, and on such a heroic scale—it is about nine feet high by some eighteen feet across when open—that the portraits are life-size. Its repercussions can be heard through the rest of the century, from immediate loud echoes in Ghirlandaio to more distant and subtle ones in Leonardo. It has a unity of tone, cool and silvery; the wonderful winter landscape and the rather formal stiffness of the figures show links with Bouts, whose pupil he may have been; in the bulky forms and linear patterns are reminiscences of fourteenth-century Gothic; the donor's patron saints remind one of Sluter. But there is a new urgency and feeling for movement in the vitality of the shepherds, and a religious emotion in the adoring Virgin, or in the angel of the Annunciation on the outside of the wings, that returns to the example of Roger. Hugo's expressiveness and his leaning to a Gothic intensity of feeling —a general characteristic of the end of the fifteenth century in North and South alike—is not only a personal trait, but, through the impact of the Portinari Altar, contributed to the stressing of these qualities in Florence.

Most of his works are large. The *Adoration of the Kings* (*plate 132*) and the *Seat of Mercy* (Edinburgh) are other examples on a monumental scale of his intensity of feeling and richness of colour and composition. It is customary to attribute works showing greater emotional tension to his later years, but this is because the Portinari Altar is the only fixed point, and that not hard and fast, and because his tragic end colours the estimate of all his work. Hugo could achieve an amazing virtuosity of detail equal to any of his predecessors; where he excelled was in combining this with a sense of the monumental. In this he equalled Jan van Eyck and Roger, and the impact of the Portinari Altar lies in its reconciling of two mutually

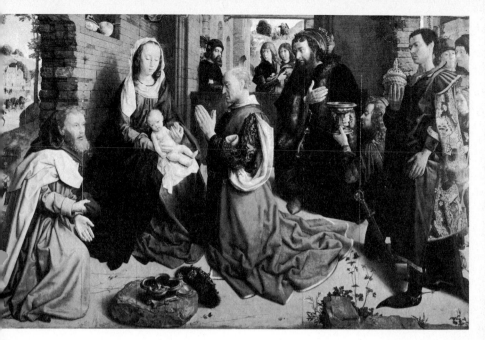

132 HUGO VAN DER GOES *Adoration of the Kings*

exclusive things—size and detail. With him Ghent ends its history, for his only artistic progeny was the anonymous Master of Moulins, and whether he was Flemish or French is as yet unknown.

In the fourteenth century, the great fertilization of French art was brought about through the long residence of the Papacy in Avignon. Although the popes themselves were French, the introduction of Italian forms and ideas was effected through the transference from Rome to Avignon of the Roman chanceries, and Italian artists migrated in their train. The greatest was Simone Martini, who died in Avignon in 1344. His influence, and that of other Italians, was towards a style which, by the fifteenth century, developed into International Gothic. There was, however, a different influence working at the same time, emanating from the same source of patronage, the Duke of Berry, for whom that arch-poem of the International Gothic style, the *Très Riches Heures* (*plate 7*), was made by the Limbourg brothers. He also imported from Flanders, or seduced from the service of his brothers, the King of France and the Duke of Burgundy,

artists of Flemish origin such as Jean Malouel, André Beauneveu, Jacquemart de Hesdin, and Henri Bellechose. This meant, in fact, that parallel with the courtly fantasy of International Gothic ran the current of pre-Eyckian realism. It also meant that the arts in France developed in a fragmented way. Each large region tended to develop its own patronage, and according to the source from which it drew its artists worked out a regional style reflecting both their origins and their interrelationships with other centres. Only with the sixteenth century was the regional character of artistic style outweighed by the concentration of patronage within the sphere of a central monarchy.

After the political disasters that overwhelmed the French Crown in the second decade of the fifteenth century, its patronage was in abeyance; the emergence of Burgundy as a major power, and the possession by the Burgundian Court of an artist of the calibre of Jan van Eyck oriented the arts in the direction of his kind of factual realism, so that even where fantasy still survived, as in the René Master's superb illustrations for King René of Anjou's *Livre du Cuer d'Amours Épris* (*plate 133*), painted in 1460/70, the magic dream-world of romantic chivalry is treated with an equally magic touch of precise naturalism in the handling of light and landscape, and achieves by these means the most poetic flights of fancy.

133 RENÉ MASTER
from Livre du Cuer d'Amours Épris

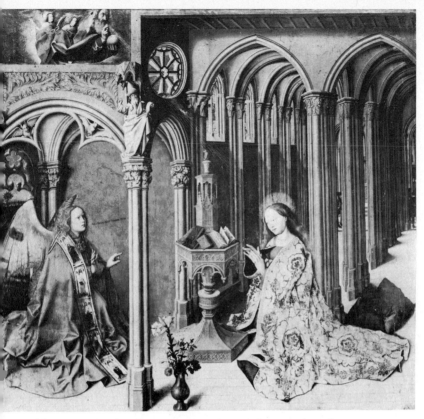

134 MASTER OF THE AIX ANNUNCIATION *Annunciation*, *central panel*

The full weight of the new Eyckian realism fell upon the unidentified Master of the Aix Annunciation (*plate 134*), who may possibly have been connected with the Court of King René, although the altarpiece was painted between 1442 and 1445 in fulfilment of the will of a draper—that is, it was a commission from a *bourgeois*, not a noble, patron, and is another instance of the emergence of a new class of patron of the kind that becomes a major factor in the work of Fouquet. The Aix *Annunciation* has figures of the weight, and architectural detail of the verisimilitude, of the kind that is familiar from the Ghent Altar onwards; moreover, the sculpture decorating the architecture is clearly connected with Sluter, while the iconography of the Annunciation taking place in the porch of a church —as a prelude to Christianity—is found in the Eyckian world.

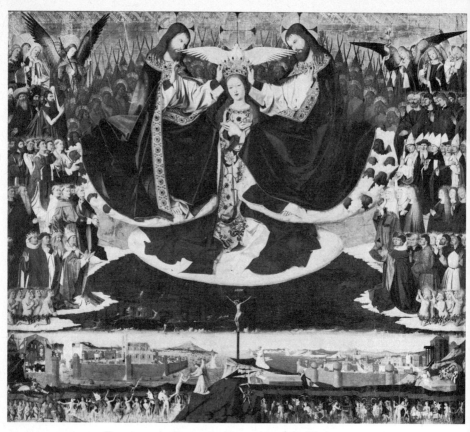

135 ENGUERRAND QUARTON *Coronation of the Virgin*

Fouquet, for instance, an artist who is largely outside the Eyckian circle, places the Annunciation in the *Hours of Étienne Chevalier* just within a chapel with an empty altar at the back. The Aix *Annunciation* also has, in the wings (which are now broken up and are in Rotterdam and Brussels), a pair of prophets each of whom has, above his head, a library shelf cluttered with heaps of books and writing materials, forming a pair of the most remarkable still-life subjects with affinities in Naples with Colantonio, who is believed to have been a source for Antonello da Messina's contact with Flemish art. Another work painted for a Provençal patron is the *Coronation of the Virgin (plate 135)* by Enguerrand Quarton (*c.* 1410–66 or later), for which the contract has survived. This states that he came from Laon, in northern France, but all attempts to discover from his two known

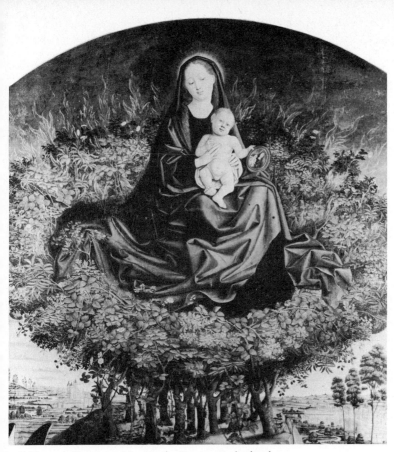

136 Nicolas Froment *Mary in the Burning Bush, detail*

works—this one, and a *Virgin of Mercy* in Chantilly—what his artistic training and links were have so far failed. Perhaps the closest one can get is to remark upon the connexion between the *Coronation* and the sculptured tympana of certain Romanesque churches, but such an iconographical and formal source for a painting is by no means unique. The *Coronation* presents, however, one of the oddities which recur more often in French painting than in that of any other region: two Persons of the Trinity represented as identical in age, dress, and movement. Sometimes this literal rendering of one of the most common Prefaces to the Canon of the Mass (that of the Holy Trinity) involves three identical representations—it does in Fouquet, for instance—but the duplication is not unknown in sculpture. Here the Holy Ghost is depicted as a dove over the crown which God the

165

Father and God the Son place upon the head of the Virgin; on either side adoring figures represent every condition of the blessed from kings and popes to ordinary men and women, and, below, the Last Judgment is presented with Rome and Jerusalem on either side, as specified in the contract. In the centre is the Crucifixion, towards which the souls of the hopeful turn as they issue from the pains of Purgatory on the left, and those of the damned turn away as they abandon themselves to Hell on the right.

Compared with Quarton, Nicolas Froment is a far cruder artist; he has had the good fortune that two documented works have survived, one of them the *Raising of Lazarus*, which is signed and dated 1461. He presents a strange mixture of styles; his figures in a landscape and an interior recall the Flemish treatment of space and the relationship of foreground to background, but the grimacing affectation of his facial expressions and the archaizing design of the main panel connect him with distinctly provincial Spanish or Neapolitan style rather than with anything specifically French. His triptych in Aix Cathedral of *Mary in the Burning Bush* (*plate 136*), of 1476, with portraits of King René and his Queen in the wings, shows a marked mellowing of the harsh style of his Florentine triptych, and the development of a much milder colour and handling. The iconography of the subject is extremely intricate and full of detailed symbolism, which he absorbs into the composition so that the additive nature of the content does not entirely destroy the impact of the design.

The Avignon *Pietà* (*plate 137*), once also at Villeneuve-lès-Avignon, is unquestionably the greatest French painting of the fifteenth century, and one of the most sublime representations of the subject in all art. It seems to have affinities with Spain, but no convincing arguments have yet been offered for connecting it with any particular Spanish, Catalan, or Portuguese artist, or with any other region than Provence; neither has any other picture yet been associated with its anonymous painter, unless it can be attached to Quarton. It must, on grounds of style, date from about 1460, and if any links with the art of any other painter or region are sought they can only be found in the spectator's identification with the donor, and participation, therefore, in the meditation on the Passion. This common ground

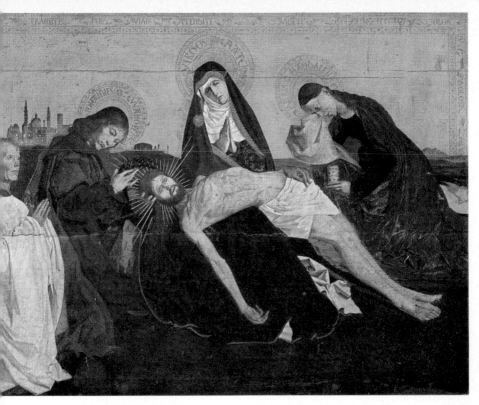

137 FRENCH SCHOOL *The Avignon Pietà*

begins outside the province of art, but is expressed in the icono-
graphical trends of the mid-fifteenth century generally. It takes its
source in the *Meditations* ascribed to St Bonaventura, and in St
Bridget's *Revelations*, devotional works of great popularity and
influence which stress on the one hand identification with the life of
Christ, and on the other visionary descriptions of His sufferings.
These books underlie the religious painting of the age, be it Roger
and Hugo, Dürer and Antonello in the fifteenth century, or
Grünewald in the sixteenth.

Jean Fouquet is very well documented, but only from incon-
veniently late in his career, and there is only one absolutely certain
work, vouched for by a contemporary. This is the illuminated
manuscript of *Les Antiquités Judaïques* which dates from about
1470/76—from the end, therefore, of the painter's life, since he is

believed to have been born about 1420 and was dead by 1481. He lived and worked in Tours, where he eventually had a large workshop, and was appointed Painter to Louis XI of France in 1475. He certainly went to Italy, where he was at some time between 1443 and 1447, and he is said (in an Italian source) to have painted a portrait of Pope Eugenius IV with two attendants, although this depends on a willingness to accept *Giachetto Francoso* as a reasonable form of Jehan the Frenchman. He was certainly back in Tours by 1448. The real evidence for the Italian journey is internal: only by contact with the fountain-head of such forms could he, at that date, have acquired such an understanding of Italian Renaissance architecture as is to be found in the background of his portrait of Jouvenel des Ursins (Louvre), or that of *Étienne Chevalier* (*plate 139*), which once formed part of the Melun Diptych (now divided between Berlin and Antwerp), or in the manuscript *Hours of Étienne Chevalier* which is at Chantilly. This does not exclude, however, his use of Gothic forms in the same manuscript, or even in the same miniature, for that of the presentation of Étienne Chevalier in his *Book of Hours* runs straight on from the Renaissance setting in which he kneels to the Gothic church porch, which serves as a throne for the Virgin and Child. The influence of Italian art does not seem to have affected him much otherwise: one cannot say, looking at a Fouquet portrait or miniature, 'here is the result of having seen such-and-such'. His approach to form is not the analytical one of Jan van Eyck; his large *Pietà* at Nouans is monumental in its design before it particularizes in its forms; his portraits give the whole effect before they enumerate the details. These are, it is true, Italian qualities, and yet there is never anything remotely Italian but his use of occasional details. Even his systems of pictorial space are individual, for he uses the continuous space development in which the eye follows an arc through the course of the narrative, or else such all-embracing systems as the simultaneous development in depth and width, as in the miniature of Boccaccio's *Trial at Vendôme* from *Le Cas des Nobles Hommes et Femmes*, where the Royal Court is depicted in a diamond form receding into the picture space and filling it from side to side.

The end of the century saw two great masters, both anonymous. The first is the Master of St Giles, who must have worked in Paris,

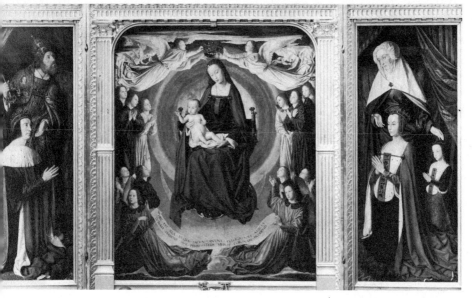

138 MASTER OF MOULINS *Moulins Altarpiece*

since one of the parts of the altarpiece from which his name derives
shows the interior and the famous golden retable of St Denis. His
colour is pallid and tender, his forms exceedingly delicate, his treat-
ment of plants and surfaces naturalistic, his compositions elegant, but
he is a miniaturist writ large. Whether he was a Frenchman who
learned his art in Flanders, or vice versa, will probably never be
settled, but he fits the declining *retardataire* atmosphere emanating
from Bruges at the end of the century, while the Master of Moulins
represents the last repercussions of the influence of Hugo van der
Goes, and does so with exceptional vigour and grandeur. In the
triptych in Moulins Cathedral (*plate 138*) the Virgin and Child are
surrounded by a garland of angels lit from the radiance emanating
from the glory against which they are seated, with the most magical
effects of light. In the wings, Duke Pierre II of Bourbon, with a rueful
countenance, faces his formidable wife, of whom he was said to have
been the humble servant rather than the husband, and the painter's
gift for characterization is carried a stage beyond the normal by his
habit of repeating the features of his sitters in the faces of their patron
saints—a piece of delicate but very effective sycophancy which can
be seen in his *St Maurice* (*plate 140*). His colour is of an astonishing

169

brilliance; his forms of great elegance. The triptych can be dated about 1498/1500, but by this date the invasions of Italy had already started; these sounded the knell of a purely indigenous art, for with the success of French arms in Italy came first the invasion of France by Italian art and then the physical presence of Italian artists at Fontainebleau. Flanders, too, succumbed to the influence of Italian style, which, misunderstood and garbled, treated not as a process of thought but merely as a fashion to be imitated for its modishness and pseudo-sophistication, resulted only in an utter confusion that lasted virtually until the sixteenth century was over.

German art of the fifteenth century has not been studied much outside the German-speaking countries, and one reason for this is its fragmentary nature, which is even more marked than is the case in France. Another is the extreme provinciality of the idiom, which can be part of its charm. On the whole, the German painters of the entire fifteenth century were followers of fashions set in Flanders, until, right at the end of the period they developed an art of their own in engraving and book-illustration at the same time as Dürer, incomparably the most outstanding artist of his generation, subjected himself to a formal Italian discipline. Yet his contemporary Grüne-wald was one of the greatest of all German painters, expressing him-self in the Gothic language of line and exaggeration of gesture and expression in one of the grandest tragic masterpieces of religious art, the Isenheim Altarpiece.

By German art is meant, at this period, the art produced in modern Germany, Austria, Switzerland, and parts at least of Czechoslovakia and Poland. The regional styles, though varied, do not differ as markedly (to a foreign eye) as do those of Italy, and the level of artistic competence, of course, is far lower. On the other hand, a fair amount is known about a large number of masters, as a result of intensive study by German art historians, and this has tended to make the whole subject rather a matter of archaeological concern. At the very beginning of the century the International Gothic influence, as in France, was dominant, and the delightful naïvety of the painter of the *Paradise Garden* (*plate 13*), of about 1415, can be paralleled by Konrad von Soest's homely St Joseph blowing on the fire in the Nativity scene from his Niederwildungen Altar of 1404 (though

139 JEAN FOUQUET
*Étienne Chevalier presented
by St Stephen*

140 MASTER OF MOULINS
St Maurice and donor

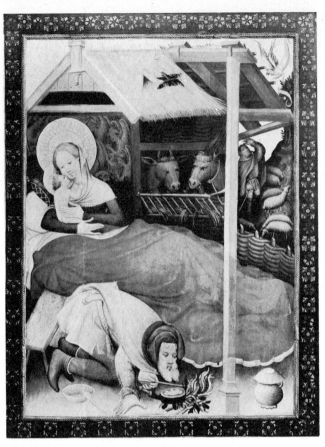

141 KONRAD VON SOEST *Nativity*

some authorities read the date as 1414) (*plate 141*). This form of International Gothic, low rather than high life in feeling, is often called the Soft Style: it is contrasted with the Angular Style ('der eckige Stil'), which is derived from Flanders and Holland rather than France. The Eyckian influence on such painters as Moser (1431) (*plate 145*) and Konrad Witz , in his *Christ walking on the Water* (*plate 66*) (1444), has already been remarked and can be seen also in the work of the Ulm sculptor and painter Hans Multscher (active in 1437).

Around the middle of the century the most important German painter was the Cologne master, Stephan Lochner, who died in 1451. His great work in Cologne was the *Patron Saints of the City* (*das*

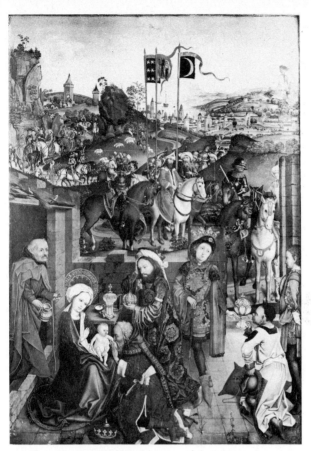

142 HANS PLEYDENWURFF *Adoration of the Magi*

Dombild) (*plate 144*), and this shows very clearly how he developed the Soft Style into something reflecting the influence of contemporary Netherlandish painting. He may have been trained there, possibly under the Master of Flémalle himself, and this would explain his evident connexion with his contemporary Roger van der Weyden. From the middle of the century onwards German painting was to be dominated by Roger's ideas and his tender sentiment (often exaggerated by his German followers) and by the harsh forms of Bouts, whose stiff figures were well known through engravings based on them. Hans Pleydenwurff's *Adoration of the Magi* (*plate 142*), of about 1460, shows this very clearly, with its echoes of almost every contemporary Fleming, but above all of Roger. Roger's Madonna type is

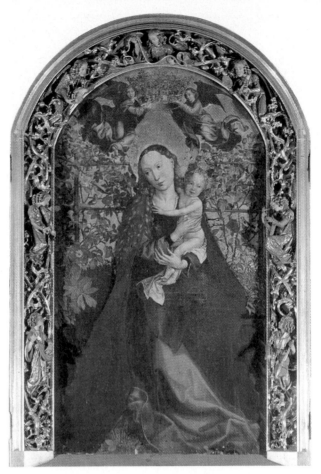

143 SCHONGAUER *Madonna of the Rosehedge*

equally to be seen in Schongauer's *Madonna of the Rosehedge* (*plate 143*), of 1473, and was thus transmitted even to Dürer.

Two Austrian painters, Michael Pacher (*c.* 1435–98) and Ruland Frueauf the Elder (died 1507), differ somewhat from the northern pattern. Pacher worked in the Tyrol and seems therefore to have been aware of Italian art, in particular that of Mantegna, and his great altarpiece of 1481 in S. Wolfgang (*plate 146*) combines Italian dignity of form with an interest in light and a Gothic passion for detail to produce one of the masterpieces of German art. This cannot be said, however, for the *Assumption*, of 1490, by Frueauf, although it has an attempt at simplification of form that may come from contact with

144 STEPHAN LOCHNER *The Dombild Madonna*

Italy. Both Pacher and Frueauf show, in their angular draperies, the influence of woodcarving, which Pacher very probably practised.

The dominance of Flemish art extended far beyond Western Europe, in the sense that Spain and Portugal were just as much Flemish colonies as were the German-speaking lands. For at least the first half of the fifteenth century the Iberian peninsula was Flemish in outlook, and this extended even as far as Italy itself, where the Kingdom of Naples came under Spanish domination and produced, in Antonello da Messina, the greatest Flemish painter born outside Flanders. In Spain itself the earliest fifteenth-century painters were almost entirely Flemish in outlook, as may be seen in the *Virgin of*

175

145 LUCAS MOSER
Tiefenbronn Altarpiece, detail

146 MICHAEL PACHER
S. Wolfgang Altarpiece, detail

the Councillors (plate 148), by Luis Dalmau, who was working be-
tween 1428 and 1460 and who signed and dated this picture in 1445,
only a few years after the death of Jan van Eyck. We know that
Dalmau was sent by King Alfonso V of Aragon to Flanders in 1431
and was back in Valencia by 1437 so he must have seen the singing
angels in the Ghent Altarpiece, finished only in 1432. This is the only
certain work by Dalmau, but it establishes the Flemish connexion,
which seems to have superseded an Italian influence in the fourteenth
century, perceptible in the works of Ferrer Bassa, Jaime Serra, and
Luis Borrassa, the last of whom was active as late as 1424. Fernando
Gallego worked between 1468 and 1507 and was also influenced by
Northern art; in his case it was primarily the work of Dieric Bouts,
and, to some extent, the German artists of the late fifteenth century
who were themselves followers of Bouts. Gallego derived some of

176

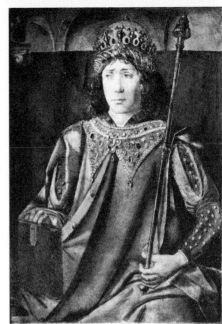

147 PEDRO BERRUGUETE
*Solomon from the
Philosophers*

148 (*below*) LUIS DALMAU *Virgin of the Councillors*

his compositions from Schongauer's engravings. The availability of these line-engravings was undoubtedly a potent factor in disseminating a style compounded of Bouts and the German Gothic artists.

Much of the content of Bartolomé Bermejo's art is derived from Flemish examples. His *Pietà* of 1490 in Barcelona Cathedral is inspired by Roger van der Weyden, although it is more Italian in many details: his splendid *St Michael* (*plate 149*) (and also a poorer version in Edinburgh) shows an Italianate dignity of design coupled with a truly Flemish love of detail in the Bouts-like portrait of the donor, or the fantastic dragon, which comes straight out of Bosch.

The Italian influence began to supersede that of the Netherlands towards the end of the century, partly, no doubt, because of the Spanish rule in Naples, established by Alfonso of Aragon. The case of Pedro Berruguete is interesting. There are twenty-eight pictures of philosophers, divided now between the Louvre and the Gallery at Urbino, which came originally from the Palace at Urbino, and there are a few other pictures, the most important of which is Piero della Francesca's *Brera Madonna* (*plate 106*) in Milan, which are claimed to be wholly or partly by Berruguete. In the case of the Piero *Madonna*, only the head and hands of the donor, Duke Federigo of Urbino himself, are so claimed, but most of the *Philosophers* have been attributed, on rather exiguous evidence, to Berruguete (*plate 147*). It is certain that they show a Flemish style—but Joos van Gent was in Urbino at the same time, in the 1470s. In 1477 a Pietro Spagnuolo —Peter the Spaniard—was in Urbino, and Pedro Berruguete was active in Avila and Toledo from 1483 onwards. His works in Spain have, so far as they can be identified, an Italo-Flemish flavour, but there is also the argument that his son, Alonso, was a pioneer of Italian Mannerism in Spain early in the sixteenth century and may well have been inspired to study in Italy by his father, who died in 1503/1504.

The only really important Portuguese painter of the period was Nuno Gonçalves, active between 1450 and 1472, whose masterpiece, the St Vincent Altarpiece, was destroyed in the Lisbon earthquake of 1755. Another altarpiece of the same subject is reasonably attributed to him (*plate 150*), and it shows the pervasive influence of Bouts in the stiff figures and the awkward but genuine emotion underlying them. The heads have a hardness of form and contour that has been

149 BARTOLOMÉ BERMEJO
St Michael

held, very probably rightly, to show that the forms of carved and painted wooden sculpture were close to the painter's mind. In the latter part of the fifteenth century the dominance of the Flemish style seemed assured—even in remote England the wall-paintings in Eton College Chapel, of the *Miracles of the Virgin* (*plate 151*), show the influence of Flanders, in this case mainly that of Roger van der Weyden, although the paintings are known to date from 1479 to 1488 and the names of two contractors are recorded—Gilbert, and William Baker, the latter of whom was surely an Englishman. The paintings are now very damaged and are among the few sad survivors of the iconoclastic fury of the sixteenth century which destroyed so many paintings and so much stained glass, both in England and in Holland, that it will probably never be possible to tell how far the influence of painters like Bouts and Roger van der Weyden really spread, and how much it was transformed in England or the northern provinces of Holland before both countries, like the rest of Europe, fell under the spell of Italian High Renaissance art.

150 GONCALVES *St Vincent Altarpiece, detail* 151 BAKER (?) *Miracles of the Virgin*

Printing, like the wheel, is one of the half-dozen great inventions of mankind, but its early history is still rather obscure. The great step forward was the invention of movable type, each letter cast separately in metal and then combined to form words and sentences. When the edition had been printed these letters were redistributed and used for the next job until they were worn out, when they were melted down and recast in the original matrices. This, together with the use of the screw-press which impressed the inked characters on dampened paper, made up the basic art of printing, unchanged for centuries, and it was certainly established as a commercial proposition by 1450. The idea is certainly to be credited to Johann Gensfleisch zum Gutenberg (1394/99–1468), a Mainz goldsmith, who perfected his invention in exile at Strasbourg about 1440; by 1450 he was in business in Mainz, but in 1455 his partner, a lawyer named Fust, foreclosed on him and set up in partnership with Schoeffer. Within thirty years presses were established all over Europe, largely run by Germans, and the modern age had begun.

In fact, printing dates from much earlier, since the woodcut principle was known long before—the St Christopher (plate 152) is dated 1423, but there are others which may go back to the beginning of the fifteenth century, or even the end of the fourteenth. This process differs from printing from types, because a woodcut is based on the fact that a smooth, even block of wood (or any similar material) will, if inked all over, print as a black rectangle: if a trench be cut in it then that trench will not be inked and will therefore print a white shape. Thus, it is possible to cut black and white shapes with knives and gouges and a picture can be made with an inscription beneath it, like the St Christopher, provided that the accompanying text is written backwards, since printing automatically reverses. A block with picture and caption cut in one can be used as one page of a complete book, and such a book is called a 'block-book'; the

disadvantages are that mistakes usually involve scrapping a whole page, perhaps after much work, and the fact that the block is usable for only one book. Nevertheless, this may well be the origin of printing from movable types, and the woodcut was known and used for single sheets of devotional pictures—souvenirs of pilgrimages and images of saints—and also for the making of playing-cards. These were occasionally coloured by hand, but, naturally enough, very few have survived. So far as is known, block-books were being produced by about 1430, although the earliest datable example is of 1470, a good twenty years after the invention of printing. The block-book seems to have died out by about 1480, killed by the much simpler and more satisfactory method of combining a woodcut illustration with type: the surprising thing is that they survived for so long. Many of them were popular devotional works, such as the *Ars Moriendi* (*The Art of Dying Well*) (*plate 153*), the *Speculum Humanae Salvationis* (*Mirror of Human Salvation*), or the *Biblia Pauperum*, a series of illustrations of Bible stories so arranged that the New Testament events were faced by the Old Testament anti-types, the stories which were held to be prophecies or prefigurations of the Acts of Christ. This is the type of book which Dürer had in mind when he published his *Apocalypse* in 1498, with German and Latin texts, or his *Life of the Virgin*, the title-page of which is dated 1511 (*plate 154*); surprisingly, it seems to have taken several years before anyone realized the advantages of printing the engraved block along with metal type in one operation. The earliest dated illustrated book of this kind was printed in Bamberg about 1461. One probable reason for this slowness to exploit the possibilities of the new craft may be found in the highly developed trade-unionism of the later Middle Ages. The Guild rules were very strict on what is now known as demarcation, and the earliest printers, while putting the scribes out of business, were very anxious not to upset the other book-crafts: about 1470, in Augsburg, an agreement was reached whereby printers could use woodcut illustrations, provided that they were cut by the *Formschneider*, or

152 (*above right*) GERMAN WOODCUT *St Christopher*; 153 (*above far right*) GERMAN WOODCUT *The Dying Man tempted to Impatience, from the Ars Moriendi*; 154 (*below right*) DÜRER *Life of the Virgin, title-page*; 155 (*below far right*) FLORENTINE WOODCUT *Christ in the Garden*

ftofon frctan dte quaamctp metts :·
la nempz dte mozte mala non mozuns :· mtllehnto ccc°
xrx° anno :·X·

OME IN DIVAE PARTHENICES MARI
HISTORIAM AB ALBERTO DVRERO
NORICO PER FIGVRAS DIGES
TAM CVM VERSIBVS ANNE
XIS CHELIDONII

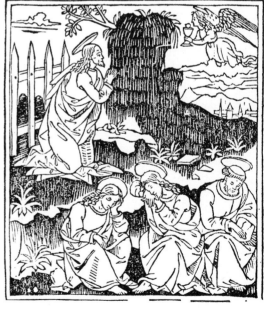

professional cutters. One practical advantage of this system over the block-book lay in the fact that the blocks could be used for more than one book, and enterprising publishers soon found that the same blocks could even be used more than once in the same book— Hartmann Schedel's famous *Liber Chronicarum* of 1493 has no less than 1,809 illustrations, but only 645 blocks were used. It is an extraordinary fact that the fifteenth-century book-buyer did not object to the same view being used for Rome and for Jerusalem.

The first Italian illustrated book appeared in 1467, and the next thirty years saw a splendid flowering of the new art in Florence and Venice, superior in quality to anything produced in Germany or the Netherlands. The earliest blocks, especially in books printed in Venice, were often simple outlines intended to be coloured by hand by an illuminator. Florence, where books were first illustrated by metal engravings, was comparatively late in the field (the first wood-cut illustration is of 1490), but very soon produced a distinct style of cutting, using black more than the Venetians, both in the decorated borders which surround the illustration and also as a background in the scene itself. The black background is usually enlivened by white lines cut almost to the edges of the forms. These have the great advantage of harmonizing perfectly with the area of the type itself, neither too black nor too thin in appearance by contrast: the Florentine *Christ in the Garden (plate 155)* from a sermon of Savonarola printed about 1497 shows this balance, and it also shows how the cutters were dependent on the painters—in this case Botticelli—for their style. The most beautiful book of the fifteenth century is undoubtedly the famous *Hypnerotomachia Poliphili (The Strife of Love in a Dream)* which was published by Aldus Manutius, the greatest printer and publisher of the age, at Venice in 1499. This is an elaborate romance which contains pages of sheer fascination with details of the ancient world, romantic rather than archaeological in inspiration, and the book has long been recognized as a reflection of, and stimulus to, late fifteenth-century feelings on the subject of antiquity, and especially the almost Scriptural reverence paid to it. The scene of *The Temple of Venus (plate 156)* is only four by five inches, but it has the elegance, lightness, and, above all, the perfect sense of interval that we find in the architecture of Brunelleschi.

156 VENETIAN WOODCUT *The Temple of Venus, from Hypnerotomachia Poliphili*

As early as 1477 the first attempt was made to illustrate a book with engravings on metal, and in 1481 Landino's *Commentary on Dante* was published in Florence with engravings probably designed by Botticelli. This was not a success, for technical reasons, and was not revived until much later as a means of illustrating books, but the idea had undoubtedly come from the perfection attained by those artists, such as Pollaiuolo, who had made single line-engravings as independent works of art.

The history of engraving on metal in *intaglio* begins a few years after that of woodcut. The process of engraving on metal (almost invariably copper) is simple, but it is almost the exact opposite of woodcut. In woodcut, or any other *relief* method, the parts cut away are those which print as whites: in any of the *intaglio* methods the actual lines gouged out of the surface of the plate and then filled with printing ink are those which print black. The main *intaglio* techniques in use in the fifteenth century were drypoint and line-engraving, with etching coming into use in the sixteenth century.

A drypoint is the simplest, since it consists of drawing on a soft copper plate with a hard steel point which gouges out a furrow in the plate. If the plate is inked, and the ink wiped off, the polished surface will retain only a film of ink, but the furrows will be filled with it and will, therefore, print as black lines if a sheet of paper is laid on the plate and subjected to great pressure. In line-engraving proper the lines are cut by pushing a tool called a burin through the copper. It is much more difficult to do than drypoint (the burin slips all too easily on the polished surface), but it has the great advantage over drypoint of printing many more impressions before wearing out. From the point of view of the book-illustrator the engraved processes are inferior to the woodcut on three counts: they require a different, and much heavier, pressure; they cannot, for this reason, be printed along with the type in one operation; they wear out very much more quickly (a wood-block, carefully treated, will give many thousands of perfect prints, whereas a copper engraving deteriorates steadily and will not give more than a few hundred prints at most). From the point of view of the artist, the copper engraving is a far more subtle and personal technique, and this is probably the reason why it was developed so quickly and soon became an independent form, with no connexion with the book-trade.

The earliest line-engravings were made in the North, in Germany and the Netherlands, about thirty years after the earliest woodcuts. The first major artist to emerge is the Master ES, who seems to have been active in the Rhineland from about 1440 until at least 1467. Some three hundred plates are known by him, a few of which are datable and several of which are signed E or ES (*plate 157*).

Nothing more is known about him, but his types are like those of the Master of Flémalle and his output was mostly figures of saints, but he also made designs for goldsmiths' work: this gives a clue to the origin of the process of engraving, since goldsmiths used tools to chase decoration on metal, and one way of testing the effect of the pattern was to rub black into the lines, sometimes also pressing paper on to them, thus obtaining a print. The higher social status accorded to line-engravers over woodcutters probably also comes from the connexion with the highly esteemed goldsmiths' guilds.

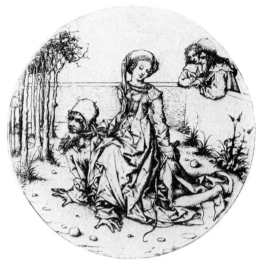

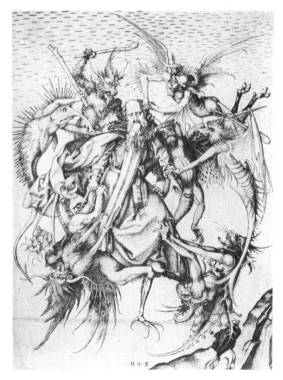

157 (*above left*) MASTER ES
*Madonna watching the
Child being bathed*

158 (*above right*) MASTER OF
THE HOUSEBOOK
Aristotle and Phyllis

159 (*right*) SCHONGAUER
Temptation of St Antony

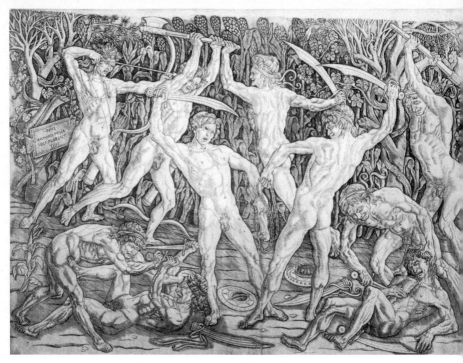

160 ANTONIO POLLAIUOLO *Battle of the Nude Men*

Even finer as an artist is Martin Schongauer, probably ES's pupil, a Colmar painter who engraved one hundred and fifteen plates, some of which are of the highest quality. In general, he seems to derive his types and compositions from Roger van der Weyden, the fountain-head of inspiration for all the Netherlandish and German painters of the later fifteenth century: Schongauer's own importance is proved by his only certain painting, the *Madonna of the Rosehedge* of 1473 (*plate 143*), an over life-size figure in the Gothic tradition clearly showing his descent from Roger. His engravings were known in Italy, and Vasari tells us that the young Michelangelo copied his *Temptation of St Antony* (*plate 159*); still more important, we know Schongauer died in 1491 because the young Dürer visited him, with the intention of working under him, only to find he had recently died.

Schongauer's contemporary was another anonymous painter and engraver, known as the Master of the Housebook (Hausbuch Meister) from a book of drawings at Schloss Wolfegg, which seems to be datable about 1475 (*plate 158*). Among the eighty-nine

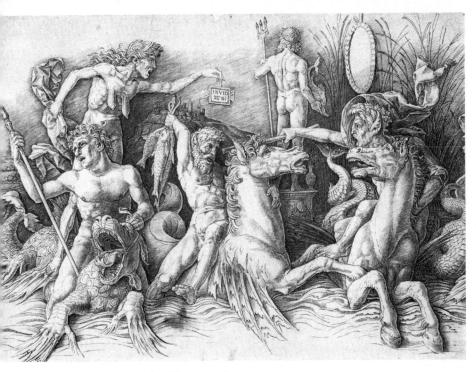

161 ANDREA MANTEGNA *Battle of the Sea Gods*

engravings attributed to him is at least one drypoint, a rare technique at this early date, since almost all early engravings are made with the burin, a striking proof of their origin in goldsmiths' work.

Italy seems to have been slightly later in developing the technique. Vasari says that engraving was invented about 1460 by the Florentine Maso Finiguerra, and, like so many of his claims, this is partly true.

Maso Finiguerra died in 1464, and he was possibly the author of the *Florentine Picture Chronicle*, a series of drawings, now in the British Museum, some of which are also reproduced in contemporary engravings; it is also true that the earliest Florentine engraving to which à date can be attached is of 1461.

Early Italian engravings can be divided into the 'Fine' and 'Broad' Manners: the Fine Manner group dates from about 1460 in Florence and consists of engravings which are cross-hatched with a fine mesh of lines, giving an effect similar to a wash-drawing. Few of them are of great artistic worth, but at least two major artists used the Broad Manner technique—Antonio Pollaiuolo and Andrea Mantegna. The

Broad Manner is closer in style to pen-drawing, since the lines are bolder and farther apart, with little hooks at the ends like the mark made by a rapid pen-stroke. The earliest examples seem to be of about 1470, and the style lasted for about twenty years. Antonio Pollaiuolo's *Battle of the Nude Men* (*plate 160*) is a signed work of about 1475, contemporary with the big altarpiece of *St Sebastian* (*plate 182*), and similar in style, although the engraving has a power and immediacy lacking in the painting. Andrea Mantegna made about nine engravings himself—the *Battle of the Sea Gods* (*plate 161*) is similar to Pollaiuolo's battle—and several more are attributed to his shop. The wiry hardness of Mantegna's outline is well suited to the Broad Manner, and the archaeological interests of the Paduan school could be furthered by the dissemination made possible by printing; for example, Dürer certainly knew Mantegna's prints.

Incomparably the greatest artist to practise extensively as an engraver, and the heir to all the technical advances made in Germany, was Albrecht Dürer, who made some two hundred woodcuts and one hundred line-engravings, as well as experimenting with both drypoint and etching on iron. Dürer was born in Nuremberg in 1471, the son of a goldsmith. In 1486 he was apprenticed to Michael Wolgemut, whose large workshop produced all kinds of art, including paintings and woodcuts for book-illustration, which were printed by Anton Koberger, the greatest printer in Germany. In 1490 Dürer left Nuremberg and wandered round Germany, until he arrived in Colmar in 1492, intending to work under Schongauer, but found that he was dead. The remaining three brothers eventually sent him to their other brother in Basle where he worked as a book-illustrator, as he also did in Strasbourg until May 1494 when he returned to Nuremberg. From the autumn of 1494 to the spring of 1495 he was in Venice, and perhaps also in Mantua, Padua, and Cremona. It seems to have been after his long 'wander-year' that he first came into contact with Italian Renaissance work of sufficient quality to change the course of his development. These were the engravings by Mantegna, including the *Battle of the Sea Gods* (*plate 161*) and the *Death of Orpheus*, which he copied in 1494, probably before he went to Venice; another drawing of 1495 reproduces a *Rape of the Sabines*, probably after a lost Pollaiuolo. In Venice he was

162 DÜRER
Self Portrait

fascinated by local types—Circassian slave-girls, courtesans, Venetian ladies in their easy, graceful dress which he contrasted with the tight, fussy clothes of the Nuremberg women, lobsters, crabs, the lion of St Mark's which he attempted to transform into a real beast. On his way home he made water-colour paintings of the landscape; these are works which lie at the root of the Northern approach to landscape, for they are not only topographical records but have all the overtones of mood of pure landscape.

His first successes came rapidly after his journey. The Elector of Saxony visited Nuremberg in 1496 and was immediately impressed with Dürer's genius, remaining his patron and admirer for the rest of his life. His early portraits also date from about then. He had painted a self-portrait for his betrothal in 1493 which, despite its virtuosity, remained somewhat flat; his father's portrait, of which the

best replica is the one in London, is masterly as a piece of characteri-
zation, and important as one of the early examples of his power of
suggesting depth by purely formal devices in a figure set against a
plain background. The *Self Portrait* (*plate 162*) in the Prado is dated
1498. In it, Dürer wears his finest clothes and exhibits that vanity in
his appearance for which his friends twitted him, but the most signi-
ficant thing about it is the Leonardesque fascination with the hair.

During these years he also established his supremacy in graphic art
which for him had certain advantages over painting. A picture took
too long to execute to allow of time for uncommissioned works,
whereas a print could be finished fairly quickly. Pictures were only
of two types in Germany: religious subjects or portraits. A print
could be about anything. Compared with a painting, prints were
cheap; they could satisfy devotional needs, or mere curiosity about
a theme or an event; they were not tied to traditional iconography
or set patterns, but could be executed according to fancy. For an
artist like Dürer, who combined great rapidity of thought with
teeming inventiveness, a medium of expression which allowed him
to work out his ideas with speed and completeness was a necessity.
Also, he had a natural bent for the linear inherited from Gothic
tradition, and lines came more easily to one of his training than
masses. His early Italian interests had been almost entirely with
linear works: Mantegna's and Pollaiuolo's prints, and the hard,
brittle, metallic linearism of Mantegna's forms derived from a
sculpturesque linear tradition with which he was at home.

One of the earliest of the large woodcuts (it is about 15 by $11\frac{1}{2}$ in.)
was *The Men's Bath House* (*plate 163*) of 1497. The forms are very
detailed, the drawing exact, and there is a feeling for mood, and an
unusualness of subject-matter unknown before this date. Lines
delineate the objects, but where two dark areas meet a white line
replaces the black, and not only are the directions of surface fully
worked out, but every effort is made to represent the object's texture
and nature. These effects are achieved more easily in engravings than
in woodcuts. The *Prodigal Son* (*plate 166*), engraved in 1498, reaches
a new level of virtuosity. Iconographically, it is new: formerly the
Prodigal stood sorrowfully among the pigs while another swineherd
knocked down acorns. Dürer places him, not in the fields that the

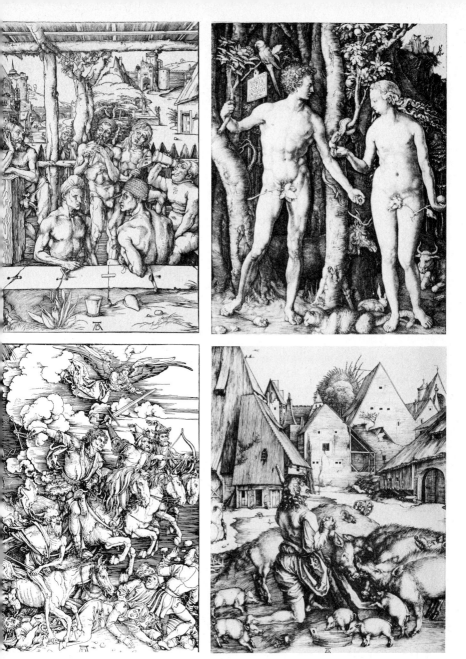

163 (*top left*) DÜRER *The Men's Bath House*; 164 (*top right*) DÜRER *Adam and Eve*; 165 (*bottom left*) DÜRER *The Four Horsemen of the Apocalypse*; 166 (*bottom right*) DÜRER *Prodigal Son*

Bible mentions, but in the farm-yard where barns and hovels give a vivid actuality to the scene, and he does not look sadly at his pigs; he kneels among them. Humbling himself among his snorting hogs, he lifts his eyes and hands in prayer and deep repentance. This simple motive gives a pathos and a humanity, an emotional overtone, which brought the design immediate fame.

In 1498 he issued the *Apocalypse* (*plate 165*). This was the earliest book issued entirely by an artist as his sole responsibility, and it set a new type for books. Where earlier ones had illustrations set into the letterpress, Dürer used the full page for his woodcut and put the text on the back. He condensed the narrative so that the incidents are never repeated in the illustrations, even when they repeat in the text, thus reducing the illustrations from as many as seventy-four in earlier books to fourteen. He also condenses the action and makes much of it continuous; for instance, in Revelations 6 the Four Horsemen go out singly, and the evil they do falls on mankind indirectly. Dürer shows them charging in a solid phalanx and mowing down humanity under their hoofs. He adapted the technique he used in the engravings to woodcuts, making them infinitely richer and more dazzling in effect. The *Apocalypse* ranks with Leonardo's *Last Supper* and Michelangelo's *Sistine Ceiling* as a supreme work of art, the fruit of spontaneous genius, using all the resources of tradition yet treating the subject in a totally new way, immediately imposing itself by sheer beauty and power of imagination.

The year 1500 appears to have been a turning-point, for about then Dürer began his move towards theory. He started to study proportion in humans and animals—particularly horses—and also perspective, but his natural balance, his innate feeling for the physical quality of things, made him compensate for the theory by becoming even more engrossed in natural detail. Drawings like the *Hare* or the *Piece of Turf*, all dating from 1500–3, are microscopic at a moment when he was experimenting with theories of ideal proportion. The engravings of this period are more detailed and delicate than ever, with two or three times as many lines to the square inch as before. All stress the textures and surfaces of things. The *St Eustace* of c. 1501 is the largest and most splendid of all his engravings—ten by thirteen inches. It is filled with minute, almost Eyckian detail, even

though the main subject is the relationship between the proportions of man, animals, and nature. The dramatis personae are reduced almost to a schematic system with the recession of the landscape managed in successive stages, and all the figures are seen in set positions—full frontal, three-quarter, and profile.

Never again did he combine so much in so small a compass, for at the same time he produced coarser prints in an effort to harmonize two styles, though what he lost in less minute handling he more than made up for in increasingly complicated iconography. The *Adam and Eve* of 1504 is a case in point (*plate 164*), for it is intended to be read as a book, with no detail so minute that it does not contribute to the significance, and with the complication of a basis in obscure medieval systems of thought. The rowan tree Adam holds was once believed to be the tree of life, the apple of sin is also that of discord, the four animals are symbols of the four humours, and also the personifications of the deadly sins, which all invaded Man after the Fall. Adam and Eve are not only our ancestors at the moment when they became our forefathers, but they embody ideals of classical beauty, harmony, and proportion, since Adam is adapted from the Apollo Belvedere, which had been discovered at the turn of the century. This conflation of the moment of their entry into the human predicament with the timeless quality of ideal form is also made to contain overtones of human nature and personality, in the maximum contrast between masculine vigour and feminine softness.

The paintings of these years are neither numerous nor very successful, except for the *Adoration of the Magi*, of 1504, but in all the painted works the extremes of iconographical and narrative detail are abandoned. His last work before he went to Venice for the second time was the set of woodcuts for the *Life of the Virgin* (*plate 154*), but this remained unfinished until after his return. The set was planned to have twenty illustrations of which seventeen were done when he left, two more were added in 1510, and in 1511 a new frontispiece was cut and the whole issued as a book like the *Apocalypse*. The woodcuts fall into two types: those in which the homely narrative and multitudinous detail recall the earlier works in which these qualities predominated, and those in which Dürer set himself one of the classic problems of design, and solved it by a conscious skill in

composition, a use of classical proportions, or the adaptation of classical poses. In turn, this raises the question of his personal work on these blocks. In Basle and Strasbourg, where he had worked for the great printers, he had been a designer of blocks, and only occasionally cut one himself: it is a waste of money to employ a designer on the mechanical part of the work. In Nuremberg he began by cutting many of his own blocks, because he was changing the whole basis of graphic art, and the creation of a new style could only be done by personal work. When the standard of cutting had been set and his workmen trained to work to his wishes, then he designed and they cut. The same happened in the engravings. First he had to establish the fantastically high quality by example; then he could leave the actual engraving to the journeymen he trained, and later he had no need to cut or engrave, though this results in deader cutting than is the case with those blocks he had worked himself.

From 1500 to 1505 was a transitional period, when it was still necessary to do much of his own hackwork, and not until 1510 was the workshop able to cope with anything he demanded. Most of the engravings and woodcuts are standard in size, not for aesthetic reasons, but because of the sizes of blocks (the larger the block the more difficult to obtain without blemish) and the size of the press.

When Dürer arrived in Venice for the second time in the summer of 1505 he was no longer the poor, unknown student he had been eleven years before. He was rich, famous, and sought after. He mixed with scholars, Humanists, musicians, connoisseurs, and instead of filling sketch-books with the surprises and curiosities of the new world he found himself in, he studied theory. He executed several paintings, including a grand commission for an altarpiece for the German church, paid for by the German merchants. The Venetians had criticized his style, saying that it was not 'antique' and that he was only an engraver and could not handle colour; the *Feast of the Rose Garlands* was intended to stifle this kind of criticism for good, and those parts which have survived extensive restoration have a richness that explains his comments that he had triumphed over his critics to the wonder and admiration of all. In type, the altarpiece is a very complicated and crowded Sacra Conversazione, which owes an enormous debt to Bellini, whom Dürer said was 'still first in painting'.

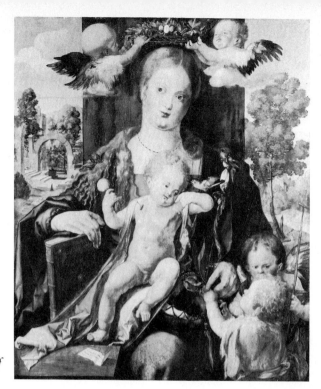

167 DÜRER
*Madonna of
the Siskin*

It is clear from such engravings as the *Little Horse* of 1505, as well
as from his tentative essays in human proportions, that Dürer had
been influenced by Leonardo even if the influence was not based on
a very wide knowledge of his works. The *Little Horse* certainly harks
back to the *Sforza Horse*, but there are other examples as well:
the *Madonna of the Siskin* (*plate 167*), painted in 1506, introduces
the infant St John, hitherto unknown to Venetian *Madonnieri*, in the
Leonardesque intercessory type. Isabella d'Este had wanted Leonardo
to paint her a *Christ disputing with the Doctors*, and he had avoided
the commission; but it is believed that he did execute a cartoon
which was eventually lost, but which may have given Dürer the
idea for his picture, particularly as Leonardo received the commission
when he was in Venice. Nothing more Leonardesque exists in
Dürer's œuvre, except a later drawing of profiles which as much
caricatures Leonardo as it imitates him. Dürer described it as 'a
picture the like of which I have never painted before', and even if
a lost Leonardo did not directly inspire it, it seems almost certain

197

the heads of the old men were derived from him. The painting offers the maximum contrasts between youth and age, beauty and ugliness, innocent wisdom and crabbed knowledge, virtue and vice—all those contrasts which ran off Leonardo's pen when he doodled.

Dürer returned to Nuremberg reluctantly; he was no longer content to be merely a good workman and he hankered after the climate of the arts in Italy. 'Here', he wrote from Venice, 'I am a gentleman; there I am a parasite. How I shall long for the sun in the cold.' Now he began developing the 'erudite' side to his art and personality that raised him so much above the other painters of his period and country. He studied mathematics and geometry, Latin and Humanist literature; he consorted, not with fellow artisans, but with Humanists and scholars—a change in his whole mode of life and thought, traceable directly to the influence of Leonardo and Mantegna, and to the example of Bellini, with whom he had been on terms of friendship in Venice.

A new kind of engraving was evolved after his return, based on the Italian type of chiaroscuro print—that is, a print, usually a wood-cut, printed in more than one colour so as to give an effect of tone. Dürer now began to make prints which, while still purely in black and white, also managed to convey the idea of a middle tone. This was done by great evenness of cutting, and by planning the print in zones of light, middle tone, and shadow. He used this manner for the *Great Passion*, finished in 1511 and published as a book like the *Apocalypse* and the *Life of the Virgin*, also finished at this time.

His greatest engravings, the *Knight, Death and the Devil, St Jerome in his Study (plate 168)*, and *Melencolia*, were produced in 1513–14, and here again the multilayers of thought embedded in the iconography have to be read, at the same time as the aesthetic quality of the print makes its impact. The Christian knight prepared for battle against sin and death, riding through the world assailed by temptation; the saint in a spiritual haven of faith and learning; the Vita Activa and the Vita Contemplativa contrasted with the Melencolia in her twilit world of *accidie*, appalled at the gulf between her powers and her vision, the spiritual portrait of the artist himself overcome by divine discontent at his own inadequacy before the immensities of art and knowledge.

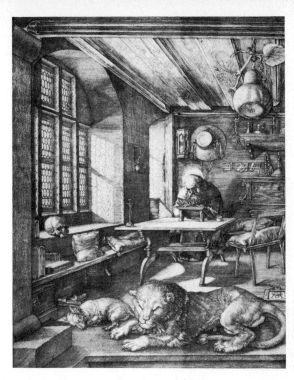

168 DÜRER *St Jerome in his Study*

The paintings of this period include the painted *Adam and Eve* (Prado, 1506–7), where he made an overconscious attempt to reconcile Gothic forms and proportions with Renaissance canons of Ideal Beauty, and the Trinity Altar (Vienna, 1507–11) which is based on St Augustine's 'City of God'. A medieval Seat of Mercy adored by angels and the faithful is approached through a frame, which he also designed, representing the Last Judgment—an imaginative and exact interpretation of the text, dazzling in colour and with subtle spatial arrangements, designed to draw the spectator into the picture space.

In 1519 he appears to have had a nervous breakdown, and when the young Jan van Scorel came to Nuremberg to be taught by him he found Dürer so preoccupied with Luther that he went elsewhere. By 1520 he was settled in his Lutheran conversion, but still continued in a religious half-world without severing his connexion with Catholicism. He had become Court Painter in 1512, and it was to get his pension and status confirmed by the new Emperor Charles V that in 1520 he made the journey to the Netherlands, which lasted exactly a year. Everywhere he was feasted and fêted, and his fascinating

diary not only records the things he was most impressed with, such as the Ghent Altar and works by Roger and Hugo, but the Brussels bed for fifty people, Mabuse's polychromed house, the gifts and tips he parted with, the man who swindled him, Patinier's wedding, and such-like trivia. His sketch-book records in superb silverpoint drawings places he visited, people he met, things he saw (*plate 169*). But he returned a broken man. He had ventured into the malarial swamps of Zeeland to see a whale, washed out to sea before he got there, and the fever he contracted undermined his constitution.

From about 1520 onwards he seems to have entertained the idea of painting a large Sacra Conversazione for which many drawings exist. At the same time he was occupied with a number of small engravings of Apostles. Eventually, possibly because the religious climate of Nuremberg was unsympathetic to a large religious work, he abandoned the altarpiece, but he adapted some of the finer Apostle figures to wings for the centre of the now non-existent triptych, and in 1526 decided to present them to his native city as a memorial to himself. These are the two tall, narrow panels of the *Four Apostles* (*plates 170, 171*), St John and St Peter in one and St Paul and St Mark

169 DÜRER *Caspar Sturm*

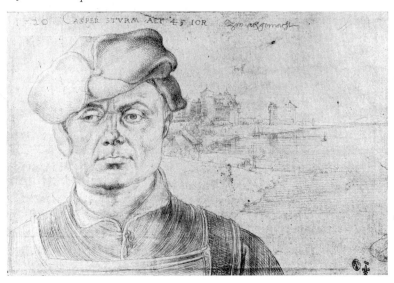

170 DÜRER *St John and St Peter*
from the Four Apostles

171 DÜRER *St Paul and St Mark*
from the Four Apostles

in the other. Each panel contains both an Apostle and an Evangelist, and, in addition to this, the four men typify the four humours: St John as the sanguine, St Mark as the choleric, St Paul as the melancholic, and St Peter as the phlegmatic, and these four temperaments are contrasted with one another so as to endow the figures with the maximum of thoughtful interpretation. Distantly, of course, they echo the four saints in the wings of Bellini's *Frari Madonna* (*plate 234*), and it may well be that the memory of format and content suggested the design of the *Apostles*. It was his last major work. He died in April 1528.

The mainspring of his life and work is to be found in the basic dichotomy of his mind. A patient and humble observer of realistic detail, using as a best-loved technique line-engraving on copper—a technique demanding an exacting and objective accuracy—he was also a visionary. He was embued with the idea of the artist as a creator, inspired by God. Art was an unteachable mystery, yet he sought to rationalize his inspiration by principles, and he recognized that both unrestrained fantasy and the impulsive imitation of nature were not enough, and that art must be controlled by knowledge. He perceived that his contemporaries, though skilled and talented, lacked the discipline of a sound training in theory, and patiently he tried to remedy this in himself; yet he was equally convinced that theories were incapable of doing justice to the immensity of God's creation, and that any good result that may be derived from a sound theoretical foundation in the arts is still entirely dependent on the artist's own intelligence and ability to reshape the theory and transcend it.

His theoretical writings are important when he treats of perspective, which he expounds in a workmanlike manner, or conic sections, in which his diagrams are thorough and practical, but in the theory of Ideal Beauty he starts from a standpoint which, however well it could be argued, precluded any useful end. Alberti and Leonardo had both taken it for granted that Ideal Beauty could be created by the artist; Dürer lays it down as a law that it cannot. Man is imperfect, and absolute beauty is the work of God; Man may not enter into so close a communion with God as to be able to re-create Ideal Beauty. He may create better figures, but not the best.

It is not true that the tension in Dürer was produced by the impact of the Renaissance on an artist trained in a Late Gothic tradition, nor did his yearning for Italy produce the conflict in his mind. The conflict produced the craving for Italy, since he found that there the artist had developed the philosophical and intellectual approach to the arts which he contrasted with the empirical and haphazardly individualistic state of the arts in Germany. Contact with the minds and works of the Italian Renaissance, with the classicism, amplitude, and serenity of Venice in general, and Mantegna, Bellini, and Giorgione in particular, did not create the tension in Dürer: it focused it.

Chapter Seven

During the first half of the fifteenth century, Florentine sculpture was dominated by Ghiberti and Donatello. During the second half, sculpture became a matter either of the acceptance of Donatello's ideas or a reaction against them, and a reaction entailed, largely, a continuation of Ghiberti's graceful and tender art. Outside Florence, the most important early fifteenth-century Italian sculptor was the Sienese Jacopo della Quercia. In some ways his style is close to Donatello's and, like him, he was a powerful influence on the young Michelangelo at the end of the century. Jacopo was born in 1374/75 and died in 1438. He was one of the competitors in the 1401 competition for the baptistery doors in Florence, which Ghiberti won, but Jacopo's entry has not survived and the earliest work attributable to him is the Tomb of Ilaria del Carretto in Lucca Cathedral, probably executed about 1406 (*plate 172*). The tomb seems to show a knowledge of Northern types, since it has a recumbent effigy upon an altar-tomb, and it has even been suggested that he knew the work of Claus Sluter. The *putti* carrying garlands are, however, a classical Roman motive, and are supposed to be the earliest use of such an antique motive on a modern tomb. For this reason, it has been suggested that he took the motive from Donatello, but this would not only mean that the tomb must be later than 1406, but that Roman tombs or altars with this motive were unknown to Jacopo, which is unlikely. One of the difficulties about Ilaria's tomb is that it was broken up and later reassembled, so that it is not known whether it is as the sculptor designed it. His next major work was the Fonte Gaia, for his native Siena, commissioned in 1409 but not finished until 1419. It too has now been dismembered, and is terribly damaged and weathered, but the surviving pieces show a bold, broad, handling comparable with Donatello's and not uninfluenced by him, although Jacopo always remains a far more Gothic artist,

203

172 Jacopo della Quercia *Tomb of Ilaria del Carretto, Lucca Cathedral*

with a strong emphasis on linear effects not, as in Donatello, used for their emotive or dramatic force, but for their decorative and poetic qualities. Jacopo, Ghiberti, and Donatello all worked on the font in the baptistery of Siena Cathedral, and Florentine influence drove Jacopo to attempt similar effects of pictorial perspective in his relief, but they were, fundamentally, alien to his mind, which was happier with the type represented by the Trenta Altar, S. Frediano, Lucca, of 1422, in which fairly high relief figures emerge from a plain ground, giving the maximum play to the linear effects of the figures themselves and their abundant drapery. His masterpiece is the series of stone reliefs round the main door of San Petronio in Bologna, and the freestanding figures of the Madonna and Child and one of the saints in the tympanum above, begun in 1425. Here again, low relief, expressive line, an avoidance in the backgrounds of the kind of pictorial effects that were fashionable in Florence, enable him to achieve a style of rare force and simplicity: it is easy to see from the *Creation of Eve* (*plate 173*) and the *Expulsion from Paradise* (*plate 174*) why Michelangelo so greatly admired these works, which form a link between him and Donatello and Masaccio.

This robustness of form is precisely what was lacking in most of the Florentine sculptors of the next generation. The influence of Donatello was so overwhelming that any reaction against it tended to be a continuation of the delicacy of Ghiberti. Alberti had dedicated his *Della Pittura* to Brunelleschi, Ghiberti, Donatello, Masaccio, and

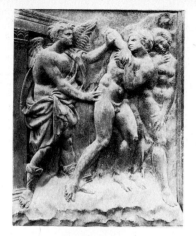
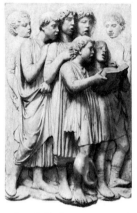
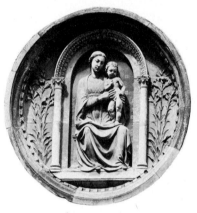

173 (*top left*) JACOPO DELLA QUERCIA *Creation of Eve, San Petronio, Bologna*;
174 (*top right*) JACOPO DELLA QUERCIA *Expulsion from Paradise, San Petronio,
Bologna*; 175 (*bottom left*) LUCA DELLA ROBBIA *Cantoria, detail, Singing Boys*;
176 (*bottom right*) LUCA DELLA ROBBIA *Madonna and Child*

Luca della Robbia, which implies that he expected Luca to play as
important a part in Florentine art as his great contemporaries.
Certainly, the promise of his *Cantoria* (*plate 175*), executed from 1431
to 1438, and for which Donatello's was commissioned as a pendant,
suggested that Donatello was by no means without a serious com-
petitor, but although Luca della Robbia continued to execute occa-
sional commissions in sculpture—the sacristy doors for the Cathedral,
made between 1464 and 1469, were the most important—his dis-
covery of the method of applying vitrified lead glazes to terracotta
led to his specializing in this decorative work for architecture and for

the relief equivalent of small devotional pictures. Plaques for buildings like the Pazzi Chapel, charming Madonna and Child reliefs (*plate 176*), splendidly decorative coats of arms, became the main products of his important workshop, which produced a delightful and popular art, and one not without a good deal of influence despite its modest ambitions, particularly since its life was prolonged into several generations. The antithesis to Donatello's vehemence was readily available in his mild Madonnas in their simple blue and white veils, and they were also a prolongation of the tender grace of Ghiberti, so that both currents of thought existed in parallel. The elegance and delicacy of handling of Desiderio and Mino go far to compensate for the loss of Donatello's energy and inventiveness, and they are also striking parallels of the same tendencies in contemporary painting.

The brothers Bernardo (1409–60) and Antonio (1427–*c*. 1479) Rossellino were architects and building contractors as well as sculptors—Bernardo built for Alberti. Their major works are two large and important tombs which involve architecture almost as much as sculpture. The earlier, by Bernardo, commemorates the great Florentine Chancellor Leonardo Bruni, and was erected in Sta Croce about 1444/50 (*plate 177*). In form it derives from the papal tomb in the baptistery by Donatello and Michelozzo, and this type of wall-tomb dominated tomb design for nearly a century, with no more than minor variations on the theme of sarcophagus, recumbent figure, and subsidiary sculpture, until the Pollaiuoli introduced the major innovation of a representation of a living figure to supplement the effigy. Antonio Rossellino's tomb for the Cardinal of Portugal, made between 1461 and 1466 for a chapel annexed to S. Miniato, on a hill above Florence, is a far grander and more imposing work, but it does not depart—except in increased splendour—from the type established by his brother (*plate 178*).

Benedetto da Maiano (1442–97) retained something of the sturdy quality of the Rossellino brothers in his portrait busts, such as the one of Pietro Mellini of 1474. This has the qualities of a portrait head by Ghirlandaio, such as that of Francesco Sassetti: it is obviously a good likeness, it is competent, but relatively uninspired.

The more delicate style of the later Quattrocento derives from Donatello's experiments in very low relief, from the softer forms

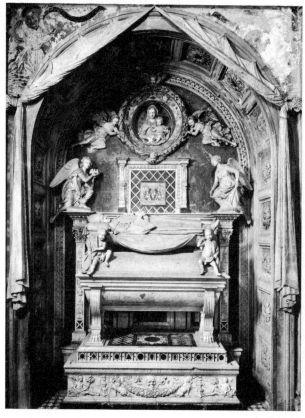

RNARDO ROSSELLINO
ni Tomb, Sta Croce, Florence

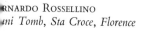

178 ANTONIO ROSSELLINO
Tomb of the Cardinal of Portugal, S. Miniato, Florence

exploited by Luca della Robbia, and from the paintings of Domenico Veneziano and the later works of Fra Filippo; Desiderio da Settignano (c. 1430–64) and Mino da Fiesole (1429–84), who, according to Vasari, was Desiderio's pupil, carried it up almost to the end of the century. Desiderio's tomb of Carlo Marsuppini, Bruni's successor as Chancellor of the Florentine State, follows the normal wall-tomb pattern and, since it faces the Bruni tomb across the nave of Sta Croce, adds an extra point of competition to the striving for elegance, grace, and rich decorative detail, particularly in such enchanting features as the little shield-bearing boy angels (*plate 180*). Both tombs were originally coloured, and traces still survive.

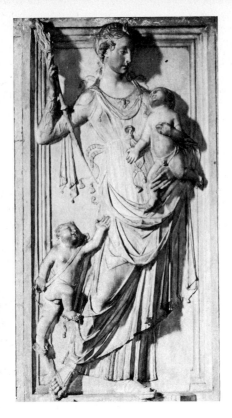

179 Mino da Fiesole *Tomb of Count Ugo of Tuscany, Badia, Florence, detail*

Desiderio's peculiar excellence, as well as the ultimate dependence of his much gentler art upon Donatello, can be seen in the Madonna relief from the Marsuppini tomb (*plate 181*), and in such works as the Sacrament Altar in S. Lorenzo; so tenderly are the forms of hair and features drawn upon the surface of the marble that his handling acquires an extraordinary translucence and delicacy. Mino's tomb of Count Ugo of Tuscany (*plate 179*), commissioned in 1469 and finished in 1481, shows the influence of the antique, a result, presumably, of the years he spent in Rome, where he made several tombs, and worked in the Sistine Chapel on the central screen. His bust of Niccolò Strozzi, of 1454, is a good example of mid-century prose.

In the last quarter of the century the two most important Florentine workshops were both run by men who were primarily sculptors, although they practised other arts with skill—Antonio Pollaiuolo and Andrea Verrocchio. The brothers Antonio and Piero Pollaiuolo are first recorded as painters in 1460, but Piero must then have been still

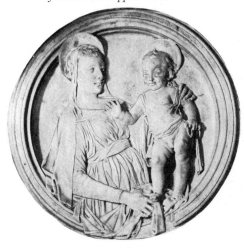

180 DESIDERIO DA SETTIGNANO
Tomb of Carlo Marsuppini,
Sta Croce, Florence

181 DESIDERIO DA SETTIGNANO
Madonna and Child, detail
from the Marsuppini Tomb

a young man, and, in any case, his documented works make it very
clear that Antonio was by far the more talented of the two. Antonio
was probably born about 1432, and his brother was about nine years
younger: Antonio died in 1498, Piero having predeceased him in
1496. Very little is known for certain about their careers, but the
traditional view is correct, in that they were passionately interested
in anatomy and the rendering of violent muscular action by means
of a wiry contour. In this they were the heirs of Donatello and
Castagno (Piero is said to have been Castagno's pupil) and the
precursors of Leonardo as scientifically minded artists. This is most
evident in the relief-like engraving, signed by Antonio, known as
the *Battle of the Nude Men (plate 160)*, where the flatness of the back-
ground and the mirror-images of the figures themselves throw into
the sharpest relief the contours and the play of muscle within the
forms. The *Martyrdom of St Sebastian (plate 182)* applies the same
pictorial principles of decorative pattern on the surface of the picture

209

and intensive study of the anatomical and botanical details. The contrast between the moon-faced saint and the brutish but vital executioners is probably to be explained by attributing the figure of the saint to Piero, who was an artist of no more than moderate competence, as witness the trouble caused by his *Virtues* commissioned by the Florentine Chamber of Commerce. The last years of their lives were spent on two papal tombs—those of Sixtus IV, begun in 1493, and Innocent VIII, from 1492 to 1498, both of which were originally in Old St Peter's. They were completed by Antonio after Piero's death in Rome, where he himself also died. Both tombs have been much altered, so that their original form is difficult to reconstruct. The tomb of Sixtus (*plate 183*) now consists of a low platform, the sides of which contain reliefs of the Virtues and the Liberal Arts, and upon which lies the recumbent effigy of the Pope. The whole is cast in bronze, most elaborately chiselled, and given a refinement and delicacy of finish which accords astonishingly with the robust vigour of the emaciated face, patently based on a death-mask, and the linear exuberance of the details of draperies, hair, jewels, and a multitude of other ornaments. The tomb of Innocent VIII (*plate 184*) breaks new ground. It is a variant of the Florentine type of wall-tomb, for instead of the customary effigy on a sarcophagus surmounted by a relief, usually of the Virgin and Child, the base consisted originally of the seated figure of the Pope, hand raised in blessing, surrounded by reliefs of the Virtues, and surmounted by the sarcophagus and effigy, with the oval relief of the Madonna supported by two angels in the lunette over the effigy. The present garbled arrangement upsets the sequence of the composition, with the living figure above the effigy contradicting the aspiration of the dead man's soul in its intercession for Divine mercy. Again, the tomb is entirely of bronze, and has the same degree of high finish as the *Sixtus*; the pose of the blessing Pope sets a pattern that echoes down the centuries, and itself echoes the thirteenth-century *St Peter enthroned*, which was then, as now, near by. The treatment of the head is less linear than in the *Sixtus*, but it is not in the modelling of the face so much as in its expression of character and life that the power of the head resides.

Andrea Verrocchio (*c.* 1435–88) was even more a sculptor, but his well-organized workshop could deal with orders for almost any kind

182 ANTONIO POLLAIUOLO
Martyrdom of St Sebastian

183 (above right) ANTONIO AND PIERO
POLLAIUOLO
Tomb of Sixtus IV, St Peter's, Rome

4 ANTONIO AND PIERO POLLAIUOLO
Tomb of Innocent VIII, St Peter's, Rome

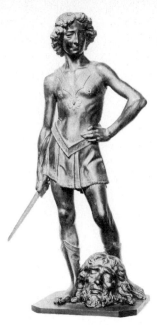

185 VERROCCHIO *David*

186 (*below right*) VERROCCHIO
Colleoni Monument, Venice

of art-work and at one time or another many important painters
worked for him, the greatest being Leonardo da Vinci. Verrocchio
may have been a pupil of Donatello in the latter's old age, but there
is a strong contrast between their approaches to sculpture; Verrocchio
is typical of the Late Quattrocento in his elegance and finesse of
handling, his avoidance of the strong emotional effect, and his
concentration on craftsmanship that indicates the strength of the
goldsmiths' tradition in bronze sculpture. A comparison between
Donatello's *David* (*plate 31*) and Verrocchio's (made before 1476)
(*plate 185*) reveals how deeply the basic ideals of the sculptor have
changed, even in relation to classical antiquity, which both men
would have admitted as a standard by which to be judged. The
Donatello is all relaxation and understatement; the Verrocchio is
tense, alert, the expression mischievous, the minute details of veins
and the thin forms of elbow and neck and hair given the sharpest
relief. In his masterpiece, the Colleoni Monument in Venice (*plate
186*), unfinished at his death, Verrocchio deliberately challenged
comparison with Donatello's *Gattamelata* (*plate 32*) at Padua. He
attempts to render military bravado by such technical feats as the

horse with one hoof raised (Donatello, less skilled in casting, had to support all four). Principally, however, Verrocchio relies on the portentous frown and stiff-legged swagger of his *condottiere*, seated high in the saddle and half turned in a strained attitude—with the result that while Donatello's figure is that of an Imperator, Verrocchio's is a village bully. The passion for minute detail, for the over-elaboration of surfaces, was now so far out of hand that a contemporary critic complained that the horse had been flayed, and despite the tension of the silhouette, the accumulation of minute forms is harmful rather than helpful to the impression of grandeur that the artist strove to create.

The tendency to overstatement is the characteristic of what is sometimes called Quattrocento Mannerism, a term easily open to abuse, but useful in conveying the slightly exaggerated quality of much of the best work done in the last years of the fifteenth century, a period in Florence that was also one of great political upheaval and confusion. The best examples can be found in the work of Botticelli and Filippino Lippi, but it is not unique to Florence, and it will be seen that there is a close similarity to the Northerners of the same general outlook, most notably Bosch and Grünewald.

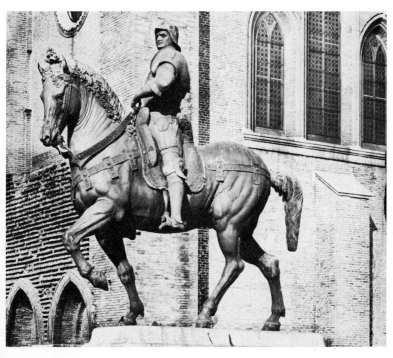

Hieronymus Bosch (*c.* 1450–1516) is one of the most puzzling painters who ever lived. His pictures are, as works of art, beautiful in themselves, and have always been recognized as works of genius, yet we have really very little idea of what they are about, and as early as the sixteenth century there must have been arguments about the devils and fantasies, since a Spanish priest then solemnly defended Bosch's orthodoxy, while a twentieth-century historian has evolved a theory of more than usual silliness about Bosch's heretical leanings. Bosch was a Dutchman, first recorded at 's Hertogenbosch in 1480/ 81, and the first work that is known, a *Crucifixion* (*plate 187*), must date from about this time, and shows, not surprisingly, the influence of Bouts and Roger van der Weyden. There is a group of more or less 'normal' pictures of this type, but quite soon afterwards—Bosch's chronology is very hit-or-miss—he seems to have developed the devil-haunted imagination which is so characteristic of the Late Middle Ages. It is hard to understand all, or even very much, of his symbolism; but there can be no reasonable doubt about the general meaning of such works as *The Ship of Fools* (*plate 188*), a well-known medieval allegory on human folly, or the obsessive nature of the *Temptation of St Antony*, a subject which seems to have been, in one form or another, close to his heart. It may serve as a reminder of the universal belief in witchcraft, but its appeal has been just as great to Freudian psychologists. Almost any details will show how superb a technician in oil-paint he was (*plate 198*), and also how his imagination was fed by the same sources as the early woodcutters, and indeed Dürer himself has links in his *Apocalypse* series and in the painting of *Christ in the Temple*, with this same fantastic riot of late fifteenth-century popular imagery and devotional prints.

Two great painters are akin to him—Breughel in the later sixteenth century and, more immediately, Mathis Nithardt-Gothardt, known as Grünewald. Bosch died before Luther broke away from the Church, but Grünewald, who was born in the 1470s, died in 1528 and may himself have ended as a Lutheran, although much of his life was spent in the service of first the Archbishop of Mainz and later the Cardinal Albrecht of Mainz. His work expresses the torment of the early sixteenth century more fully than that of any other artist. Dürer was too steeped in Italian culture to have much use for the

187 BOSCH *Crucifixion* 188 BOSCH *The Ship of Fools*

tortured Gothic forms which Grünewald twisted to suit his expressive purposes in his masterpiece, the Isenheim Altar, of about 1515. This was painted before Luther nailed his theses to the door of Wittenberg Cathedral in 1517, but it is painted by a man who, like Bosch, used his great technical powers to express a simple, unmistakable message of emotional intensity and terrible realism. These visions are entirely in the spirit of St Bridget of Sweden, whose *Revelations* were one of the most popular devotional books of the fourteenth and fifteenth centuries; they would have been repugnant to all but a very small number of Italians, of whom Savonarola would certainly have been one, and Botticelli might well have been another.

The Isenheim Altar is a complicated structure with four layers of painted surfaces—that is, two sets of wings, like a double cupboard, enclosing the final altarpiece, which consists of three carved wood

215

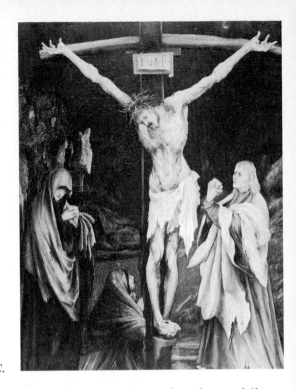

189 GRÜNEWALD
Crucifixion,
Washington D.C.

statues of saints. There are also two side panels and a predella. In form, therefore, it harks back to the type of Burgundian and German carved altar of which the Broederlam at Dijon is a classic example. It was painted for a lazar-house, which explains the presence of the plague saint, St Sebastian, and the patrons of the more austere and solitary forms of monasticism, St Antony Abbot and St Paul the Hermit. On the outside is the *Crucifixion* (*plate 194*), not seen as an event, but as a meditation on the most frightful aspects of suffering, with the theological significance stressed by the Baptist, whose stabbing finger points to the tortured body of Christ, while below the Cross stands the Lamb of Sacrifice. The wings open to disclose an *Annunciation*, a *Nativity* (*plate 195*), and an *Ascension*; and these open again to disclose on either side of the carved innermost shrine two panels, *Sts Paul and Antony in the Desert* and a *Temptation of St Antony*. The *Crucifixion* is sombre and livid; inside, all is a magic glory of brilliant colour and light, and the final scenes of the Desert Saints are again lurid and eerie, with, in the *Temptation*, the kind of devil-haunted imagery that permeated Bosch's visions of sin.

This is a sixteenth-century picture, but the imagery harks back to the expressive violence of Romanesque, and in his portrayal of the ghastly wounds, the agonized feet and hands, the dying face, here and in the smaller *Crucifixion* in Washington (*plate 189*). Grünewald stands at the absolute extreme pole from the elegiac serenity of the High Renaissance, which at this moment was in its final stage in Rome.

Botticelli was born about 1445 and died in 1510. He too is an artist who crosses the dividing line between the hopeful confidence of the fifteenth century and the dark fulfilment of the Savonarola period, so that it is not out of character that he too should develop eventually the same urgency and passionate desire to express the suffering involved in the Passion. Botticelli was probably a pupil of Fra Filippo, so that he must have inherited all the skills of the Italian Renaissance before his first identifiable commission in 1470, for a very Pollaiuoloesque *Fortitude* to go with a series of *Virtues* by Piero Pollaiuolo. From this point his work ranges through the simple, if languorous, imagery of the *Madonna of the Magnificat* (*plate 191*) to the extremely sophisticated imagery of the *Primavera* and the *Birth of Venus* (*plate 190*), both of which, under the guise of simple mythologies are really elaborate images of Neoplatonic interpretations, in a Christian sense, of the Venus myth. Thus, *Primavera* (*plate 1*) is a kind of allegory of civilized living, with Venus as a sort of pagan Madonna (complete with halo) who should lift up Man's mind to the contemplation of that beauty which is Divine in origin. In the same way, the *Birth of Venus* is a very long way away from the Venus Pandemos. It may be argued that this is a rather artificial interpretation, and in a way it is, but it is an interpretation that made sense to the late fifteenth century. It can clearly be seen how, later, under the impact of Savonarola's theocracy and the troubles besetting Italy, Botticelli's imagery becomes less esoteric and more clearly Christian. The best possible example is the *Mystic Nativity* (*plate 199*) with its inscription: 'I Sandro painted this picture at the end of the year 1500 (?) in the troubles of Italy in the half time after the time according to the 11th chapter of St John in the second woe of the Apocalypse in the loosing of the devil for three and a half years then he will be chained in the 12th chapter and we shall see clearly (?) . . . as in this picture.' In order to emphasize the

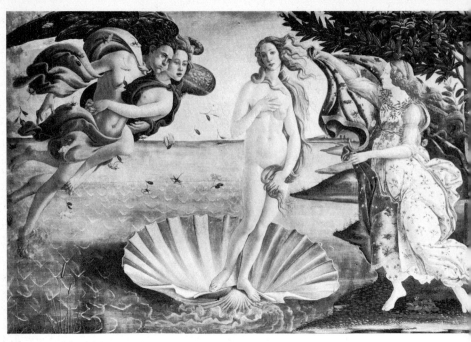

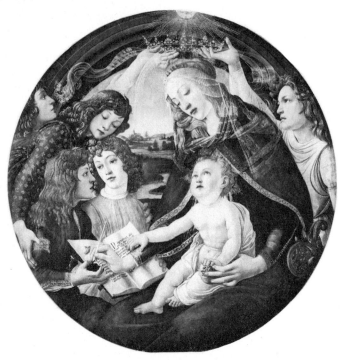

190 (*above left*) BOTTICELLI
Birth of Venus

191 (*below left*) BOTTICELLI
Madonna of the Magnificat

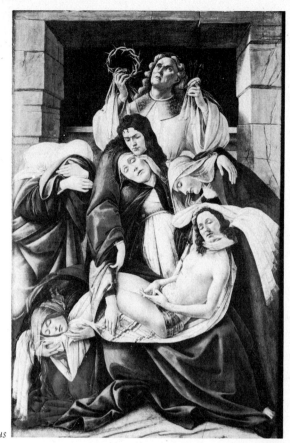

192 (*right*) BOTTICELLI *Deposition*

193 (*below*) BOTTICELLI *Mars and Venus*

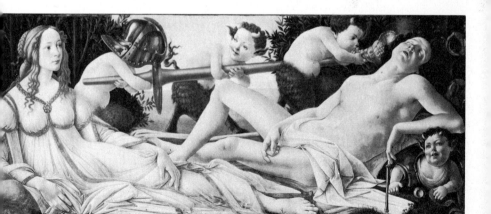

importance of the Madonna and Child and the relative unimportance of the humans, he has reverted to the early medieval device of disregarding scale and perspective and grading the actual sizes of the figures according to their importance; hence the Madonna is far the largest although placed apparently in the middle distance.

The feature that links him most firmly with the Florentine heritage is his linear quality; the view of Botticelli that estimates him as an artist of languid grace, soft and of a kind of sexless sensuality, overlooks the hard, wiry outlines and the firmness—the marble, almost —of his surfaces. Lilies and roses, languor and rapture are all there, superficially, but held together underneath by an almost Gothic precision of line, and a concern for solid form derived from the Florentine obsession with sculpture.

Botticelli's last works, executed between 1500 and 1510, have something of the emotional intensity of the Northerners, and his *Deposition (plate 192)* may well be compared with Grünewald's *Crucifixion (plate 194)* of about ten years later, with the reservation that no Italian would have conceived of representing it in those terms. For all the agony of suffering that Botticelli expresses, the forms of his dead Christ echo those of the calm, proud nude in the *Mars and Venus (plate 193)*, and the stylizations he has used to render the impact of his forms more poignant are of virtually the same kind as in the mythology. The Virgin's tragic mask, the collapse of Christ's dead body, are pathetic, but the formal balance of the composition, the deliberate use of the purest forms to express the abandon of grief touch chords which are different in essence as well as in resonance from Grünewald's horrific vision.

At the height of his most successful period, during the 1480s, he had made use of every convention of continuous representation, movement, agitation of pose and drapery, surface elaboration, for instance in the three frescoes he contributed to the Sistine Chapel series. This trend towards the organization of the surface of the picture in terms of the maximum effect to be derived from a multiplicity of contrasting forms becomes an abiding feature of Florentine art at the end of the century. Filippino Lippi (1457/8–1504) was probably Botticelli's pupil after his own father's death in 1469, and he shares something of the same obsessive quality.

194 GRÜNEWALD
Isenheim Altarpiece,
Crucifixion

195 GRÜNEWALD
Isenheim Altarpiece,
Nativity

196 FILIPPINO LIPPI *Madonna and Child with St Dominic and St-Jerome*

In Filippino's work there is even more nervousness and agitation; every drapery flutters wildly and all the figures float or posture, yet there is less genuine emotion expressed and many of his works have too great a display of his passion for modish classical bric-à-brac. This is not true of his masterpiece, the *Vision of St Bernard* (1486) (*plate 202*), which is contemporary with the calm (but rather insipid) version of the same subject by Perugino. Filippino's picture has a grace and tenderness that his work only occasionally achieves, as in the *Madonna and Child with St Dominic and St Jerome* (*plate 196*). The frescoes in the Strozzi Chapel in Florence, on the other hand, show his desire to obtain emotional excitement and, at the same time, to display his knowledge of antique objects (*plate 197*).

These pictures were painted at the end of the century, and it is not difficult to see how the tide was now turning away towards the sobriety and realism of Perugino and Leonardo, whose researches were devoted to actuality and simplicity of grouping rather than to the febrile emotionalism of the Quattrocento Mannerists. Nevertheless, there is an excitement to be derived from Filippino and Botticelli that is never provided by the staid Perugino. The art of Piero di Cosimo provides a wistful half-way house. He was, according to Vasari, a wayward and extravagant character, living on hard-boiled eggs cooked fifty at a time along with his glue. His greatest contemporary fame rested on his designs for carnival processions, especially those for one gruesome Triumph of Death in 1511. His *Lapiths and Centaurs (plate 217)* shows the sympathy with nature and with the half-human that seems to have been one of the most attractive sides of his character.

197 FILIPPINO LIPPI *St Philip Casting Out the Devil*

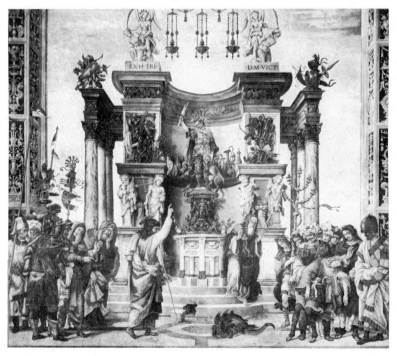

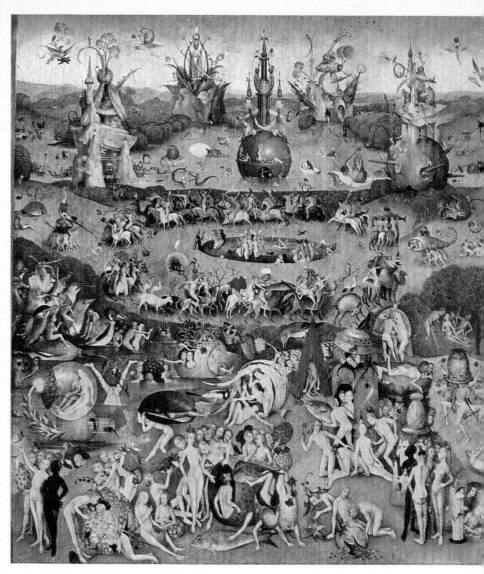

198 BOSCH *Earthly Paradise*

199 (*right*) BOTTICELLI *Mystic Nat*

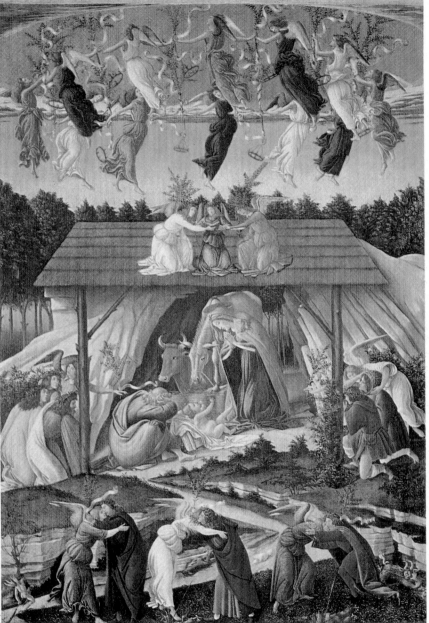

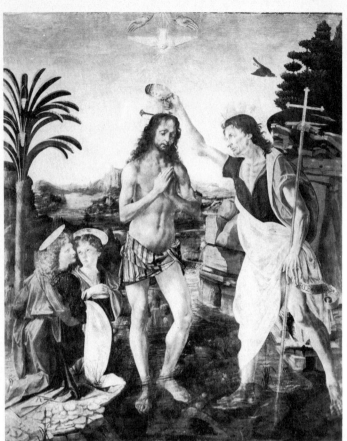

200 VERROCCHIO
The Baptism of Christ

201 LEONARDO DA VINCI
Annunciation

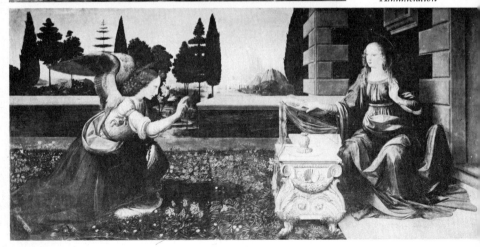

Chapter Eight

Leonardo da Vinci was regarded, even by his contemporaries, as an astonishing virtuoso, and to the men of the sixteenth century he seemed to have been the last of the primitives, or the first of the generation active around 1500 which they regarded as the culmination of the whole process of the Renaissance. Frequently Leonardo, Raphael, and Michelangelo are taken together in these terms, but it is important to remember that Leonardo was born in 1452 and was therefore at work long before the others, who are usually thought of as his contemporaries. The only real parallel is with Bramante, who was slightly older and whose friendship with Leonardo in Milan in the 1480s and 1490s was probably decisive for many aspects of Milanese art around 1500. Leonardo has always been famous because of the fantastic range of his genius; he was not only one of the greatest artists in an age of great artists, but he was probably the best anatomist in the world and a natural scientist almost without a peer in many branches of knowledge such as botany, geology, and even the beginnings of aeronautics. Nevertheless, his thousands of notes and drawings on these and other subjects have only been rediscovered and evaluated comparatively recently, and to many of his contemporaries Leonardo must have seemed a strange man who wasted his time on extravagant projects that never came to anything. There are barely some fifteen pictures by him, and some of these are damaged beyond repair. He began life as a perfectly traditional apprentice in the shop of the painter and sculptor Verrocchio, and the first account of his precocious genius is that he painted the left-hand angel in the *Baptism* (*plate 200*) by Verrocchio, and that as a result Verrocchio swore that he would give up painting. It is certainly true that Verrocchio did concentrate on sculpture from this time on, and that the picture of the *Baptism* is clearly executed by two very different hands, and even then not entirely finished; it is therefore reasonable

227

202 FILIPPINO LIPPI *Vision of St Bernard*

203 PERUGINO *Vision of St Bernard*

to assume that Verrocchio decided to employ Leonardo as the principal painter in the firm. It is not certain when this took place, but Leonardo became a Master in the Guild of Painters in 1472 and was living in Verrocchio's house in 1476 when an anonymous accusation of homosexuality was made against him. The accusation was almost certainly true, and may explain some of Leonardo's characteristics such as his tendency to live as a recluse, and his proneness to abandon things half done. There is an early *Annunciation* (*plate 201*) which is usually regarded as his work, painted when still in Verrocchio's shop, and this shows, in the wings of the angel and in the drapery of the Madonna, two of the characteristics of his art. The angel's wings have been studied in detail from those of a bird and are quite different from the conventionally feathered wings which most fifteenth-century painters gave to their angels. Similarly, there is a drawing for the Madonna's draperies which has obviously been made from an actual piece of cloth. In the fifteenth century this was a revolutionary proceeding, for most painters painted the folds in garments from their imagination, but it soon became known that the young Leonardo was making careful drawings of the fall of actual folds and using the drawings to work from. The result was not to send other painters to make similar studies; they simply borrowed Leonardo's drawings; but in both cases it is evident that he was already demonstrating that passion for actuality and curiosity about the appearance of nature which was to be his principal characteristic. Not surprisingly, he soon began to use the new oil technique, or rather to experiment with it, for many of his paintings have been much damaged by the fact that he was experimenting with new technical methods. One such case is the *Madonna with the Flower Vase* (*plate 205*), probably painted in the 1470s, which has a minutely painted vase of flowers with drops of condensation represented with such skill that Vasari commented on them nearly a century later. Of about the same date is a much more beautiful picture which has unfortunately been cut down; this is the portrait that almost certainly represents Ginevra de' Benci, and was painted probably on the occasion of her marriage in 1474 (*plate 206*). The sitter's pale face stands out against a dark background of carefully observed juniper branches —*ginepra*—an obvious reference to her name. Originally there must

204 LEONARDO DA VINCI *Adoration of the Kings*

have been hands, very probably those shown in the drawing in the Royal Collection at Windsor Castle (*plate 211*). As early as 1474, therefore, Leonardo had evolved a half-length portrait that looks forward to the *Mona Lisa*.

The most important work of this period, however, is the *Adoration of the Kings* (*plate 204*), which was commissioned in 1481 for a monastery just outside Florence. Leonardo left it unfinished, and no payments are recorded after 1481, but the careful, brownish lay-in is one of the most important works painted in Florence in the last quarter of the fifteenth century. The picture (which is about eight feet square) is a solution to the problem of representing a large number of figures crowded round a central group of Madonna and

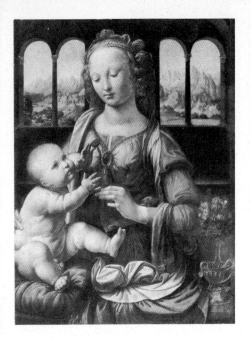 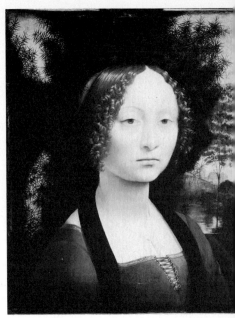

Child, yet so arranged that the most important figures are not swamped. This he did by using a pyramidal form of composition, which creates an effective depth, but at the same time gives major linear patterns on the surface of the picture so that the spectator's eye is led to the most important parts. The *Adoration* is full of closely observed gestures and facial expressions, and it has a haunting, romantic quality in the shadowy press of figures around the serene central group, in the medley of old men, youths, horses, riders, which surge up from among the ghostly figures that inhabit the ruined architecture in the background. It is no exaggeration to recognize in this picture the watershed of Renaissance art, for as much as Masaccio's *Pisa Madonna* or *Tribute Money* (*plate 38*) it breaks with all that had gone before it, and determines the eventual course of Florentine, and therefore of Italian, painting. Unfinished though it may have been, and possibly largely because no considerations of extraneous detail blurred the concentration on the purely formal solutions it proposed, it was an event after which the forms of Florentine art as they had till then been pursued might still linger on in a Botticelli or a Ghirlandaio, but linger only as survivals of an older, relegated order.

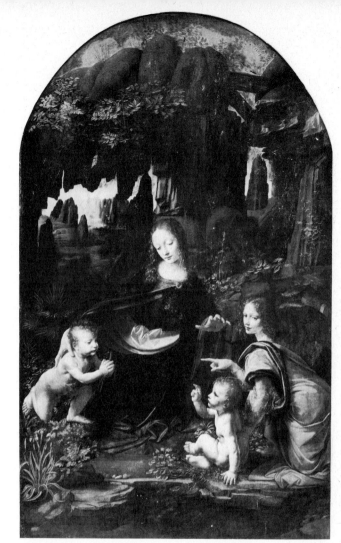

207 LEONARDO DA VINCI
*Virgin of the Rocks,
Paris version*

Among Leonardo's notebooks is a draft of a letter to Lodovico
Sforza, the Duke of Milan, in which he claimed at some length
to be able to do almost everything, but principally to be a military
engineer, and only at the end, almost as an afterthought, did he say
that he could act as an architect, a sculptor, and 'in painting I can do
as much as anyone, whoever he may be'. It is not known whether
this letter was ever sent, but Leonardo was certainly in Milan in 1483
when he was commissioned to paint the picture now usually known
as the *Virgin of the Rocks (plate 207)*. This painting has long been a

233

208 LEONARDO DA VINCI *Study of Acorns* 209 LEONARDO DA VINCI *Anatomical Study*

source of controversy since there are two versions, one in the Louvre and one in the National Gallery in London. With almost any other fifteenth-century painter the existence of two closely similar pictures would not present any problem at all, but Leonardo completed so few pictures that it seems almost inconceivable that he should have painted two so nearly the same. The documents begin in 1483 and go on until 1506 and all of them seem to refer to one picture which, it is now generally agreed, can only be the London version. On the other hand, the Paris version not only is clearly by Leonardo, but is obviously rather earlier in style and retains sufficient likeness to the pictures of the Florentine period to make it convincingly datable in 1483. Once more the basic form of the composition is pyramidal and the interrelationship of the figures is such that a triangular pattern is formed on the picture plane, the apex of which is the head of the Madonna. Once more, the relationship of the figures to their mysterious setting has the same quality of dream-like fantasy as in

234

210 LEONARDO DA VINCI *Landscape with Storm* 211 LEONARDO DA VINCI *Study of Hands*

the *Adoration*, with overtones here of the purely intellectual approach
to the problem presented by the disposition in a convincing internal
space of four figures in the closest and most meaningful psychological
union. Leonardo's interest in botany and geology can be seen in the
curious setting in a cave as well as in the flowers which carpet the
ground. Many drawings of this period exist for similar flowers, and
there is a very beautiful drawing in Turin for the head of the angel.
At the same time, he was making scores of drawings in his notebooks
on a variety of other subjects (*plates 208, 209, 210, 211*), principally on
architecture, human anatomy, and the anatomy of the horse. The
many drawings of horses and riders (*plate 221*) are probably con-
nected with a projected book on the anatomy of the horse, while
others were made for the monument to Lodovico Sforza's father on
which he spent sixteen years, but which never got beyond the clay
model of the horse. This was destroyed early in the sixteenth century
and the figure of Sforza himself was never even begun.

235

212 GIOVANNI BELLINI *Agony in the Garden*

213 MANTEGNA *Agony in the Garden*

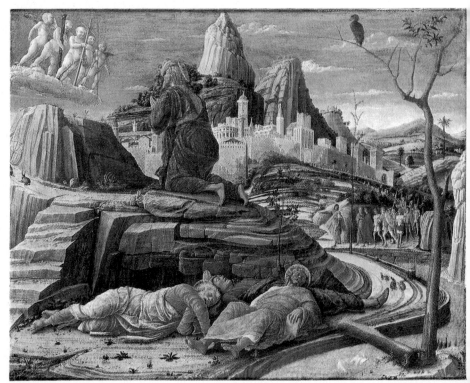

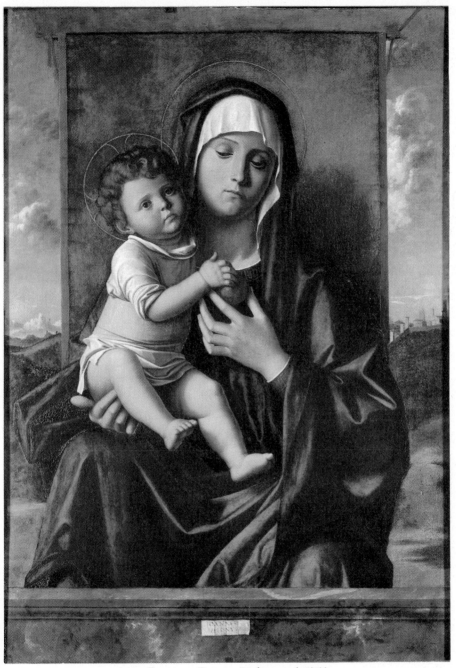

214 GIOVANNI BELLINI *Madonna and Child*

The other great work of this period is, of course, the *Last Supper* (*plate 215*) in the refectory of the monastery of Sta Maria delle Grazie —one of the most famous pictures in the world, though now hardly more than a noble ruin. Leonardo is known to have been working on it in 1497, and it is the picture, which, perhaps more than any other, can be said to be the first painting of the High Renaissance. It is probably no coincidence that the monastery church was being completed at this very moment by Bramante in a style which was to evolve within a few years into the classical architecture of the High Renaissance. What is so important in the *Last Supper* is the way in which Leonardo went far beyond his predecessors in the attempt to render the inner drama of the precise moment at which Christ announced that one of His disciples would betray Him. If one looks at an earlier example, such as Castagno's (*plate 85*), or even an almost contemporary one such as Ghirlandaio's, it is clear that the artist has simply disposed the Apostles on either side of the central figure, eleven of them with pious expressions and the twelfth, Judas, clearly singled out by the fact that he is on the opposite side of the table from all the others, and has a different expression. In Leonardo's picture there is, for the first time, a grouping of the Apostles not merely symmetrically, but in small groups of three contrasted types that balance each other as they turn questioningly one to the other, and yet interlock through the whole composition as the meaning of Christ's words and the emotions they evoke run through them. Judas is singled out not by being made villainous-looking but by the way that he starts back at his own guilty knowledge, and has his head so placed that, alone among all the figures, his face is in shadow.

There is a story, probably apocryphal, that the Prior, in a vain effort to spur Leonardo on to further effort, complained that he used to come in the morning, stand looking at the picture for half an hour, put on a dozen brush-strokes and go away for the day. Leonardo explained that he was having great difficulty in visualizing the face of anyone as wicked as Judas, but suggested that if there was really a great hurry he would put in the Prior's portrait. The offer was presumably not accepted; but the idea of the artist as a meditative philosopher and not simply as a highly skilled workman who covered so many square feet of wall each day must have seemed

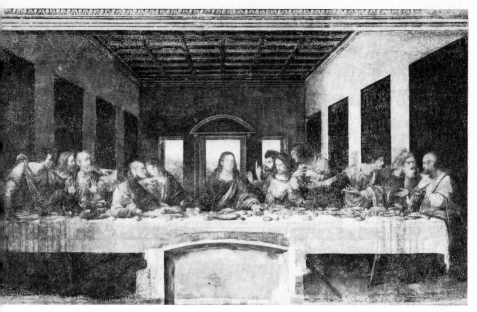

215 LEONARDO DA VINCI *Last Supper*

very strange to the Prior, and indeed to most of his contemporaries. The sixteenth-century conception of the artist as a creative genius, like the poet and unlike ordinary craftsmen, can certainly be traced back to Leonardo.

At the end of 1499 the French invaded Milan and the Sforza dynasty fell. Both Bramante and Leonardo left the city and went south, Bramante to Rome where he was to evolve those architectural forms that in their lucidity and harmony are the very essence of the High Renaissance, and to preside over the birth of the designs for the new St Peter's; and Leonardo through Mantua and Venice to Florence, where he arrived in 1500, and where, with longish intervals away, he was to spend the next six years. During his second Florentine period his position was markedly different from what it had been before he went to Milan. He had gone as a promising young man; he returned preceded by the fame of his *Last Supper*. Much of his time and energy he spent in continuing the studies in anatomy that had occupied him in Milan, where he had begun a book on it; it was he who invented the system of so representing a muscle that its function was clear, while eliminating its bulk which only obscured what lay

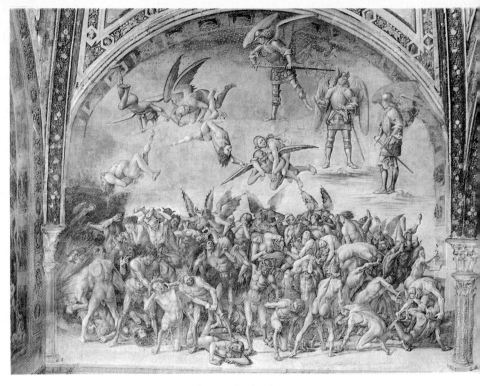

216 SIGNORELLI *Last Judgment, detail, The Damned*

217 PIERO DI COSIMO *Lapiths and Centaurs*

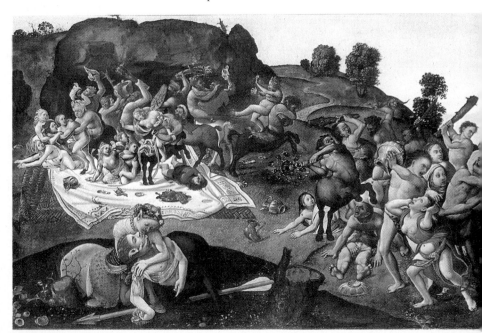

underneath it. It is also clear that Leonardo's anatomical drawings were made from actual dissection on bodies, from a medical standpoint—nothing else would explain the pathetic drawing of a foetus within the womb—and not merely from the observed surface for experiment and assistance in his painting. He put the lessons to good use, though, for in 1503 he was commissioned by the Signoria in Florence to paint on one of the walls of the Great Council Chamber a picture of the Florentine victory of the Battle of Anghiari, as a pendant to Michelangelo's *Battle of Cascina*. Michelangelo's choice of subject was not the battle itself but nude studies of the warriors preparing to fight: it was a hymn to the perfection of male beauty and virility. Leonardo chose to represent the white heat of the battle itself; a furious medley of men and horses in a struggling mass, the horses fighting as ferociously as the men, in an attempt to render what he himself called the bestial madness of war. But he also chose to use a novel technique—he had neither knowledge nor experience of fresco painting, as had been proved in Milan—and the wax medium that he used proved not only useless but destructive, for it melted and ran. In 1505 work stopped, and all that survived were a few drawings. All that is known of the painting is derived from these and from some free copies made before its eventual disintegration.

The other works of this period are the cartoons for the *Madonna and Child with St Anne*, and the *Mona Lisa*. The cartoons are a continuation and an extension of the problem he first faced in the *Virgin of the Rocks*: how to compose in pyramidal form a group of two adults and two children, closely knit physically and psychologically. The earliest of them is probably the one in London (*plate 218*), executed most likely towards the end of his stay in Milan. The Virgin is seated on one of St Anne's knees, holding the Child, who leans across them both; the heads of the two women are at the same level, their faces turned inwards, and both with the tender, mysterious half-smile which gives movement and vivacity to the expression. But the group is fairly wide at the base, and the pyramid rather wider than deep; the little St John is not fully knit into the group. The Louvre picture is an unfinished painted panel (the London one is a drawing on paper), for which no preparatory

241

cartoon stage is known to exist. Here the Virgin, seated on St Anne's lap, leans forward to restrain the Child, who attempts to bestride the lamb; the two women are impacted one into the other, and St Anne's tender glance is directed downwards at her daughter, while the Virgin and Child look at each other, so that there is an almost Giottesque use of the meaningful look, imposed upon a formal structure reminiscent of Masaccio's similar composition. The little St John has been replaced by the lamb, and the meaning is extended by the significance of the Child clasping the symbol of His Passion.

Mona Lisa was not a famous beauty, nor a grand person, but merely the wife of a Florentine official. Leonardo had painted several portraits in Milan—Ludovico's mistress, and a musician, and there are probably two others that owe much to him, even if he did not entirely execute them himself. He had also been compelled to begin one of Isabella d'Este when he was in Mantua after his flight from Milan. There is a close connexion between the *Mona Lisa* (*plate 219*) and the features he used for the Virgin and St Anne in the cartoons, even in the one which he is believed to have started in Milan, so that her gentle and secretive face seems to have been as much in his mind's eye as a real physical presence. Vasari elaborates upon her tender colouring, on her moist eyes, and delicately tinted lids and mouth and nostrils: not a hint of this natural flesh that he so admired survives in the subaqueous gloom through which she now looks out at us. She develops the type of the early *Ginevra*, and with her folded hands lying on the arm of her chair creates the classic half-length pose that continues to echo down the centuries from Raphael to Rembrandt, and has become so much a commonplace that it is difficult to realize on looking at her that it was once new and fresh. The parapet of the window against which she sits looks out on to a vast and shadowy landscape, as fantastic as the cave that shelters the *Virgin of the Rocks*, as imaginative as his views of alpine scenery in storms and floods. The execution is in an oil-technique of infinite delicacy and softness; the tones of the modelling are as if breathed rather than painted on to the panel, and only the major forms survive—her flickering half-smile, her long nose, her eyes as heavily lidded below as above and eyebrowless so that the smooth expanse of her forehead has no interruptions. How much real woman, how

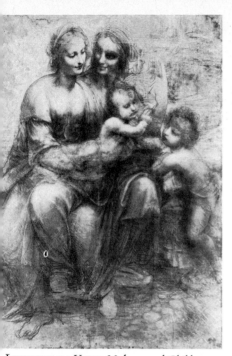

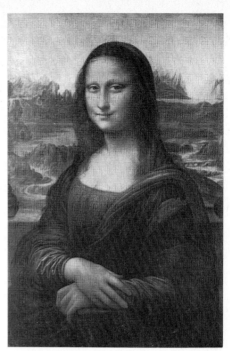

LEONARDO DA VINCI *Madonna and Child with St Anne, London version*

219 LEONARDO DA VINCI *Mona Lisa*

much tutelary Muse, will always remain an enigma, and perhaps intentionally, since she is the embodiment of an idea as much as an essay in portraiture.

Leonardo spent nearly the whole of 1502 away from Florence, serving as military engineer to the ruffianly Cesare Borgia in his campaign of terrorism; in 1506 he came to terms with the French invaders and returned to Milan. He was appointed Painter to Francis I of France in 1507, and began, in his usual dilatory way, to design an equestrian monument to the city's governor, Trivulzio. He also resumed his anatomical drawings, and filled books with his study of muscles and embryology. When French control of Milan ended in 1512, he turned towards the new centre of patronage in Rome, and in 1513 he went there at the instance of Giulio de' Medici, the Pope's cousin, and was lodged in the Vatican. Nothing came of the four years he stayed there but increasing frustrations born of his unproductiveness, and this at a moment when Raphael and Michelangelo were executing their greatest works. In 1517, with perhaps

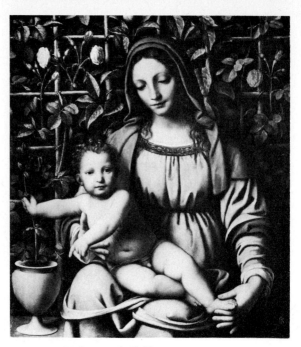

220 Luini *Madonna and Child*

something of desperation, he went to France, accepting the offers of
Francis I, who was seeking to build up a team of Italian artists for
prestige purposes. But he was an old man by now with only two
more years to live, and it seems not unreasonable to suggest that he
was tired, disillusioned, and overburdened, not only by the weight
of his immense and almost unusable knowledge, but also by con-
sciousness of the little he had to show for it all, and by the way in
which in the end his fame had left him isolated while the victories
lay with younger men who had learned from him, but who now
divided Rome between them, and whose brilliant language of syn-
thesis and generalization was entirely alien to his patient questioning
of each individual form and his refusal to elaborate general theories.

All that he had left behind in Milan was the wreck of the promis-
ing school existing at the end of the fifteenth century. Bramante's
Roman works were few, though influential; it was in Milan that the
stimulation and excitement of the creation of a new style had existed.
Vincenzo Foppa (1427/30–1515/16) was the leading painter in Milan
until the advent of Leonardo; he had the same background as

Mantegna, with a Paduan and Squarcionesque training, and had leaned somewhat towards Giovanni Bellini—who did not, in North Italy at that time?—but his quiet provincial talent with its hints of Florentine perspective, rather generalized forms, and tender handling were quickly submerged. Bramantino, who died in 1530, worked chiefly in Milan, where he became Painter to Francesco Sforza II in 1525. His name would suggest that he was a follower of Bramante, but whether in painting or in architecture is uncertain; the sketch-book of ruins of Rome, often attributed to him, is, however, fairly certainly by him. His art was a strange one, almost Poussinesque in its arrangement of volumes and in the austerity of its composition. The influence of Leonardo was almost entirely disruptive. His fascinating chiaroscuro, the soft modelling of his forms, his infinitely delicate, smoky finish, was imitated fervently and indiscriminately, his tender mysterious smiles became a standard grimace with his followers. Only Bernardino Luini (c. 1481/2–1532), who began well within the fold of Bramantino and Foppa, and was dragged into the orbit of Leonardo, not by personal contact but by the mesmeric effect of his works, survives the dangerous influence, but at the cost of his lightness and gaiety of colour, which took on the gloom of Leonardo's overworked surface, and the independence of his vision, which becomes a pale reflection of Leonardo's compound of naturalism and tenderly idealized and reticent smiles (*plate 220*).

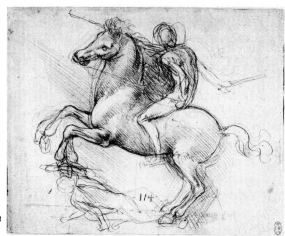

221 LEONARDO DA VINCI *Study of a Horseman*

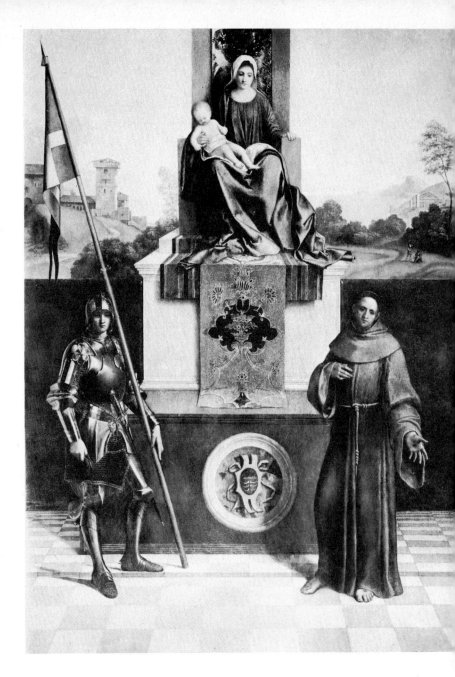

222 GIORGIONE *Castelfranco Madonna*

Two of the followers of Piero della Francesca afford a good example of the diversity of style of the last years of the fifteenth century. Neither Signorelli nor Perugino seem, at first sight, to have very much in common with Piero, or indeed with each other; but both men were born about the middle of the century and were perhaps working under Piero in the 1460s. Subsequently Signorelli developed a powerful linear style, rather melodramatic at times, which in its obsession with outline and with the dramatic possibilities of the male nude obviously looks forward to the work of Michelangelo. Perugino, on the other hand, was the master of Raphael and the initiator of a phase, sometimes called Early Classicism, which was the herald of the High Renaissance style of the years around 1510.

Signorelli was born at some date in the 1440s at Cortona and is known to have been active as a painter by 1470. A few fragments dating from 1474 seem to confirm the influence of Piero della Francesca, but very soon after this he must have gone to Florence, where he at once came completely under the spell of the ideas of movement and anatomy which were being worked out in conjunction with expressive outline by Antonio Pollaiuolo and Verrocchio. He appears to have received a commission for one of the Vatican frescoes in the Sistine Chapel in the early 1480s, and from then until his death in 1523 his style hardly changed, though his later works, from about 1505 onwards, have a harshness of colour and a repetitive dullness consistent with his having maintained, in the last years of his life, a provincial workshop which did not attempt to rival the works of Michelangelo and Raphael that he had seen when he visited Rome about 1508 and in 1513. The climax of his whole career, the most typical example of his art and one of the characteristic works of the Late Quattrocento, is the fresco cycle which he painted in the Cathedral at Orvieto between 1499 and 1503. The whole chapel

consists of a series of four large frescoes on the walls, smaller frescoes on either side of the window over the altar, and a further series on the vaulting and round the entrance arch. More than fifty years earlier Fra Angelico had begun a *Last Judgment* on the ceiling immediately above the altar so that the theme of the fresco cycle was more or less fixed. Signorelli turned it into an enormous and pessimistic representation of the End of the World, and there can be no doubt that this choice must have seemed very relevant to the people commissioning the cycle.

During the 1490s the political state of Central Italy had been more than usually upset, and Florence, in particular, had passed through the extraordinary episode following the death of Lorenzo de' Medici and the expulsion from the city of his heirs. The apocalyptic preaching of Savonarola had set the whole city by the ears and brought it to the brink of civil war. Savonarola had provoked the Pope to such an extent that he had brought down excommunication on himself, and he was eventually judicially murdered in circumstances of the greatest complexity from which the facts that emerge most clearly are the vengeful barbarity of his accusers and that he brought a great deal of his fate on himself in a deliberate search for martyrdom. He had endeavoured to impose a theocratic rule on Florence which was by no means to the taste of all the Florentines. His sermons apparently struck terror into everyone, although to read them nowadays they seem turgid revivalism. In particular Savonarola was continually threatening the vengeance of God in general terms, and an invasion by the French as part of that vengeance. In 1494 the first of the French invasions took place, and to the surprise of everyone the French army swept through Italy, easily routing the professional mercenary soldiers of the Italian states who were not accustomed to fighting battles in which people were killed. So rapid was the French advance that they found themselves at Naples almost before they knew what had happened, and, having outrun their supply lines, they were forced to fight their way back again. The reputation of the Italian commanders as great professional soldiers was irretrievably shattered, and it became clear that a modern centralized state such as France had become could dominate a loose federation of Italian states, none of which could ever be trusted to keep faith with its

temporary allies. In 1499 the French returned and took possession of the Duchy of Milan, this being the occasion when both Leonardo and Bramante left the city. Half of the sixteenth century was spent in a warfare between France and Spain, fought out in Italy for the possession of the peninsula. The economic and political power of a state like Florence was broken for ever, although the Italians retained their cultural supremacy for at least another century. In 1494 and again in 1499 the French armies by-passed Orvieto on their way to Rome, so that the town, isolated on its hill-top, was not seriously affected by the fighting. The two salvations of the city were the direct cause of the completion of the fresco cycle, and that Signorelli chose to illustrate terrors which, according to Revelations are to accompany the arrival of Antichrist and the End of the World was highly significant. The arch over the entrance shows a number of scenes, the earthquakes, the ships stranded on mountain-tops, the eclipse, and the rain of blood which appear in various apocryphal legends as the warnings in the last ages of the world. As one enters the chapel proper, on the left and right walls are two large scenes of the spurious miracles worked by Antichrist and the crowds who are seduced by him before he is finally put down by the archangels. The right-hand wall has the next stage, the Resurrection of the Flesh, with bodies and skeletons crawling out of the ground and with various scenes of families reunited. The next two scenes on either side of the altar and immediately below Fra Angelico's figure of Christ in Judgment are the traditional representation of the Blessed and the Damned. It is in the scenes of the Damned that Signorelli's imagination is most fully revealed and both the Devils and the Damned are drawn with hard Florentine outlines and with a vigour which is entirely different from earlier representations of the same subject (*plate 216*). Instead of fantasy creatures, half man, half beast, or insect, his devils are entirely human, and they torture their unhappy, writhing victims with the passionate enjoyment that only humans bring to such a task; their horrible humanity is increased by their colour, for their bodies and faces shade through every gradation of the greys and purples and greens of decomposing flesh. Signorelli's normally strident and harsh colour sense has here an appropriateness markedly lacking in his more pacific subjects. The Resurrection scene provides

a fascinating commentary on the difference between the empirical anatomy that so obsessed Florentine artists in the third quarter of the fifteenth century and Leonardo's really profound studies in the subject, for the bodies of the risen dead display bone formations of purely fanciful character and quite imaginary musculature, yet Signorelli has always been credited with a more than normal interest in anatomy, and even Vasari speaks of his showing 'the true method of making nudes'.

Yet he anticipates Michelangelo's work in the Sistine Chapel, both in the ceiling and, even more, in the *Last Judgment*; but the difference between them is not simply that Michelangelo had a deeper imagination and a greater technical mastery. Signorelli's figures, in fact, sum up all the advances in knowledge that had been made from Masaccio onwards and they have the same forcefulness and clarity, taken as individual figures, that inform those of Castagno or Donatello. The great weakness of Signorelli's work, like that of Botticelli or Filippino, is that all the parts compete against one another so that the fresco as a whole becomes filled with a multiplicity of gesticulating figures and it is impossible to determine amid the uproar which are the important figures and which the subordinate ones.

Precisely this feeling for lucidity and for simplification in the narrative was the contribution made by Perugino, and he undoubtedly learnt it from Piero della Francesca during the very years when Signorelli was also studying under him. Perugino was born near Perugia, at about the same time as Signorelli, and died in the same year, 1523. Like Signorelli, his best work was done between 1495 and 1500 and, indeed, he retired to Perugia about 1506 when it became evident that his style was so old-fashioned that there was little chance of further employment, either in Florence or in Rome. Again, like Signorelli, Perugino must have gone to Florence very soon after leaving Piero's shop, since he is recorded in the Florentine Guild in 1472. He was commissioned in 1481 to paint the key frescoes in the Sistine Chapel in the Vatican. This was the most important commission of the late fifteenth century, for it involved a complete cycle of frescoes on a most ambitious scale and scheme, and on it were employed all the major painters of the day, most of them Florentines, but also including Perugino, Pinturicchio, and Signorelli.

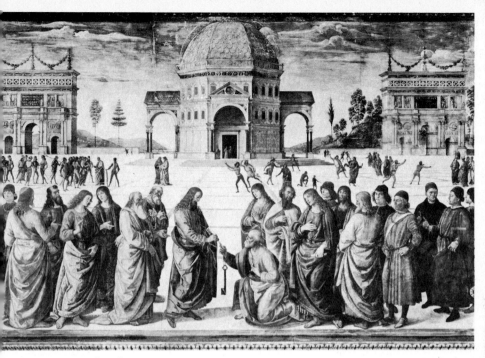

223 PERUGINO *The Charge to Peter*

It is a comment on the state of the arts in Rome that for so grand a work it was necessary to rely entirely on artists temporarily brought in for the purpose, and a signal contrast with what obtained thirty years later, when the artists—admittedly also imported—came to establish Rome as the central focus in the arts, and to found a specifically Roman and papal tradition of patronage. Perugino—who seems to have been Sixtus IV's favourite painter—executed the pair of histories on the altar wall flanking an altarpiece of the *Assumption*, which he also painted (and which were all destroyed to make way for Michelangelo's *Last Judgment*), and *The Charge to Peter* (*plate 223*) This fresco stands out from all the others in the chapel in the extreme clarity of its composition and also in the way in which the architectural elements are made to play an important part in the composition as a whole and are not merely decorative adjuncts. The church in the background is not merely symbolical; it is the centre of the composition. The picture is so organized that the concentration of the spectator is fixed on the single event; the perspective of the paving, the alternation of light and dark masses, the placing of

subsidiary figures and groups, and the triumphal arches in the background, all contribute not to a diffusion of interest but to its focusing on the central point. The same qualities of calm and order can be seen in his *Vision of St Bernard* (*plate 203*), which, as an object lesson should be compared with the same subject by Filippino (*plate 202*), and in the superb fresco of the *Crucifixion* which is treated not as an event to be represented realistically, but as a subject of contemplation, a mystery to be pondered in the stillness of a placid landscape. In both cases, however, and much more obviously in some of his Madonnas, there is a certain emptiness and, above all, a vacuously pious expression on the faces which can become positively irritating. This is the price that had to be paid for the restoration of order into late fifteenth-century Florentine painting. The fresco cycle painted in the Sala del Cambio at Perugia between about 1496 and 1500— exactly contemporary with Signorelli's frescoes at Orvieto—has most of Perugino's virtues as well as his shortcomings; it is also a vitally important work in the history of art, since it is almost certain that it was here that the seventeen-year-old Raphael gained his first experience as a fresco painter on a large scale. If occasionally Perugino's heads strike one as foolish, or the composition as thin, it should be remembered that he was going against the current. Without Perugino's use of decoration as an adjunct rather than as a principal factor, of simple bulky silhouettes to establish an ordered calm, of architecture as an ideal and rational setting to enhance the proportions and balance of his figures, the Vatican Stanze would never have received the kind of decoration they did, for the cast of Raphael's mind would have probably taken quite another mould had his training been wholly Florentine, instead of being channelled first in the direction of Perugino's idealized and reticent forms.

If Raphael learnt fresco painting in the studio of Perugino, Michelangelo was taught the rudiments of fresco technique in the workshop of Domenico Ghirlandaio. Ghirlandaio was born in 1449 and died in 1494, but in the course of this comparatively short life he painted a number of large frescoes in various Florentine churches as well as one in the Sistine Chapel in the Vatican. As an artist he is not now very highly thought of, but his works are invaluable documents for the social historian, and his skill as a fresco painter,

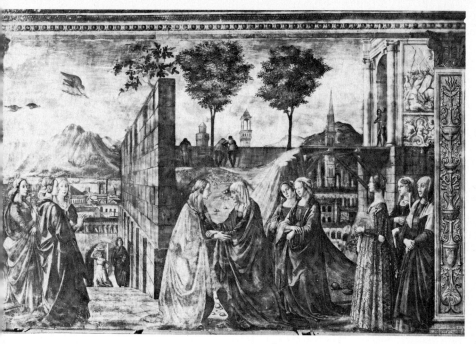

224 GHIRLANDAIO *Visitation*

which was very considerable, meant that Michelangelo had the best possible grounding in that difficult craft. Ghirlandaio was commissioned to paint the fresco the *Calling of the First Apostles* in 1481/82 in the Sistine Chapel but the nominal subject occupies a comparatively small part of the fresco field, most of which is given up to a series of splendid full-length portraits of prominent members of the Florentine community in Rome. It has been suggested, very probably correctly, that the reason for this was that Pope Sixtus IV, who had been implicated in 1478 in the Pazzi conspiracy against the Medici rulers of Florence, wished to make some sort of conciliatory gesture, and this representation of the main Florentine families was to be interpreted as a sort of olive branch if not *amende honorable*. In any case, nearly all Ghirlandaio's frescoes consist of a nominally religious subject with portraits of the donor and his family and friends. The most famous examples of this are to be found in the chapel of the Sassetti family in Sta Trinita in Florence, and the even larger fresco cycle in the choir of Sta Maria Novella (*plate 224*). Stylistically Ghirlandaio's art was sober and somewhat old-fashioned,

but his essentially prosaic mind made him open to influence from Flanders and left him comparatively untouched by the emotional enthusiasms which stimulated a painter like Botticelli. The altarpiece of the Sassetti Chapel, the *Adoration of the Shepherds*, of 1485 (*plate 225*), is a good example of Ghirlandaio's work as a tempera painter; it also shows, in the figures of the shepherds at the right, clear traces of Flemish naturalism and, in particular, the influence of the enormous triptych by Hugo van der Goes which had arrived in Florence about 1475, which was a miracle of virtuosity and an example of the technique of oil-painting which many Florentine painters sought vainly to emulate. In Ghirlandaio's *Adoration*, the shepherds are borrowed from Flemish naturalism, and even rather literally from Hugo's great altarpiece, and the naked Child lying on the ground also echoes the Northern type of Nativity which had, much earlier, influenced Fra Filippo's late *Nativities*. The classical sarcophagus, which serves as a cot for the Child, has an imaginary classical inscription which runs: ENSE CADENS SOLYMO POMPEI FULVI(US) AUGUR NUMEN AIT QUAE ME CONTEG(IT) URNA DABIT (I, Fulvius the Augur of Pompeius, slain by the sword near Jerusalem, prophesy that the Godhead will use this sarcophagus in which I lie). This, and the triumphal arch in the background, like the classical reliefs in the Sta Maria Novella frescoes, show that Ghirlandaio, like most of his contemporaries, was obsessed with the idea of the antique world and imitated it, superficially at any rate, with some exactness. The inscription and the lettering on the sarcophagus and the shape of the sarcophagus itself could easily be classical and they provide a good example of the way in which in the late fifteenth century the Christian world was thought of as growing naturally out of pagan antiquity.

Ghirlandaio never attempted oil-painting, although he was clearly fascinated by the possibility of elaborate detail which it afforded. One of the few Italian painters of the fifteenth century who achieved a degree of skill in oil-painting comparable with the Flemings themselves was the rather strange figure of Antonello da Messina. Antonello was the only major painter in the whole of the fifteenth century who was born south of Rome, yet he had great influence in Venice. He was born in Sicily about 1430 and died there in 1479. It

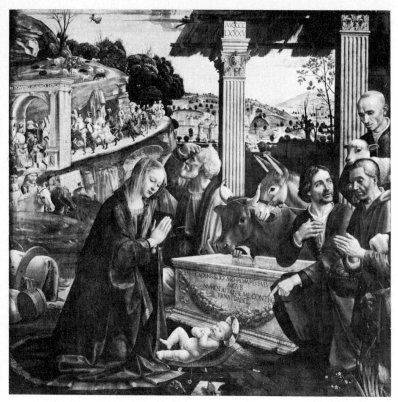

225 GHIRLANDAIO *Adoration of the Shepherds*

used to be thought that the minute skill of his oil-paintings, such as the *St Jerome in his Study* (*Frontispiece*), implied that he must have been trained in Flanders and he is sometimes even referred to as a pupil of Jan van Eyck. This view is no longer tenable, since Antonello could have seen Flemish paintings in Naples, and in any case his own style is based on that of Jan van Eyck who died in 1441. Had Antonello gone to Flanders as a young man about 1450 he would certainly have been influenced by Roger van der Weyden rather than by Jan van Eyck, whose influence faded almost immediately after his death. The first dated work by Antonello is the *Salvator Mundi* of 1465, also in London. This has a complete mastery of the oil-technique, together with a largeness of design reminiscent of the mosaics in Sicilian churches. Many of Antonello's works seem to have been destroyed in various earthquakes, so that his reputation must now, for lack of

226 ANTONELLO DA MESSINA *S. Cassiano Altarpiece, fragment*

early works, be taken on trust, but his fame must have spread since he went to Venice in 1475, and there, in 1475/76, he painted a large altarpiece for the church of S. Cassiano (*plate 226*). This altarpiece is now known only from fragments in Vienna, and from copies which have made it possible to reconstruct the original appearance of the picture. It must have been one of the three great altarpieces all of which date from the mid 1470s, and all of which developed the new idea of continuing the actual space of the chapel within the picture in such a way that the figures appear to be in an imaginary space beyond the real world of the spectator but which is at the same time an extension of that world. These altarpieces are all of the Sacra Conversazione type; that is to say, they represent the Madonna and Child enthroned and surrounded by saints so that all the figures appear to have some emotional relationship. This idea was not new —it occurs before the middle of the century in the work of Fra Angelico, Fra Filippo Lippi, and Domenico Veneziano—but the new form meant a still more intimate connexion with the spectator. This

type can also be seen in the work of Mantegna, for example in the S. Zeno Altarpiece (*plate 110*) of 1459, but the three altarpieces of the middle 'seventies all share the characteristic of the continuation of the space of the actual chapel into the picture space. The others were the Brera Altarpiece (*plate 106*) by Piero della Francesca, and one by Giovanni Bellini for a church in Venice, now known only from two bad copies. Only the fragmentary S. Cassiano Altarpiece can be dated, so that it is not really possible to determine the interaction between these three great works. In 1476, however, having produced this masterpiece and astounded the Venetians by his skill as a portrait painter in oil, Antonello returned to his native Sicily, where he died three years later.

Venetian painting of the late fifteenth century derives very largely from a fusion between the work of Mantegna and that of Antonello da Messina. This fusion was the result of the upbringing and interests of Giovanni Bellini, who is far the most important and also the most typical Venetian painter of the last years of the fifteenth century. Giovanni Bellini was the younger son of Jacopo Bellini, who had an established workshop in Venice up to his death in 1470/71. Jacopo Bellini, who was born about 1400, was a pupil of Gentile da Fabriano,

227 Jacopo Bellini
 Madonna and Child

whom he accompanied to Florence where, in 1423, he appears in the police records. It seems that some unruly Florentine children threw stones at some paintings by Gentile which had been put out into the workshop yard to dry in the sun, and Jacopo, zealous in his master's interests, beat them so hard that their parents brought him before the magistrate. Jacopo Bellini was brought up to practise the International Gothic style, and this can be seen in his few surviving paintings (*plate 227*), but is clearest in the two sketch-books, one in the British Museum and one in the Louvre, which he left to his son Gentile and which have come down to us. They contain hundreds of drawings, rather like those by Pisanello, but with an even more marked tendency towards highly elaborate perspective settings of fairy-tale castles and semi-imaginary classical monuments which have a nominal religious subject somewhere in the background. The sketch-books also contain ideas (*plates 228, 229*) which his sons later developed on a grander scale, notably the *Pietà* type of Entombment of Christ which seems to develop ultimately from Donatello, but, since the individual drawings in the sketch-books cannot be dated with any certainty, may well in this form have been one of Jacopo's major contributions. Jacopo's elder son, born probably about 1429, was presumably named after Gentile da Fabriano. He died in 1507, having worked for much of his life in the family workshop. His

228 (*left*) JACOPO BELLINI
Drawing of Christ before Pilate

229 (*right*) JACOPO BELLINI
Drawing of the Entombment

fame as a portrait painter was such that in 1478 he was chosen by the
Venetian Government to go to Constantinople in answer to a request
from the Sultan for an artist skilled in portrait painting. He is known
to have spent most of his time on a series of large paintings represent-
ing scenes from Venetian history, or the processions and ceremonies
of the great Venetian charitable foundations. Most of these have been
destroyed, but the survivors, including the *St Mark preaching at
Alexandria* which was completed after his death by his brother

230 GENTILE BELLINI *Procession in Piazza di San Marco*

Giovanni, show that these large works, like those still in Venice, one of which is dated 1496, were a combination of very large portrait groups, together with views of Venice itself which, in their topographical accuracy, reflect the passionate love of all Venetians for their city (*plate 230*) and which look forward to the views painted two and a half centuries later by Canaletto and Guardi.

Gentile's brother, Giovanni, died in 1516 at a very great age. He was born about 1430, but, like Gentile, he probably worked in the family business until the death of their father. Their sister Nicolosia married Mantegna in 1454 and the austere forms of Paduan classicism exerted very great influence on both the brothers, as may be seen by a direct comparison between the two pictures of the *Agony in the Garden* by Mantegna (*plate 213*) and Giovanni Bellini (*plate 212*) which hang in the National Gallery, London. Even here, however, there is a feeling for light and colour, a softening down of the asperities of form, the birth even of the landscape of mood, which show that Giovanni was already developing away from Mantegna towards the sensuous and colouristic style which we associate with Venice and which was, in fact, created by him and handed down to the great painters of the sixteenth century. Giorgione, Titian, and Sebastiano del Piombo were all his pupils, and even those artists who were not trained in his shop were profoundly influenced by him, so pervasive was his style, so inventive and versatile his imagination.

The history paintings done in the Doge's Palace—works which established him in the premier position in Venice, since it gave him his official rank—were destroyed in the fires that burnt the decoration by Gentile da Fabriano and Pisanello, so that nothing at all is known of this type of state art, dedicated to the glory of the Republic and its elected rulers. Some of his official portraits of the Doges survive, such as that of Doge Loredano (*plate 231*), of about 1502, and there are a few other portraits besides those in the state altarpiece commissions, like the one of Fugger, the Augsburg banker, and the delicate *Man* in the Royal Collection. These show Giovanni to have been interested in the Flemish type of three-quarter view against a landscape background, rather of the Memlinc type. The kind of picture for which he is most celebrated is, however, the Madonna and Child group, either as a small devotional work (*plate 214*) or in

231 GIOVANNI BELLINI
The Doge Loredano

the whole series of the very grand altarpieces which mark the development of the new forms of Sacra Conversazione. The medium-sized Madonnas were obviously immensely popular among private patrons, and the quality of them varies very much, from ones executed entirely by his own hand to much coarser studio repetitions of his designs, though this would make no difference to the signature, so that 'OP. IOH. BELL.' is more of a trade-mark than an indication of personal responsibility—and thus it would have been understood at the time.

Many of the painters who formed his principal competitors, but who had been trained in his shop, also produced large numbers of these half-length Madonnas with a full-length Child, often standing on a parapet and with a landscape background, and the type continues long after his death. Catena, for example, and Basaiti, Cima, Montagna, and his chief competitors from the Vivarini workshop and circle, produced works clearly influenced by him and derived from his types, so that the term 'Madonnieri' has come to refer to a particular kind of Venetian workshop painter specializing in this

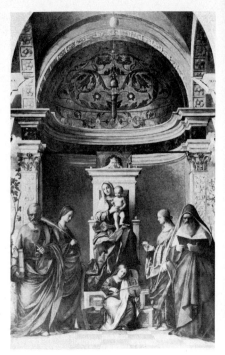

232 GIOVANNI BELLINI *S. Giobbe Altarpiece* 233 GIOVANNI BELLINI *S. Zaccaria Altarpiece*

much sought-after kind of devotional picture. His large Sacra Conversazione altarpieces also had similarly powerful repercussions in Venice and throughout northern Italy. The first, probably, of these was one in SS. Giovanni e Paolo which was burnt in 1867 and which is known only from copies. The immediately striking points about it are the device of suggesting the continuation of the spectator's space within the picture, the use of an open background of sky, the raising of the Madonna's throne well above the level of the surrounding saints, and the insertion of the charming child angel singers below the throne. It will never be possible to solve the problem whether this picture or Antonello's S. Cassiano Altarpiece (*plate 226*) was painted first, nor whether both were preceded by Piero's Brera Altarpiece (*plate 106*), and it has been advanced— admittedly on the evidence of the copies—that 1480/85 is a possible date for it. The next great example in the series is the S. Giobbe Altarpiece (*plate 232*), which it is quite reasonable to date about 1480/85, by comparison with other works of the same period. The

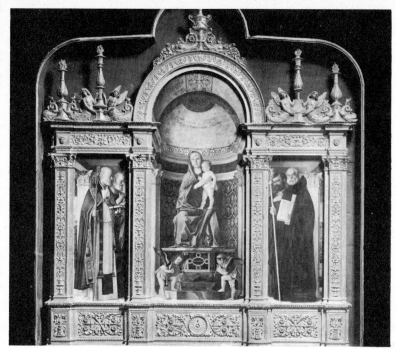

234 Giovanni Bellini *Frari Altarpiece*

same features of the very high throne, the continuous space, the angel musicians, are present, but here the setting is an interior and the rather strong light falls from the right, to cast long shadows on the apse, and to bathe the nude bodies of S. Giobbe (Job) and St Sebastian (both plague saints) in calm radiance. The *Frari Madonna* (*plate 234*) of 1488 differs from the S. Giobbe Altarpiece and the later S. Zaccaria one in that it is considerably smaller—the figures are half life-size. It takes up the S. Zeno Altarpiece by Mantegna, for the pilasters of the frame are incorporated in the design of the interior space and the saints isolated from the Madonna and Child by being in, so to speak, different rooms. The final form is the S. Zaccaria Altarpiece of 1505 (*plate 233*), which sums up all Bellini's experiments in the type. The space is continuous with the spectator's world, but instead of the low viewpoint—at the base of the picture in the *S. Giobbe* and well below the Madonna's feet in the *Frari*—the viewpoint is now placed well up the picture so that there is a deep expanse of paved floor before the single musician angel at the base

of the throne marks the back of the very slight arc on which the figures are aligned. The deep apsed niche containing the throne is set in the open, for on either side of it can be seen the cloudy sky and trees, so that this is a compromise between the interior type of the *S. Giobbe* and the Madonna enthroned in an open loggia in the votive picture of Doge Barbarigo in Murano Cathedral. The four saints echo one another in pose—the two men on the outside facing into the spectator's world, the two women in profile facing the throne, and yet all four have the distant unseeing expressions of complete abstraction. The Madonna sits and waits, the Child, as thoughtful as His Mother, stands hesitating over a tiny gesture, and even the angel-musician listens, not to the music that he is making, but to the last faint note that has died away. The cool, pearly light slips gently over the forms, bathing them in a quiet radiance; all is perfect stillness and reflection. This is an old man's picture, the fruit of a lifetime of patient study and consideration, but with that unhurried quality, that lack of urgency, which is the sign of perfection in both under-standing and communication. It is also, in a sense, the swan-song of the form. The Madonna here is still the human mother with a child whom we know to be more than human, but who is not made so by any outward circumstance. This is the perfect embodiment of the Humanist attitude to things Divine; the accessibility of the Divine instead of its separation, its inviolability. The step towards this form of thought is implicit in the change from Piero's Madonna, seated among but not above the saints around her, to the higher throne and the more exalted presence of the *S. Giobbe*, or, for that matter, the S. Cassiano Altarpiece. Later, from about the 1480s onwards, this trend was quickened, until after the turn of the century, and in such painters as Fra Bartolommeo, the Virgin is represented in Glory and the simple humanity is entirely replaced by the effulgent majesty of a celestial vision. Raphael's *Madonna di Foligno* of 1512 conforms to this type, which becomes the norm. The Madonna then acquires many and varied attributes of a non-human kind: she becomes the Queen of Heaven, or develops less exalted though equally separating qualities of otherness such as sophistication, fashionably languorous grace, a deliberate consciousness of her role, and an air of unattaina-bility which she in turn communicates to her Son. There was also

235 GIORGIONE *Tempest*

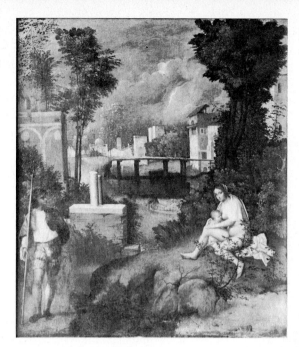

236 (*below*) GIOVANNI BELLINI
 Feast of the Gods

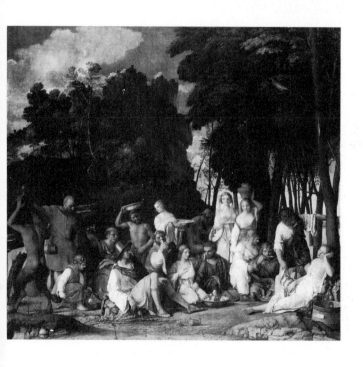

a current of influence passing from Bellini's own pupils backwards towards their master, who had far too receptive an intelligence to be unaware of the currents which he himself had set in motion. The landscape of mood, adumbrated by Bellini as far back as the London *Agony in the Garden* (*plate 212*), and fully developed in the background of Giorgione's *Castelfranco Madonna* of about 1505/7 (*plate 222*), or in the new secular subjects to which he was giving a particular impetus and significance, such as the *Tempest* (*plate 235*) or the *Sleeping Venus* (*plate 250*), are reflected in many of Bellini's later devotional Madonnas such as the *Madonna degli Alberetti* of 1510. These influences transform the type of the Sacra Conversazione as well, since the *St Jerome and other Saints* of 1513 has the newer softness of handling and unified vision inspired by Giorgione, who by this date had already been dead three years. The death of Giorgione left Bellini supreme in his last years, for, despite the implications of Titian's rivalry and persistent attempts to displace him from his official position, Bellini demonstrated in his late works his ability to develop his style and ideas so as to keep pace with the new vision current after the turn of the century. The *Feast of the Gods*, of 1514 (*plate 236*), is an essay in the new type of mythology, with the gods of Olympus disguised as peasants enjoying a heavenly picnic in a vein of tenderly elegiac eroticism, while in the *Lady at her Toilet*, of 1515 (*plate 237*), the nude figure is reminiscent of the reticence and intimacy of Giorgione's poetic art.

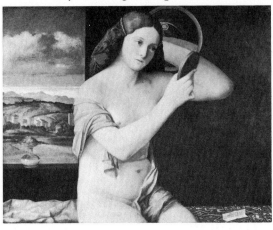

237 GIOVANNI BELLINI
Lady at her Toilet

The developments described in this book culminated, in the genera-
tion after 1500, in a brief flowering of all the arts in Italy, which is
usually called the High Renaissance. In effect, this corresponds with
the pontificates of Julius II (1503–13) and Leo X (1513–21), and the
disaster of the Sack of Rome by the Imperial troops in May 1527
ended it just as decisively as 4 August 1914 ended the era which we
now look back on as *La belle époque*. It is true that Michelangelo's
greatest masterpieces, the Medici Chapel, the *Last Judgment*, the
Rondanini Pietà, and, above all, his conception of St Peter's, are all
much later than 1527: what is important is that they are funda-
mentally different in style from the St Peter's *Pietà*, the *David*, and the
Sistine Ceiling, as well as different from Bramante's idea for St Peter's.

Bramante died in 1514, Leonardo da Vinci in 1519, and Raphael
in 1520; with them the Renaissance passed into history, for it is a
watershed which divides Giovanni Bellini, Piero della Francesca, and
even Giorgione from Michelangelo and Tintoretto. Perhaps only
Titian was able to cross it, approaching Giovanni Bellini at the
beginning of his career and El Greco at the end.

The salient characteristics of the High Renaissance have been stated
often enough—harmony, symmetry, and above all the understand-
ing and recapture of classical antiquity in the service of new ideals.
One of the greatest surviving monuments is the little *tempietto* in the
courtyard of S. Pietro in Montorio in Rome, built by Bramante in
1502 (*plate 238*). It marks the traditional place of martyrdom of
St Peter on Mons Aureus, and it is a restatement of the Early
Christian type of circular church often erected as a commemoration
of some peculiarly sacred spot. The design could hardly be simpler—a
circular colonnade enclosing a circular temple—but it is perfect in its
symmetry and in the mysterious effect of the harmony of its elements,
all of which are classically pure in their individual proportions.

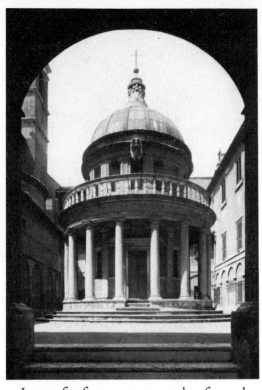

It was far from easy to evolve from the allegories of Botticelli, expressed in linear designs of the utmost complexity, to the simple grandeur of Raphael's *Stanze* in the Vatican, and it must have seemed to contemporaries that in many cases the stylistic gains of the previous generation were being thrown away—what was the use of the vigorous movement and anatomical researches of Antonio Pollaiuolo, or the graceful rhythms of Botticelli, if the new generation of painters represented their figures as calm and motionless? Perugino had been mocked, in his last years, as out of date, and so he was; but nevertheless it was necessary that his form of 'Early Classicism' should prepare the way for Raphael's deceptively simple compositions, just as much as Signorelli's tortured nudes point still further forward to the Michelangelesque complexities of Late Mannerism.

Raphael's development is clear. He was born in Urbino in 1483 and received a provincial training, mainly under Perugino. At the age of seventeen he proved himself one of the most promising of the

239 RAPHAEL *Assumption and Coronation of the Virgin*

younger painters, but he was still much influenced by Perugino in such works as the Vatican *Assumption and Coronation of the Virgin* (*plate 239*) or the *Crucifixion* in the National Gallery, London, both painted when he was about twenty. Very soon after this he went to Florence, realized the deficiencies of his provincial schooling, and set himself to study Leonardo and Michelangelo. The portrait of Maddalena Doni (*plate 243*) owes almost everything to Leonardo's *Mona Lisa*; the *Madonna with the Goldfinch* (*Madonna del Cardellino*) (*plate 240*) is one of a series of compositions, all of which are exercises based on Leonardo's cartoons of the *Madonna and Child with St Anne* (*plate 218*); the *Madonna del Granduca* (*plate 241*) shows him experimenting with the simple dark background that Leonardo used to obtain greater effect of relief as well as simplicity of composition. In all these pictures there is also a tautening of the draughtsmanship, a realization that contour can be made to do things beyond the range of Perugino's imagination, and this is due to Michelangelo's example in such celebrated feats of virtuosity as the cartoon (now lost)

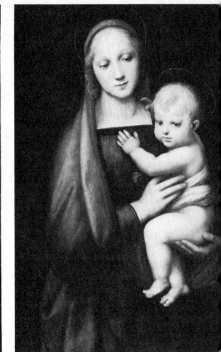

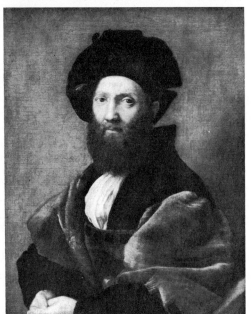

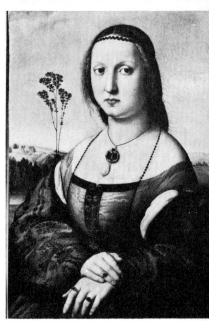

240 (*far left*) RAPHAEL
Madonna with the Gold-
finch (*Madonna del
Cardellino*)

241 (*left*) RAPHAEL
Madonna del Granduca

242 (*below far left*) RAPHAEL
Baldassare Castiglione

243 (*below left*) RAPHAEL
Maddalena Doni

244 FRA BARTOLOMMEO
Vision of St Bernard

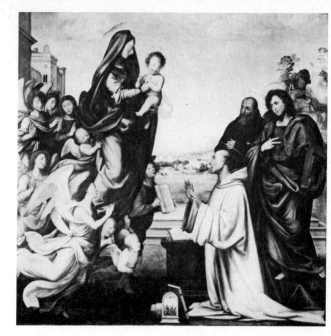

for the battlepiece in the Palazzo della Signoria. Raphael learned
from everyone, and not the least from Fra Bartolommeo. Fra
Bartolommeo was probably born in 1474 and was therefore about
a year older than Michelangelo, but there was not the towering
difference in skill—at that date—between him and Raphael that
separated the latter from Michelangelo. In any case, Fra Barto-
lommeo's *Vision of St Bernard*, of 1506 (*plate 244*), had many things
to teach Raphael, particularly by comparison with the pictures of the
same subject by Filippino Lippi and even Perugino himself: in Fra
Bartolommeo's picture there is a clear separation between the super-
natural apparition at the left and the natural figures at the right, and
the Madonna is made to float in the air instead of walking into the
room, as she does in Quattrocento versions of the theme. The
description given by Wölfflin is apposite: 'The vision is depicted in
an unexpected way, unlike the gentle, shy woman of Filippino's
picture, laying her hand on the pious man's book as she steps up to
his desk; here it is a supernatural apparition sweeping down from
above, wrapped in the solemnity of a great floating mantle and
accompanied by a choir of angels pressing closely round and filled
with awe and reverence. Filippino had painted girls, half-shy and

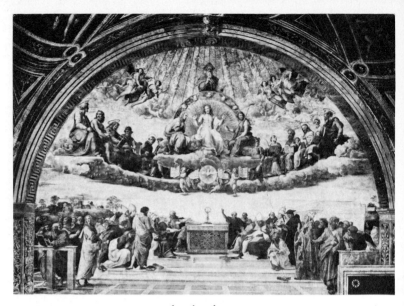

245 RAPHAEL *Dispute concerning the Blessed Sacrament*

half-curious, accompanying the Virgin on her visit; Fra Bartolom-
meo wants, not that the spectator should smile but that he should be
stirred to devotion . . . the saint received the miracle with pious
wonder, and this is so finely rendered that, by comparison, Filippino
seems trite and even Perugino, in his picture at Munich, seems
indifferent. The heavy, trailing, white robe has a new dignity of line,
and the two saints behind St. Bernard are made to play their part in
the emotional atmosphere. . . .' (H. Wölfflin, *Classic Art.*)

About 1508 Raphael went to Rome, and there he received the
great commissions that gave him the chance to develop his genius to
its fullest extent; here the untried provincial—he was then about
twenty-six—was given the commission to decorate the Vatican
Stanze, a task not much inferior to that which Michelangelo had just
begun in the Sistine Chapel. The *Dispute concerning the Blessed Sacra-
ment (plate 245)*, as it is usually but erroneously called, was probably
begun in 1509 and still has distinct echoes of Perugino and Fra
Bartolommeo, especially in the rather wooden rows of saints on the
all too solid clouds. Nevertheless, the skill in the grouping of the
figures on earth so that the eye is led into the centre of the picture,
to the monstrance on the altar, presages the full development of his

style in the next fresco, the *School of Athens*, which would take us beyond the limits of this book. The portrait of Castiglione (*plate 242*) (author of *The Courtier*, the foundation of the idea of the English gentleman) can stand for Raphael's aims and ideals in his later period. The contrast with the *Maddalena Doni* (*plate 243*), painted some ten years earlier, shows the speed of his development.

Michelangelo was much less the brilliant student. He claimed to owe nothing to anyone, and it is true that his apprenticeship to Ghirlandaio did no more than give him the chance to learn fresco technique from one of the finest living exponents. Nevertheless, he considered himself primarily a sculptor, often signing his letters *Michelangiolo schultore* in protest at being made to work as a painter; certainly his great fame was established in the years immediately after 1500 by his *Pietà* in St Peter's and his *David* in Florence.

The *Pietà* (*plate 247*) was carved in Rome in the last years of the fifteenth century, Michelangelo having fled there in 1496 to escape from the explosive situation created by the expulsion of the Medici, his early patrons, and the attempt to set up a theocratic dictatorship under Savonarola. The problem was to carve a single monumental group composed of the two awkward shapes presented by a full-grown man lying across a woman's lap; this he did by a judicious adjustment of the poses, so that the gesture of the Virgin's hand is made into an Exposition of the Body of Christ rather than a lament, and, at the same time, Michelangelo was able to relate the two figures in such a way that the disparity in size is not apparent. The group is very highly finished and has a tender sentiment which hardly reappears in his work, but in all this it is the climax of everything that the later sculptors of the fifteenth century—the Desiderios, the Minos—had sought. In his later works he was to return to the heroic ideals of Donatello and Jacopo della Quercia, as may be seen in the over life-size *David* (*plate 246*), completed in 1504. This raw-boned youth, arrogant in his strength and superbly conscious of the inevitability of his victory over his unseen opponent, has always been a sort of ideal Florentine. He is certainly the ideal creation of Florentine art of the purest strain in the fifteenth century, beginning with Masaccio, Donatello, and Castagno and going on through Pollaiuolo's warriors.

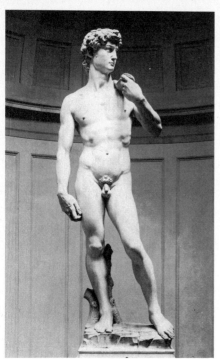
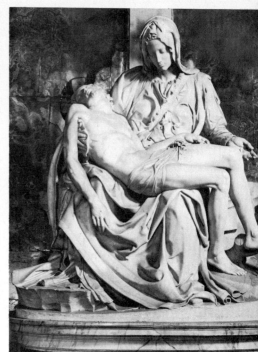

246 MICHELANGELO *David* 247 MICHELANGELO *Pietà, St. Peter's, Rome*

From this point of view it is not surprising that the typical work which finishes the Quattrocento in Florence and looks forward to the High Renaissance in Rome should be a male nude, tensed in the anticipation of violent action, every muscle gliding under the skin so that the spectator feels only that he is in the presence of perfection and serene confidence, where even in the works of Donatello there is always the tragic sense of the human condition. For Michelangelo that sense was still to come, and it was to last for most of his long life, but in 1504 that was still in the future.

The *Doni Tondo* (*plate 248*), contemporary with the *David*, shows how his mastery of contour led him to think of forms in terms of carved blocks with colour added as an after-thought and with almost all the emphasis on movement and the play of expressive line—the pleasure we take in the superb *contrapposto* and the power of the Virgin's left arm almost makes us forget the extraordinary clumsiness of her gesture, reaching back over her shoulder for the Child instead of, more reasonably, turning sideways.

274

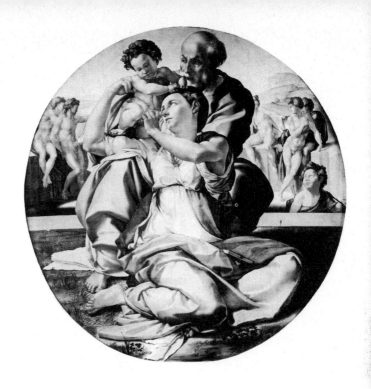

248 MICHELANGELO
Holy Family
(*Doni Tondo*)

A few years later, in 1508, Michelangelo began his huge task in the Sistine Chapel of the Vatican. Lying on his back, for years on end, he interpreted the story of the Divine Creation in terms of Neoplatonic imagery, daring to imagine the *Logos* over the altar; the primeval act of creation by which God created the Idea, before the separation of light from dark or the creation of form from the void. (Several times in the Mass the priest is directed to raise his eyes to Heaven; once at the words 'Veni Sanctificator, omnipotens, aeterne Deus: et benedic hoc Sacrificium. . . .' This must have been in Michelangelo's mind.) This was the Beginning, but Michelangelo worked his way back to this point, progressing through the simple, traditional stories of the Deluge and the Creation of Man, which he tells in simple, human terms. The *Creation of Adam* (*plate 249*) is so famous that it is almost impossible to see it with fresh eyes, as Michelangelo's contemporaries saw it—simply as the spark of life given to Man by God: 'And God created man in his own image . . . and breathed into his face the breath of life; and man became a living soul'.

275

Twenty years earlier nobody would have had the technical mastery to create so perfect a human form, like a Greek god; still less would anyone have had so boldly simple a conception of the scene, with the earth no more than indicated behind Adam and everything concentrated on the expression of Adam's reluctant, sluggish body which is animated by the impulse, like an electric shock, passing down his arm. Only Leonardo's *Last Supper* (*plate 215*) had attempted to render psychological situations in terms of gesture and expression. Twenty years later everybody, in imitation of Michelangelo himself, would have given the scene too much energy, too much intensity; the nobility would have disappeared from the conception.

Mannerist art is inconceivable without the impulse given by Michelangelo towards virtuosity, and Vasari is explicit in his testimony: 'But who is there who will not admire, bereft of speech, the *terribilità* of Jonas, the last figure in the Chapel, where the power of art is such that the vaulting, which in actual fact curves forward from the wall, is contradicted by the appearance of the figure which seems to bend backwards and makes the wall-surface seem straight; thus, defeated by the art of drawing, by light and shade, it seems to curve away? Oh truly happy age! oh most fortunate artists! Well may you be so called that in your own days have been enlightened by such a fount of light, removing the darkness from your eyes, seeing every difficulty smoothed away by so marvellous, so unique an artist. . . . Thank Heaven for this, therefore, and strive to imitate Michelangelo in all things.' All other considerations, economic, political, and religious, are secondary to this.

It is only fair to point to Venice, which, after surviving the Holy League of 1508 directed against her, was the only one of the Italian states to retain her independence and prosperity in the mid-sixteenth century. Here the economic and political factors which were certainly important for the rest of Italy do not apply, and the art of Titian retains a sunny splendour far distant from the grandeurs and miseries of Mannerism in Rome, Florence, or Parma. Titian develops along the lines laid down by Giovanni Bellini and Giorgione, whose *Castelfranco Madonna* (*plate 222*) is adapted from the Giovanni Bellini type of large altarpiece, but treated with greater richness of colour and depth of tone. The opulence and subtlety of the oil medium allowed

249 MICHELANGELO *Creation of Adam, detail*

Giorgione to explore entirely new ideas and to experiment with new effects, and in such a picture as the *Tempest (plate 235)* he also developed a new type of picture, making a decisive break with earlier landscape painting in Venice and elsewhere. The subject of this enigmatic picture has never been satisfactorily explained; it is, indeed, probable that there is no subject in the simple sense in which it would have been understood by a fifteenth-century painter or patron, and that, in fact, what the artist is expressing is a mood, a poetic response to natural phenomena.

The increasingly complex nature of the content can be seen developing quite clearly when the patron began to commission non-religious pictures, and many of the early mythologies reflect the best-of-both-worlds character of fifteenth-century Humanism. The lost *Hercules* of 1460 by Pollaiuolo may well have been interpreted as *exempla* of the Christian virtue of Fortitude, and the myth of *Apollo and Daphne*, also by Pollaiuolo, can be instanced as an allegory with Christian overtones, just as the *Primavera (plate 1)* by Botticelli, with its obscure but intelligible meaning, is far from being the simple

277

pagan mythology that it appears to be at first sight. Yet all these pictures have a content which, ultimately, can be explained; the idea of a connoisseur, a person who enjoys a painting for its own sake and is prepared to allow the artist full liberty, would have been foreign to the fifteenth-century painter and patron alike. Giorgione and Titian began to paint for a small class of men, most of whom were well educated and able to appreciate a picture for its own sake, because it involved passages of beautiful painting, as well as for its subject. The earlier patron, who liked pictures but on the whole regarded them as semi-practical objects, bought images of the Madonna or his patron saint; this was largely because the educated classes, throughout most of the fifteenth century, were predominantly clerical or else professional men of learning, and only the exceptional patrons such as the Medici or the Gonzaga ranged over wider intellectual territory. The rise of secular education, coupled with the tendency to equate education with a knowledge of Latin and Greek literature—that is, Humanism—led to a demand for such pictures as the *Tempest* or the *Sleeping Venus* (*plate 250*). This picture was left unfinished at Giorgione's premature death in 1510 and Titian completed it. With it, a new era dawned in the arts.

250 GIORGIONE and TITIAN *Sleeping Venus*

List of Illustrations and Artists

Artists are listed in alphabetical order. Roman figures denote text references and bold figures denote pages on which illustrations appear.

Bibliographical Note

No bibliographical details are given here, but a list of books on Italian Renaissance Art, and the principal monographs on the painters and sculptors mentioned will be found in:
P. and L. MURRAY, *Dictionary of Art and Artists*, London, 1966.

Index of Names